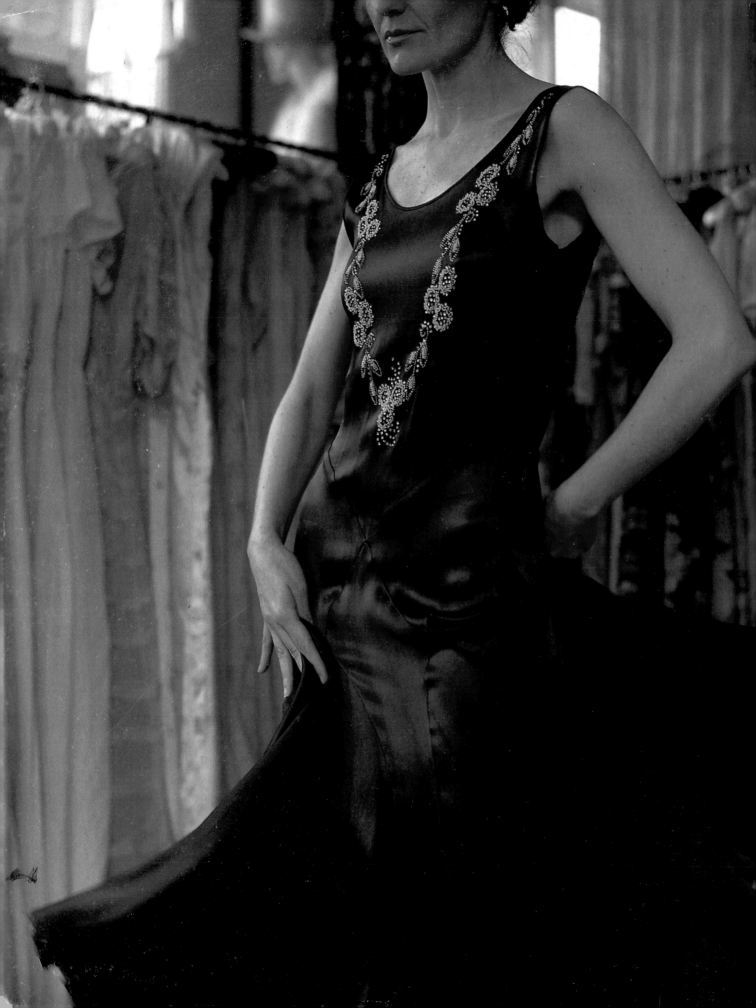

Viva VINTAGE

FIND IT, WEAR IT, LOVE IT!

TRUDIE BAMFORD

CARROLL & BROWN PUBLISHERS LIMITED

First published in 2003 in the United Kingdom by

Carroll & Brown Publishers Limited
20 Lonsdale Road
London NW6 6RD

Art Director: Tim Foster
Project Editor: Kirsten Chapman
Designers: Luis Peral-Aranda, Peggy Sadler
Commissioned photography: Jules Selmes, Polly Wreford

Reproduced by Emirates Printing Press, United Arab Emirates
Printed and bound in the United Kingdom by The Bath Press

Contents

why buy vintage?

"Fashion is more usually a gentle progression of revisited ideas."
Bruce Oldfield, Designer

When top designers send models down the catwalk in ten-year-old dresses and film stars appear at award ceremonies and premieres in vintage evening gowns, one thing is clear: vintage is here to stay. For too long the province of the collector or the eccentric, vintage clothing has started to achieve the recognition it deserves, with stylish women from around the world including it in their wardrobes.

Vintage clothing embodies nostalgic romance, which appeals to our hearts, while its ability to look fresher than current fashions appeals to the style-conscious mind. The fact that a 40-year-old dress can look as chic as current designs shouldn't surprise us; as Bruce Oldfield says, designers have been using the past for inspiration for many years. Some of the highlights of the spring/summer designer collections released while I was writing this book were: feminine tea dresses in the style of the 1930s; fitted, pastel shift dresses inspired by the 1950s; daring minis similar to those popular in the 1960s; and sportswear inspired by the 1980s. It stands to reason, therefore, that style-conscious women are keeping a few steps ahead of trends by choosing vintage clothing and using it to create their own contemporary looks.

Thankfully, as vintage clothing has become more popular, it has become easier than ever to find. Most cities have a number of vintage or retro shops, often specialising in certain eras or styles. Bargain-hunters can scour charity and thrift shops, market stalls and house clearances for original pieces at give-away prices. And now vintage buyers have an even more powerful tool at their disposal: the World Wide Web. With the numerous websites that specialise in vintage, buyers can access a tremendous range of vintage clothing, accessories and jewellery, and the variety and volume of items available mean that everyone can find what she is looking for, regardless of budget, size or taste.

But while vintage is now easily accessible and appeals to most women who love fashion, some still feel nervous when choosing or wearing vintage. Although it doesn't require specialist knowledge to buy vintage clothing, it is true that it

requires a little more thought and effort. If you walk into a branch of a fashion chain or a womenswear shop and buy a dress, you can be reasonably sure that you will look in fashion – after all, thousands of other women will be wearing the same dress as you. You should be able to find a size that fits – although whether it fits well and flatters your shape is another matter. But you pay a price for that convenience: identikit styling; the reduced quality of construction that is inevitable with mass-produced garments; and an item of clothing that will look dated by next year. And who wants to enter a room and see another woman wearing the same dress – especially if she looks better in it?

In contrast, vintage clothing is individual and unique. Rather than choosing from styles that designers and manufacturers have decided you should be wearing this season, you can choose clothing that appeals to your style, and that both fits and flatters your shape. You can choose a dress for a special occasion, safe in the knowledge that no one else will be wearing anything similar. You can establish a look that's unique to you, or you can play around with a variety of looks, changing them from day to day. And you can buy garments of high quality and design, at prices that are the same, or even less, than prices you would pay elsewhere. For the stylish woman, vintage clothing is a chic supplement – or even alternative – to a modern wardrobe.

It's true that vintage garments require a little more care. After all, you'll want to continue wearing them for years to come, perhaps even to hand them down to your daughter. They may need some work done to them before you wear them, perhaps alterations to ensure a good fit, or cleaning or repairs to eliminate the signs of age. But each garment is an investment, it deserves to have a little time and effort put into it, because it is special and unique and will bring you many moments of pleasure in future. "Viva Vintage!" because trends come and go, but true style remains forever.

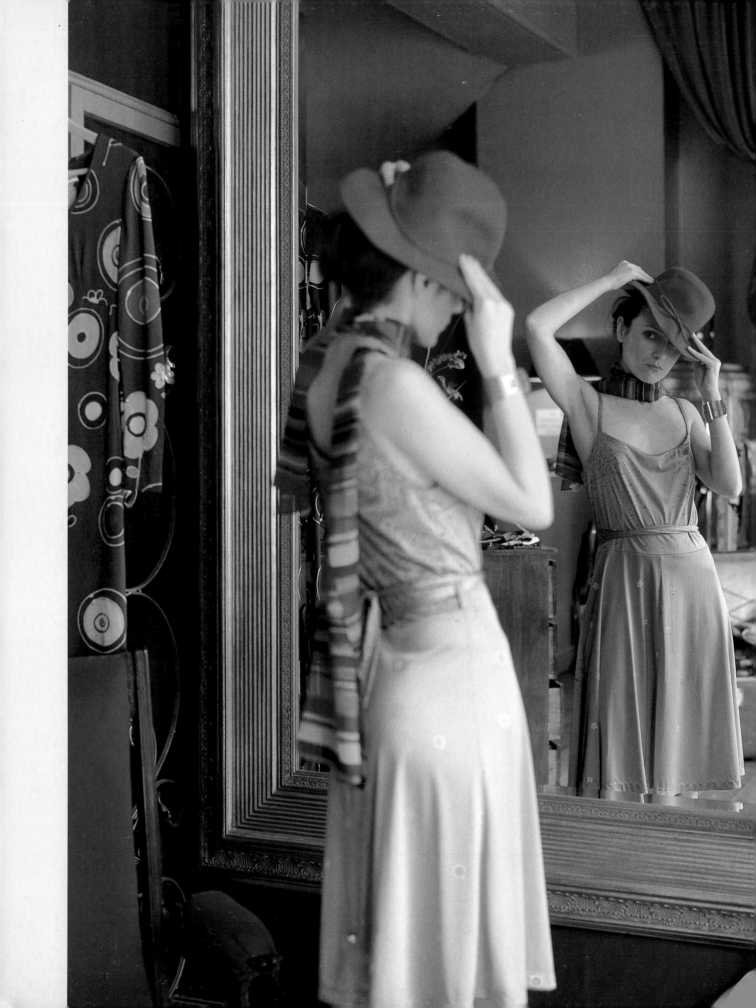

1
choose it!

shopping in a vintage-wonderland

If you have never been vintage shopping before, you are in for a treat – and a few surprises. To shoppers used to the identikit nature of the large fashion chains, where every shop carries the same styles, plays the same music, and has the same bored shop assistants, the variety and quirkiness of vintage shops will come as a breath of fresh air.

Although vintage shops vary in size and number of staff, their assistants are generally willing to help, and keen to share their knowledge of vintage styles, creating a more personal shopping experience than in chain stores. The type of person who is drawn to work with vintage clothing is usually someone with imagination, eclectic taste and an independent spirit, and she'll probably be more interested in sharing her enjoyment of vintage fashions than in making stacks of money. Charity and thrift shops are slightly different, as they are often governed by the rules of a national organisation, but a similar relaxed atmosphere prevails.

Where to shop

When looking for vintage clothes, you'll probably find that some people call them "vintage", some "retro", some "antique", some just "second-hand". Dealers have never settled on definitive titles, but roughly speaking: antique clothing is earlier than the 1920s; vintage covers 1920s to 1980s; retro clothing is post-1960s; and anything later than the 1980s is second-hand. It's useful to remember this, as it will help you to find sources you might otherwise overlook.

Vintage and retro shops often don't do much advertising, so the best way to find them may be asking around. If you're in a strange town,

the local music shop is usually a good place to start. And if you find one vintage shop, don't be shy: ask the assistants if there are others around. You'll soon build up your own little black book of sources. If you love to rummage, you could try jumble sales and car boot sales – although you'll usually have to sift through a lot of junk to find anything worth buying.

Searching the racks and rails

The better vintage shops are well laid out, with rails, shelves and display cases for the stock. But some shops are jam-packed, and it's not unknown for clothes to be piled high in bags, and even in heaps, on the floor. Even if it isn't immediately apparent, shop owners often have some form of system – for example, organising the clothes by era or by size – so try asking if you are looking for something in particular.

More importantly, the stock you can see on the shop floor may be only the tip of the iceberg – often sellers store clothes, bringing them out as they become seasonal or fashionable. If you make friends with the owner, you could get access to the stockroom and discounted goods, and she may even be willing to look out for specific items and let you know when they come in. The same rule applies to vintage websites. Most sellers don't have time to constantly update their stock, and they may have more than you can see on the website. If you know what you're looking for, ask – they might have it already or be happy to look out for it for you.

Market stalls work on a similar basis, so chat with the owners; they may bring extra clothes for you to look through next time. Charity shops sometimes label older clothing as "fancy dress", so ask if there is a fancy-dress rail – it can bring out some gems.

Ready for a change

Most vintage shops have a fun atmosphere, with staff making the most of the clothes at their disposal and experimenting with styles of dress.

So don't feel that you have to make an impression with flashy designer wear; these are the kind of shops that encourage diversity, not snobbery. Besides, you're less likely to get money off your purchases if you are wearing an expensive ensemble. Wear clothing that you can move easily in and consider leaving your bag at home or using one that straps across your body, leaving your hands free to explore.

If you're going to try garments on, wear something that you can quickly change in and

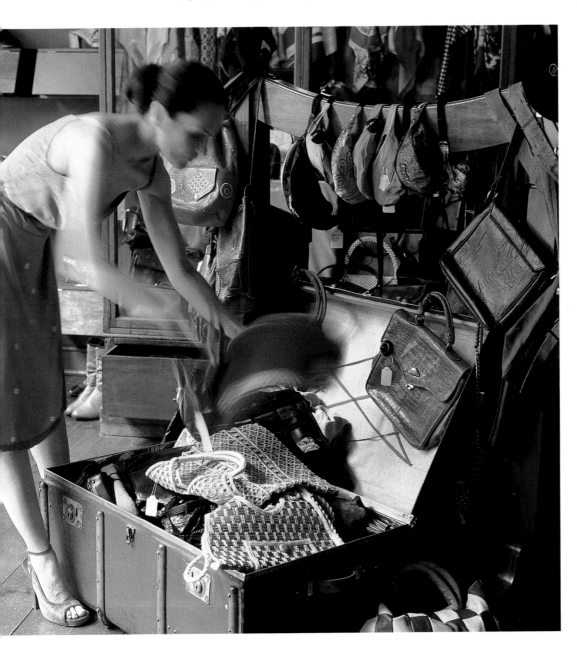

You may need to rummage to find what you're looking for, but that's all part of the fun. Beneath the apparent disorder might be some treasures you really can't live without.

out of, especially your shoes. Clothes that you don't mind getting a bit dusty are best, as the changing-room conditions may not be ideal. And avoid wearing sharp hair ornaments or jewellery, which could snag delicate fabrics. Keep make-up to a minimum – it looks good on you but not on clothes.

Any happy returns?

Check very carefully the shop's returns policy before making any purchases. Because most vintage items have been worn before and many have some flaws, sellers are sometimes reluctant to refund money on items, preferring to sell on a "sold as seen" basis. However, if you are unable to try the garments on or if you are buying from a website, you might want a bit more flexibility, so check if you can get a full refund before you buy. Try to be tolerant if the shop's policies aren't quite what you are used to – these are only small businesses with small budgets; they don't have the financial backing of more conventional shops.

The key to successful vintage shopping is to enjoy it. Try not to see it as goal oriented – "I need a black dress for tonight's party" – because you are likely to get frustrated and may overlook several great items in your search for one. Go shopping with an open mind, enjoy browsing and finding out what appeals to you. If you're able to, you'll find it more pleasant to visit vintage shops when they're quiet – usually mid-week or during office hours. Check opening times before visiting, as they're often open at different hours to other regular clothing shops.

Six steps to online success

Some people are reluctant to buy from websites because they are unable to see the clothes and try them on before purchasing – but don't reject this rich source of vintage clothing and accessories. Stick to some basic rules and you'll be able to make the most of online resources.

1 Ask for as much information as possible about an item before you buy it. Sellers may be able to supply you with extra pictures and details and should be happy to give you additional measurements.

2 Be patient when looking through websites. Often sellers have put the website together themselves, and the design may leave much to be desired. Try to disregard the look of the website, because there may be some gems hidden among the dark photographs, clashing colours and flashing text.

3 Check the payment and delivery options before you start browsing the stock – it's disappointing to find just the dress you've been looking for, only to discover that the seller doesn't deliver to your country.

4 Keep a record of all correspondence between you and the seller, in case of dispute, and always request registered mail, so that you can trace the parcel.

5 If there is a feedback section on the site, check it carefully to give you an idea of the level of service you can expect. Add to it once you have completed your transaction.

6 Make sure you are happy with the returns policy before making a purchase – some sellers will only give a partial refund on returned goods, so ask first.

strategic shopping

Vintage clothing comes from a range of eras and covers time periods in which the world changed dramatically. The styles often reflect what was happening at the time, with a paucity or generosity of cut; bright, cheerful colours or subdued shades; and influences from the preoccupations of the time, such as the 1960s drugs experimentation that led to psychedelic prints.

f you are new to vintage clothing, you're probably excited by such a range of items and styles, but it's possible, too, to be a little daunted. This section will help you to find a few easy ways into the world of vintage shopping.

One of the key things to remember is to stick to basics to begin with. As your confidence grows, and your taste develops, you can start to expand your wardrobe with more distinctive pieces. Look for versatility in the clothes you choose, especially if they are expensive.

Vintage sellers are rarely money-oriented, so when they offer to help, you can be confident they aren't just trying to make a sale.

Start with what you know

Before you go shopping, have a look through your existing wardrobe and analyse your clothes. Which styles are you drawn to? Which pieces are your favourites, the ones you can rely on to make you look and feel good? Which garments were mistake buys skulking at the back of the cupboard? (Come on, we all have them.) Without thinking about it, you probably have a distinct style already, but you can use vintage to develop and extend it – or to change it entirely if you discover you hate it.

Once you get to the vintage shop, keep your eyes out for clothes that are similar in style to your existing wardrobe, at least to begin with. If you feel better in straight skirts, look out for slim shift dresses and pencil skirts. If you love floaty clothes, spend some time looking at the pretty peasant styles or chiffon tea dresses. Until you get used to vintage shops, in which your taste is the driving force rather than the retailers', stick to familiar styles and designs. Otherwise you may end up going home with a psychedelic mini dress that you would never wear and that will put you off vintage shopping for life.

Enlist some help

If you don't have much confidence in your fashion choices, enlist the help of a stylish friend – she'll probably be delighted to help. And don't forget to make the most of the shop assistant or owner. The more experienced vintage seller will be able to guide you to the

Styles to suit: easy starter pieces

EVENING GOWN: Every woman needs one showstopper, and for real glamour it has to be vintage. Choose a simple style in a luxurious fabric or with stunning beading or embroidery, for the best value for money.

WOOL, TWEED OR LEATHER COAT: Vintage materials are usually of a higher quality than those used in many of today's clothes. Choose a coat that can take you from season to season and that can be worn with smart or casual clothes.

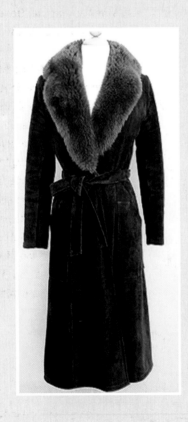

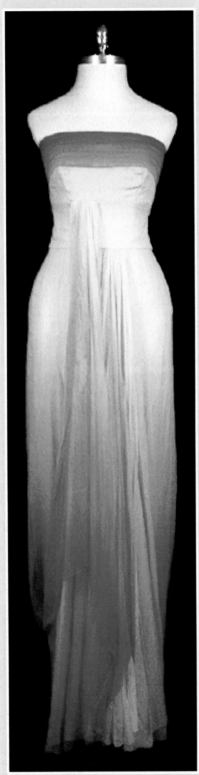

PENCIL SKIRT: This elegant classic, popular in the 1950s and 1980s, has the bonus of being extremely flattering on most shapes.

SHIRT DRESS: From the crisp styles of the 1950s to the slinkier 1970s versions, this style is versatile, easy to wear and looks effortlessly chic.

CASHMERE SWEATER: The quality of vintage cashmere is superb, and a cashmere sweater or cardigan holds its style indefinitely and looks equally good with a smart dress or a pair of jeans.

HANDBAG: The range of styles is fantastic, and the construction generally much more sturdy than today's throwaway-after-one-season bags. The cheaper prices also mean that you can build up a good selection to go with any outfit.

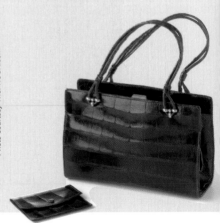

CIRCULAR SKIRT: This 1950s essential suits most figures and is incredibly versatile. Look out for fun cotton prints for spring and summer or appliquéd wool or felt for winter.

SUIT OR SHIFT DRESS: The tailoring of vintage outfits is unsurpassed in today's clothing, especially in luxury fabrics such as silk, linen and wool.

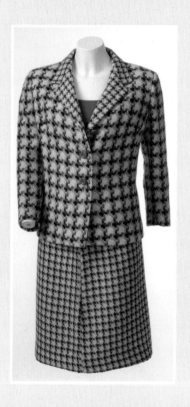

best styles and cuts for you, help you to put looks together and give you advice about the aftercare of more fragile items. Most sellers will probably enjoy helping you, and you will benefit from their expertise.

Pick a theme, any theme ...

One fun way to ease yourself into wearing vintage clothing and accessories is by choosing a theme, then looking out for pieces to fit it. This could gradually develop into your own personal image or trademark.

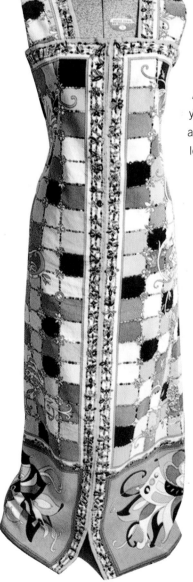

Shopping with a theme in mind also may help you to loosen up and enjoy browsing. However, don't be too blinkered, if you see something else that appeals to you, but it doesn't fit into the theme, who cares? Get it anyway. After all, this is all about enjoying yourself, building up your confidence as well as your wardrobe, and learning what suits you.

Which styles appeal to you?

If you like the exotic look, keep an eye out for saris, Chinese brocade jackets, embroidered chinoiserie shawls, European peasant jackets and blouses, or original kimonos. If you want cheerful styles, seek out clothing with polka dots, luscious floral patterns or the Paris-themed prints of the 1950s. Or you could look for items from a particular designer, such as original Laura Ashley dresses or Liberty shirts.

The wonderful designs of Emilio Pucci make great investments.

Which items can't you get enough of?

If you love hats, start a hat collection. Search out slick men's trilbies and fedoras, 1940s berets, floppy hippy hats, little pillboxes with mysterious eye veils and velvet-trimmed cloches. Do you like to brighten up your outfits with jewellery? Look out for delicate chandelier earrings from the 1920s, clunky Bakelite bangles from the 1950s, diamanté novelty brooches from the 1940s and mood rings from the 1970s. Or why not build up a collection of vintage nightgowns: from the silk gowns of the 1930s to the filmy baby dolls of the 1960s?

If you start a hat collection, you can always use the more eccentric ones for display purposes.

Think twice before buying...

JEANS: They might have been cool at the time, and their style might be in fashion right now, but vintage denim is generally uncomfortable and unflattering. Unless you are a die-hard collector, you're better off choosing modern jeans and adding a vintage twist with the rest of your outfit.

UNDERWEAR: Vintage slips and nightgowns are gorgeous and can even double as evening dresses, but vintage bras and knickers are definitely dodgy. If the thought of putting on underwear that somebody else has worn isn't enough to stop you, consider the advances that underwear manufacturers have made in styling and construction, and stick to your Wonderbra.

REAL FUR: You'll see bargain price furs in most vintage shops – and for a good reason. That jacket might be an original 1950s mink, but that won't stop it offending many people. Forget real fur and stick to animal-friendly fakes. And do not, under any circumstances, buy a fur from an endangered animal such as the ocelot or leopard: the commercial trade of these furs has been banned for many years, even on the second-hand market.

SHOES: As appealing as vintage shoe styles are, they are rarely wearable, for both practical and aesthetic reasons. Women of earlier ages, and especially in the first half of the 20th century, wore their shoes until they wore out – and a pair of bunion-stretched shoes doesn't look good with any outfit. If you still can't resist, however, consider shoes for display only.

GLOVES: Those original 1920s kid gloves might look gorgeous in the shop, but they won't look quite as good stretched over your modern-sized hands. Vintage gloves really were tiny and fit few women today. If you do find some that fit, great, otherwise stick to modern gloves.

One last word of advice: vintage shopping is not a contest. The prize doesn't go to the smartest, the coolest or the most fashionable. Regardless of what fashion magazines tell us, you don't have to be a trendsetter to be happy, and having your finger on the fashion pulse is not a sign of success. So relax, and be who you want to be. And if that's Marilyn Monroe, you're in for quite a vintage shopping treat.

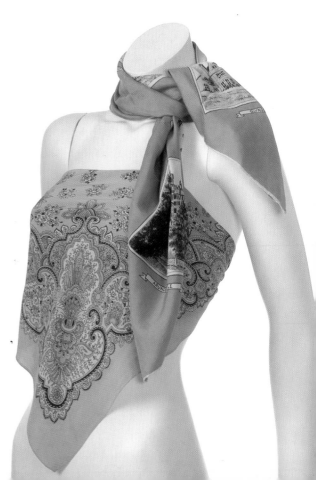

discovering the age

One of the things that makes shopping for vintage clothing so much fun is the feeling it creates of being on a treasure hunt. First of all, you are looking for a beautiful garment, one that jumps out at you and says "I'm the one, take me home and love me." Then, when you find one, you can start to look for clues about it: how old it is; what it is made of; and for what occasion it was made.

Sometimes the hunt is easy, you will have a label to tell you all about the garment; other times the item will tell you little at first glance, and you'll have to look carefully to find the answers.

It might not seem to matter whether that gorgeous floral dress is an original 1920s piece or a 1970s copy – you're going to buy it anyway, because you love it. But it's useful to establish the age of a garment before you buy it. The price will often be determined by its age, so if it is a 1970s copy, you should be paying a lot less than if it is an original 1930s dress – and vice versa, if that 1930s dress has been priced as a later copy, you could be getting a real bargain.

Don't assume that vintage sellers always get the dating of their garments right – they aren't all experts, and sometimes they make mistakes, especially when they are dealing with large numbers of items. And, sadly, there are a few unscrupulous sellers out there who try to take advantage of a buyer's lack of knowledge by dating garments as older than they are, in order to charge higher prices for them.

It's also good to know a garment's age for your own peace of mind, especially if you are trying to create an authentic look from a particular era. And, after you have bought an item of vintage clothing, it's useful to know its age so that you know how best to care for it.

Eight instant age giveaways

1 Peter Pan collars – small rounded collars found on jackets, coats and blouses – were popular in the early 1960s.

2 One-shouldered dresses and tops are characteristic of the 1970s disco era.

3 Bracelet-length sleeves on jackets and coats are typical of the late 1950s.

4 Uneven, jagged hemlines – known as handkerchief hems – were the height of fashion on late-1920s eveningwear and reappeared in the late 1970s.

5 The Empire line – where the garment's waistline is just below the breasts – dates a garment to the early 1960s.

6 Halter-neck dresses and tops are a distinctive 1950s shape.

7 Sweetheart necklines are unmistakably 1940s, especially when teamed with built-up shoulders.

8 If a dress has its waistline somewhere around the hips, it may well date from the 1920s.

So how can you establish the age of a garment? The answer lies in the three "Cs": cut, construction and cloth.

Cut

Your first clue is in the cut – the way the garment is designed and styled. As you can see from the special features about each decade, the clothing of each era had a distinctive style. When a vintage item grabs your attention, look at it carefully. Is the fabric cut on the bias? It probably dates to the 1930s. Does a suit have wide, padded shoulders tapering in to a narrow waist with peplums? If so, it most likely dates to the 1940s. If you familiarise yourself with the silhouettes and designs of each decade (some are shown below) you will be able to get a rough idea of the age of a garment just by looking at it. You can further expand your knowledge of each decade's styles by visiting textile museums and exhibitions, or by looking at fashion history books.

Construction

As the 20th century progressed, styles began to recur from decade to decade; so how can you tell if that full-skirted party dress is from the 1950s or is an 1980s copy? This is where you need to look more carefully at the garment and, quite literally, to turn it inside out. Even when designers revive older styles, construction methods are constantly changing, so a dress that may look authentically 1950s on the outside may be unmistakably 1980s once you

Learning the shapes of the eras

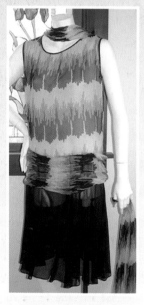

A dress from the 1920s often has a straight-up-and-down shape and little emphasis on the bust. Hemlines on evening dresses were generally loose to allow movement when dancing.

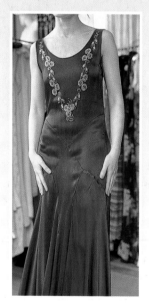

The bias cut of a 1930s dress created a slim silhouette with some flare at the hem.

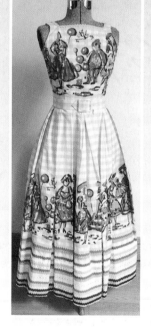

The New Look shape, popular in the 1950s, combined a large bust, trim waist and full skirt.

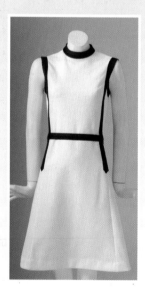

The A-line, in which the skirt flares out straight and stiff from the waist or bust, is typical of the 1960s.

Labels are a useful aid to dating a garment. You may recognise a name, such as Ossie Clark or Jacqmar, or the lettering may give it away, such as on the '60s curl of the Verona label.

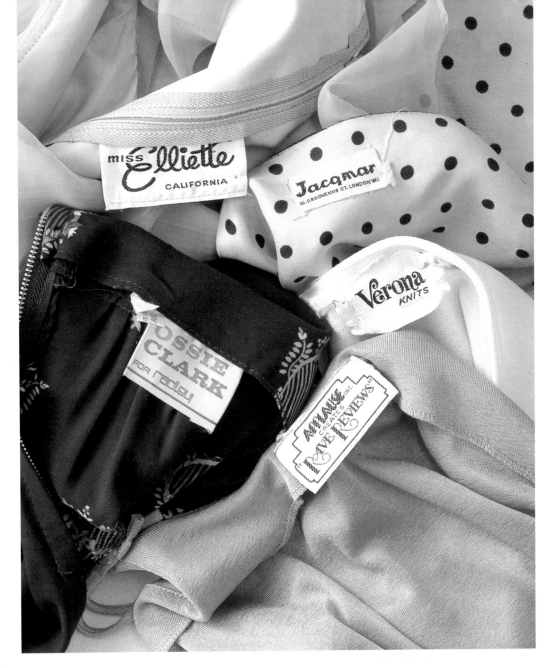

Trudie's top tip

The care labels that we see inside modern clothing were introduced in the early 1970s – if you find one of these inside a garment, you can be sure that it is from the 1970s or later. Look very carefully if you suspect that a garment is newer than the seller is telling you – some will snip out the label to try and fool buyers, but you can usually see traces of a label sewn into one of the seams.

look inside it. Don't be shy; most vintage sellers appreciate a customer who takes time and care when looking through their clothing, and may even offer you some assistance.

A label of distinction

The first thing you need to do is look for a label – if you find one, it will be extremely helpful in dating the garment. The majority of clothes made before the 1950s were either handmade or made by dressmakers, so they often don't have labels inside them. However, you may well find a label sewn into pre-1950s clothing if it

was made for a shop or by a well-known designer. By studying the design of the label you can often get an idea of the age of the garment. Label styles usually reflect the styles of the era, so a label from the 1930s might have Art Deco-style lettering, a bold, graphic design or flowing script, while labels from the 1960s will have a playful design, with simple lettering and bright colours.

Finishing at the edges?

As you look inside the garment, check the seams and the stitching. Machine-sewn

garments have small regular stitching, often finished with zigzag edging or overlocked seams (see box, page 33). Garments that have been hand stitched have less regular stitching, and often have unfinished seam edges, if they are home-made, or carefully finished seams, if they have been made by a dressmaker or tailor. Older garments were made to last, and often have extra fabric in the seams to allow for future alterations.

All of this may give you some clues as to the garment's age – the earlier the garment, the more time and care would have gone into its construction. Clothing from the 1960s onwards is more likely to be flimsily made, without extra seam allowances.

Clothes made by a tailor or dressmaker may have beautifully finished edges, such as this bound seam.

Cloth

The fabric that is used will give you another clue as to the age of the garment. Most clothing was made from natural fabrics, such as cotton, silk, wool and linen before the late 1950s. But around this time, the textile industry began to undergo a fabric revolution. In fashion, the introduction of artificial fibres was arguably as important as the arrival of the mini skirt.

The first non-natural fibres to appear on the clothing scene were rayon and acetate, fabrics that were made from plant fibres altered in the laboratory. Introduced in 1889 and 1924 respectively, rayon and acetate look and drape the body like silk, but are cheaper to produce. But these were just a taste of what was to come.

In the 1940s and '50s scientists started to produce synthetic fabrics made from non-organic matter such as coal, water and petroleum. Nylon was the first to be introduced, just before the Second World War. One of the strongest fibres known to man, it's not surprising that it was soon prized in the production of women's hosiery. Polyester was introduced in 1953, and was hailed as a miracle fabric: strong, wrinkle-resistant and easy to care for. Spandex and Lycra were introduced into the marketplace in the 1960s, but really came into their own in the disco gear of the 1970s and the exercise wear of the 1980s, because of their amazing ability to be pushed and pulled in all directions and still spring back into shape. Synthetics can often mimic the look and feel of natural fibres; see the box, left, for some ideas on how to tell the difference.

Buttons, snaps and zips

Garment fastenings are another excellent way to judge the age of a garment. Zip fastenings were rarely used in clothes before the 1940s, and the plastic zipper dates to the 1960s, so clothing from before that decade usually has metal zippers. In the 1920s and 1930s, dresses were designed to slip straight over the head, with perhaps a few hooks and eyes or metal snap fastenings. Items from before the 1960s will usually have any fastenings or zips at the side of the garment, often concealed by a flap of fabric. Look carefully at any buttons; natural materials like glass, horn or metal were usually used

Distinguishing synthetics from natural fibres

You're unlikely to find a label inside a vintage dress telling you from what material it's made, but feeling the fabric and looking at it carefully will help you to recognise whether it is natural or man-made. Try crushing the fabric between your fingers – natural fabrics crease more easily than most synthetics. Acrylic, often used in knits as an alternative to wool, may have a slight sheen to it. If the fabric is silky, and you aren't sure whether it's silk or rayon, look carefully at the weave: rayon is more regular and tight in its weave, and usually feels more slippery than silk. Spend time looking at modern clothes that do have a fabric label, and you'll soon establish your own ways of telling the difference.

Trudie's top tip

Occasionally fastenings have been replaced at a later date, so if you are absolutely sure that a dress is 1930s, but it has a plastic zipper, you could be right about its age, because a later owner may have replaced a rusted or broken metal zipper with a plastic one.

before the 1950s, when plastics, Bakelite and other man-made buttons became popular.

And the trimmings?

Finally, check the trimmings on a garment – sequins, beads, lace or embroidery. Have they been hand sewn? Is the lace cotton or man-made, which feels stiffer and scratchy? What about linings – are they natural fabrics such as muslin or silk or are they made of polyester?

The more time you spend looking at vintage clothing, the easier it will be for you to judge the age of a garment. Many vintage sellers are very knowledgeable, and will be delighted to share their experience with you. Ask them what techniques they use to establish the age of a garment, and then try out the same methods – as you become more experienced yourself, you may even be able to give them some tips on dating vintage clothing. Take your time when shopping, see it as a hobby, and an enjoyable learning process. Try not to be quick to make assumptions, but keep an open mind as you examine items. Occasionally you might get caught out – some later copies are surprisingly authentic – but since you are buying items to wear, and not as an antique collectible, you shouldn't get too upset. Just learn as you go along and enjoy building up your knowledge and experience of dating vintage garments.

1920s

the age of the flapper

"The Roaring Twenties" aptly sums up this decade, with its frantic decadence and shifting values. The First World War had left people exhausted and disillusioned; the younger generation saw that life was fragile and short and vowed to enjoy it while they could. This was the age of cocktails and nightclubs, of modern art and jazz, of golf, tennis and trips to the Riviera. Everything was fast and exciting, from the sleek, new motorcars to the steps of popular dances like the Charleston.

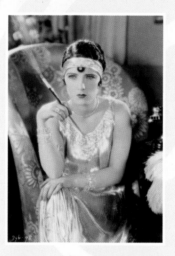

Actresses like Evelyn Brent epitomised the spirit of independence.

These were exciting times for women, who began to experience a measure of freedom for the first time. During the war years women had filled the gaps in the workplace as men went off to fight; now they were reluctant to relinquish their positions, and many continued to work – the first generation of "career girls". Changes in legislation throughout the decade gave women more rights than ever, including an equal right to vote.

The rules of etiquette that had governed society for so many generations no longer seemed valid, and to be labelled "fast" was something to be proud of, not feared. Dancing, going out unchaperoned, smoking, driving a car and wearing cosmetics were no longer things only the daring could do, they were now fashionable and glamorous. The popularity of cinema contributed to this change; women aspired to be as alluring as the stars they saw on screen. As standards changed so did fashion, with some of the most striking advances of the century.

The styles of the 1920s are unmistakeable, evoking the heady excitement of the time. The decade's eveningwear is of particular interest, with its simplicity of design contrasting with luxurious finish and trim.

Daytime choices

Since women's lives were more active than ever before, their clothes needed to be comfortable, functional and easy to care for. Hemlines had been creeping up steadily since the mid 1900s, and, as the 1920s progressed, they rose from mid-calf to knee length. The older generation, raised with Victorian modesty, were horrified, but young women seized upon the new styles with enthusiasm – they were flattering, practical and thrillingly modern.

As if to compensate for the show of leg, clothes became less form-fitting, flattening out the silhouette with a loose, tubular cut. Waistlines gradually dropped from the waist down to the hips, and they stayed there until late in the decade, when they slowly began to rise again. These looser cuts didn't require bust-enhancing or waist-cinching corsets, and the naturally slim wore them with the minimum of underwear underneath, while less lucky girls compressed their busts and hips with elasticated girdles to achieve the desired boyish silhouette.

There was a great emphasis on health in the 1920s, and this contributed to many of the decade's trends. An athletic lifestyle was admired, for women as well as men, and leisure time was spent playing golf and tennis, swimming and hiking, and taking part in other outdoor pursuits. Designers were quick to pick up on this, creating

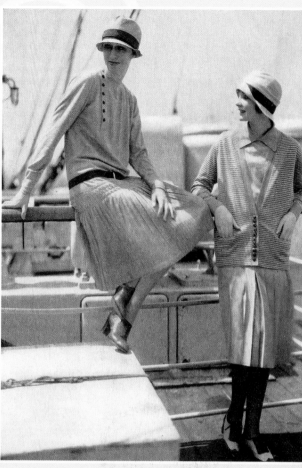

This 1926 Vogue *shot picked up on the leisurely ideal.*

A suntan, avoided by generations of women, was now a desirable accessory, a sign of health and wealth.

clothing suitable for those who played sports, or who wanted to look like they did. Lightweight fabrics like cotton and jersey made clothes that were easy to move in, and worked well with the new simple designs.

Shorter skirts meant that stockings were more important than ever, and sheer silk – or later in the decade, rayon – stockings were worn for day and night. The very daring dispensed with stockings altogether in summer, deciding that bare, suntanned legs were more comfortable and looked as pretty. A suntan, avoided by generations of women, was now a desirable accessory, a sign of health and wealth.

Knitwear was extremely popular for the day, and women who couldn't afford the originals copied the chic designs of Coco Chanel and Elsa Schiaparelli at home. Designs echoed men's knitwear styles, with V necks, golfing plaids and bold, geometric patterns. Sweaters were long and loose, worn over neatly pleated linen or woollen skirts.

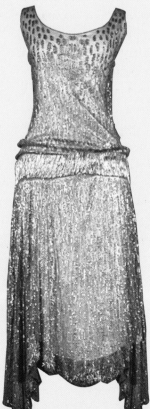

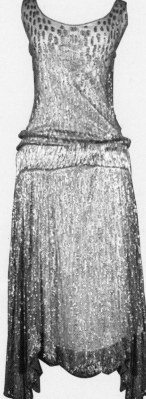

A beaded and sequinned dress would catch the light and sway when the wearer danced.

Photo courtesy TheFROCK.com

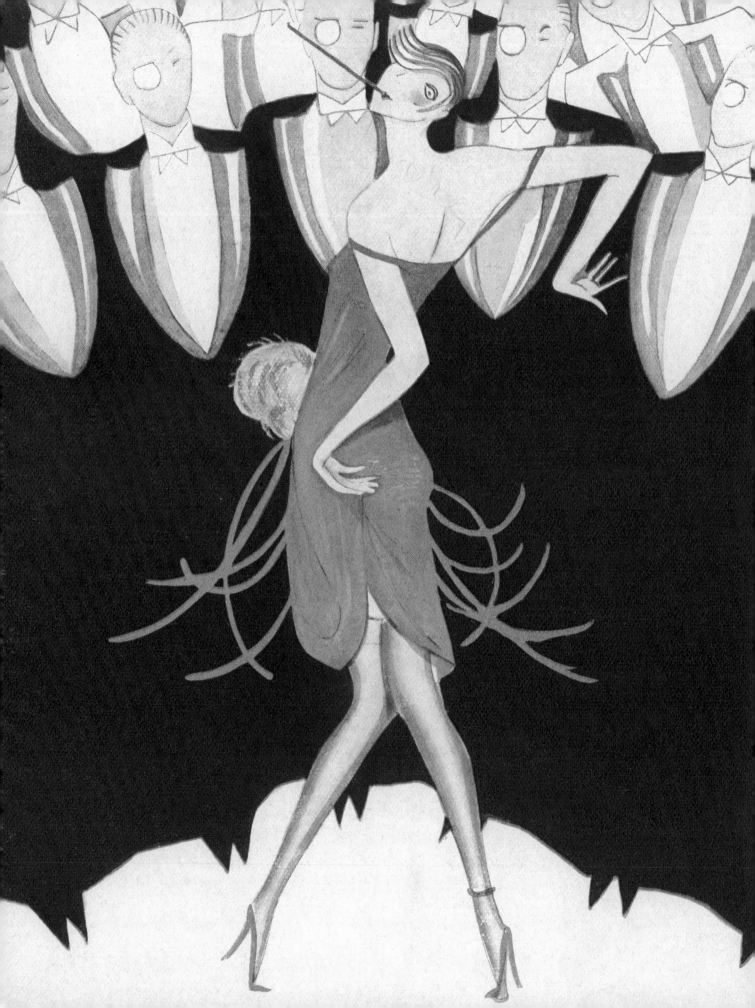

Another major step in fashion was the introduction of trousers for women. To begin with, these were only acceptable on holiday. Silk beach pyjamas were worn by the fashionable, but by the end of the decade, many women had adopted the wide linen trousers, pioneered by Chanel, for daytime leisure wear.

Daywear colours were bold, contrasting large blocks of orange, red, cobalt or emerald with the cooler tones of white or grey. Silk or cotton printed in small geometric patterns made pretty day dresses, while crisp white linen showed off tailored summer suits to perfection.

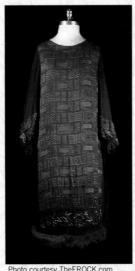

Photo courtesy TheFROCK.com

Evening style

With nightclubs and dancehalls springing up everywhere, eveningwear took on a new dimension. Until now, evening dress was formal and ornate, suitable to wear to a dinner party, the theatre or a ball. Now women wanted glamour and sex appeal, they wanted to wear their evening dresses to a cocktail party, then on to a nightclub or to an intimate dinner *à deux*. Rather than restrict movement, like the ball gowns of the previous generation, eveningwear needed to enhance movement, as women from all levels of society danced their way through the decade.

Eveningwear styles were similar to the cut of daywear, and most dresses were sleeveless and had a simple scoop or V neck. Dress lengths were short, as with daywear, and uneven hems, which dipped at the back or hung in handkerchief points, were especially popular in the second half of the decade.

Fabrics were sumptuous and exotic, from rich silk to devoré velvet. Silk chiffon was used to make ethereal dresses, which floated with every movement. Gold and silver lamé were

used towards the end of the decade, producing lightweight dresses that looked superb under electric lights. Trimmings of heavy beading or layers of silk fringe would help dresses to shimmy with their wearers.

Archaeological discoveries, such as Tutankhamen's tomb, triggered a craze for anything Egyptian, and hieroglyphics, exotic flowers and scarabs were some of the motifs that appeared on eveningwear as embroidery or fabric designs.

Black moved out of mourning wear and into eveningwear, as Chanel and other young designers promoted it as chic, flattering and sophisticated. Sleek, black dresses, in fluid silk or velvet, were trimmed with a cluster of red or pink flowers or a contrasting sash around the hips. When used, colours were simple and bold, from deep crimson to jade green; but neutrals – cream, white and silver grey – dominated.

Luscious swathes of fur topped evening gowns, with ermine stoles and coats providing the ultimate touch of luxury. Dramatic evening coats were often made to match dresses, with the dress fabric echoed in the coat's lining or collar.

Eveningwear wasn't only for going out in; dressing for dinner was expected even if you were dining at home. The silk pyjama set made an exotic and comfortable outfit, although only the very young or Bohemian wore it outside the home.

Evening coats had trimmings and embroidery for a luxurious feel.

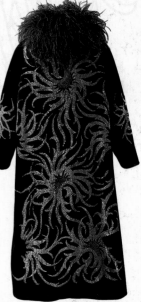

There was a fascination with the Orient, and this was echoed in the opulent embroidery and brocade that appeared on evening dresses and coats.

This pink silk flapper dress has a characteristic handkerchief hem.

For the fashionable bride

At the start of the 1920s, wedding-dress styles were heavily influenced by the draped harem styles that were popular during the previous decade. Skirts were ankle length, with a slight fullness that narrowed around the ankles. The bodice had a crossed-over design, and the chest was covered with a "modesty panel" of embroidered chiffon or net. The waist was highlighted with a fabric sash, and sleeves were usually long and plain. A long lace veil flowed to the floor, and was arranged in a cap-like fashion over the head, with clusters of orange blossom at each ear.

As skirt lengths in general began to rise and waistlines drop, wedding gowns followed suit. A sleeveless, tubular dress with a short skirt became the fashion. Veils were still worn to the floor, and were often made from two layers: lace over tulle. The veil was attached to a bandeau headdress or a garland of flowers, worn low on the forehead.

Dresses were made from organdie, chiffon, satin or silk. A sheer chiffon overdress could be worn over a simple chemise, and trimmed with tiny seed pearls, embroidery or lace. Delicate fabrics, like organdie and chiffon, were made into dresses with pretty ruffled skirts; while satin and silk looked sleek and modern.

Bridesmaids wore simple chiffon dresses, often with tiered, ruffled skirts. A matching cloche hat was trimmed with the same flowers as the posy. Later in the decade bridesmaids' dresses became longer, with a full skirt and more definition to the waistline. A decorative, wide-brimmed picture hat and an armful of flowers finished off the outfit. Colours were soft and muted: sage green, mauve, smoke grey or rose.

Finishing touches

The simplicity of dress shapes in the 1920s was offset by the addition of accessories. Long bead and pearl necklaces were worn with everything, from daywear to eveningwear. Costume jewellery, pioneered by Chanel, ensured that pieces were popular and accessible to all, from an ornate paste clip fastening a turban, to a simple string of beads jazzing up a home-made dress.

Hats began the decade large and lavishly trimmed, but as dress designs became sleeker, so did the hats, resulting in the classic cloche, a bell-shaped hat, usually made out of felt. These were worn during the day, fitting tightly over bobbed hair, and pulled down low over the eyes. The choice for the evening was either a turban, in velvet or silk, or a simple bandeau of fabric, sometimes jewelled or beaded. Evening bags were small enough to hold in the hand, especially for evening, when only a compact, lipstick and handkerchief were needed. Metallic mesh bags suited the exotic eveningwear, and these are still highly sought after today. Ostrich-feather fans made a striking addition to an evening dress, and were useful in stuffy nightclubs.

As evening gowns were often sleeveless, both summer and winter, the shawl became a necessary, and a highly decorative, addition to eveningwear. These shawls were usually made of silk with a deep, knotted fringe, and heavily embroidered with a floral, Oriental or geometric design. Draped over bare arms and shoulders, they provided a feminine touch to a simply cut evening dress. Smaller chiffon or silk scarves were wrapped around the neck during the day, trailing out behind the wearer for a romantic look.

The twenties meant ...

beaded flapper dresses,
long strings of pearls,
geometric-design knitted sweaters,
Cuban-heeled shoes,
cloche hats, beach pyjamas,
embroidered shawls,
mesh evening bags

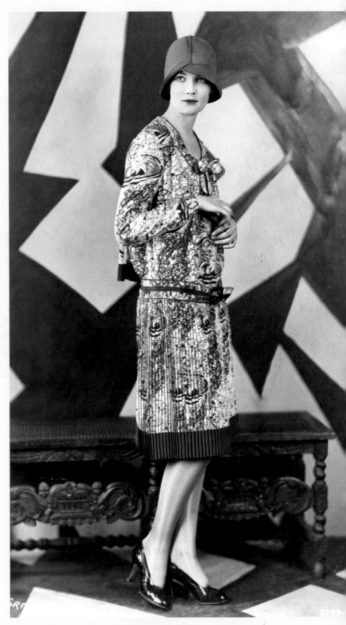

A cloche hat and patent shoes completed the '20s look.

boue soeurs, louise boulanger, callot soeurs, coco chanel, christoff von drecoll, mariano fortuny, paul poiret, elsa schiaparelli, madeleine vionnet

that's not a size 12!

Have you ever wished that you could drop a size or two? Well, with vintage clothing you get to drop your size altogether – it doesn't exist. The standard sizing that we see on modern clothes labels didn't come into force until the late 1950s, so clothing from before that time is unlikely to have a size on the label, if there is a label at all.

Since the 1950s, "standard" sizing has been anything but – as the average woman has increased in size, becoming taller and more curvaceous, sizing has been adjusted accordingly. Moreover, clever manufacturers have made sizes more generous to flatter women into buying their clothes; this is why that pair of size 14 vintage jeans won't go past your ankles even though you're only a modern size 10. So, when choosing vintage, size doesn't matter.

"But how will I know what will fit me?" you might ask. Easy – you're going to create your own personal sizing guide so that you can judge whether a garment will fit you without even trying it on. Such knowledge is particularly important when buying vintage garments, as market stalls and vintage stores seldom have proper changing facilities, or you may be choosing items from an online shop or from an auction.

Creating your size guide

This sounds a lot more complicated than it is, but you've probably been sizing up your potential purchases in a simple way for years, for example, when you hold up a skirt against yourself to see how long it is. Spending a little time at home learning how clothes hang against you and how they look once they're on will mean that when you come to explore vintage shops, you'll have a quick visual check as to which clothes are likely to be a good fit.

Learning the lie of clothes

First, take some items of clothing that fit you well, say a dress, a skirt, a pair of trousers, a blouse and a jacket, preferably in non-stretch fabrics such as cotton. Hold each of them up against your body and look carefully at where each garment falls against you. For example, hold waistbands taut against your waist, with your thumbs at each edge, and note where your thumbs touch your body. With long sleeves, place the armhole of one sleeve against the crease of your armpit and, keeping your arm by your side, note where the cuff falls against your wrist. With blouses or jackets, button them up and lay them across your chest. Without stretching the material, find out exactly how far around your body the side seams reach.

Then try on each of the garments in front of a full-length mirror and try to memorise how the different cuts correspond to the contours of your body. Do the same with different styles and sizes of these garments, so you can learn to judge which styles hang short or long, which emphasise any problem areas and which are more forgiving.

Getting precise figures

Next you need to know your own measurements – you may be reluctant, but they're only

numbers. Take the measurements shown in the box below, and write them on a piece of card. This card is your personal size chart, so put it in your purse whenever you go vintage shopping.

When you see a vintage garment that you like, hold it up against yourself and see whether it is approximately your size. If it seems right, get out your size chart and a tape measure – if you don't want to carry a tape measure with you, vintage sellers will usually be happy to lend you one. Measure the key points of the garment and check these figures against your size chart, allowing about 1 inch (2 cm) extra on each measurement for ease of movement. Now you should have a fairly good idea of whether the garment will fit, without even having to try it on.

Getting great fit

So, you've found a dress that fits you – but does it fit you well? That foxy sweater dress might stretch nicely over your hips, but does it flatter them? And you might be thrilled that you can do up the zip on that slinky evening gown, but will you be able to sit down in it comfortably without splitting the seams?

As if it were made for you ...

With modern garments we have learned to accept adequate fit as being good enough, simply because few of us can afford the alternative of haute couture. Manufacturers have decided on standard sizes and produce their clothes accordingly, and we try to squeeze our nonconforming bodies into them. Vintage dressing has to be different – the cut and sizing of each garment is unique, often tailored especially for the original owner's figure. Fabrics from the 1950s and earlier will usually be made from natural fabrics with little give – there's no merciful Lycra in these clothes. It's important that you take time and care when vintage shopping to make sure that the clothes you choose fit well – or can be realistically altered – and that they suit your shape, flattering your good points and minimising the bad bits.

Taking your measurements

Use a flexible tape measure to find these key figures, making sure that the tape is taut but not tight. You might want to add extra measurements for any problem areas you have, such as upper arms or thighs.
- Bust: around the fullest part.
- Waist: around the narrowest part of your torso.
- Hips: around the widest part, usually about 8 to 9 inches (20 to 22 cm) below the waist.

- Shoulder to waist: from the centre of the shoulder straight down to the waist.
- Shoulder to wrist: from the centre of the shoulder down along the outside of the arm to the wrist bone.
- Waist to knee: straight down the front of the leg.
- Waist to ankle: straight down the front of the leg.

How to ... try on a dress

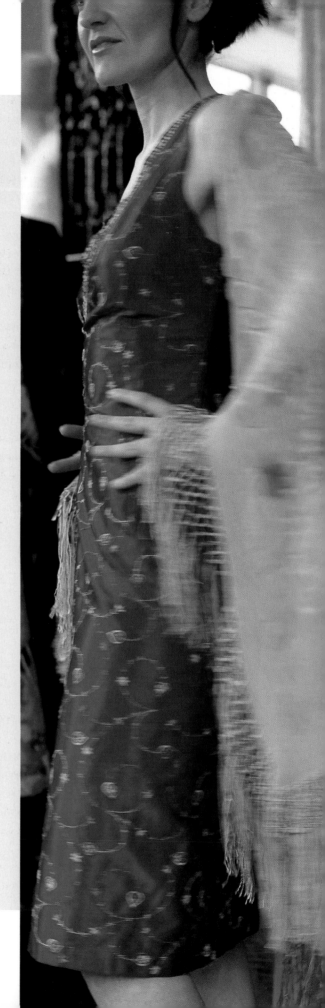

When you're trying on vintage clothes it's important to be honest with yourself – does the garment feel comfortable? Does it hug or skim all the right places? And does it make you look and feel good? Here's a brief guide to trying on a dress.

1 Undo all the fastenings, and either step into the garment or slip it carefully over your head. If it won't go over your hips or shoulders or if you can't do up the fastenings, then it has failed the first test – don't continue the struggle, you could damage it.

2 Standing straight, look at yourself in a mirror from all angles. Is it puckered or wrinkled because it is too tight in areas? Does it make your legs look like tree trunks, your waist appear to be under your armpits or your bottom double in size? Is the hem trailing behind you on the floor? You might want to carry a pocket mirror for that essential rear view – although you might prefer to ignore what you look like from behind, it's probably best to know what everyone else can see.

3 Now move your body. Crouch down or sit on a chair – can you still breathe? Bend forward – are you revealing a little too much cleavage? Lift your arms straight out in front of you. Does the material strain across your shoulders or do the sleeves ride up to your elbows? If so, it's probably too small.

4 Get an opinion. If you tend to get carried away in the exciting world of vintage shopping, take along a friend who can be honest without being brutal, and make sure that you listen to her. Don't rely on the opinion of the seller unless you know she is reliable and sincere. After all, she wants you to buy, so she's unlikely to tell you that an item doesn't suit you.

Be realistic

The temptation to snap up a gorgeous vintage garment, regardless of size or fit, is very great. "After all," you think to yourself, "I may never find another '50s cocktail dress as perfect as this one," and so you buy it, despite the fact that it won't go past your knees. But when it comes to vintage fit, try not to let your heart rule your head. If a garment doesn't fit, don't think "It would be OK if I grew a couple of inches/stuffed my bra/didn't breathe out," – start looking through the next rail of clothes. And if you really can't stop thinking about that dress, go back and look at it again. Could you take up the hems and cuffs? Would it ruin the shape to have the waistline taken in? If the fit is only a little bit off and the garment can be altered (see page 85), then it might be worth buying. Otherwise, unless you want it finishing its days in the darkest recesses of your wardrobe, leave it behind, however reluctantly. That gorgeous dress deserves to be worn – if not by you, then by someone else who it will fit. There will always be other dresses.

Different decades, different shapes

Just like clothes, women's body shapes go in and out of fashion. As you try on and buy more vintage clothes, you'll get an idea of which eras produced the best clothes for you, but here is a starting point:

TWENTIES: The straight-up-and-down shapes of the 1920s are, sadly, unforgiving to anyone with hips and a bottom, but look incredible on the very slim. If you love the 1920s styles, but haven't got the right boyish figure for them, try out some of the classic accessories instead, like a dramatic cloche hat or an exotically embroidered shawl.

THIRTIES: The bias cutting of the 1930s can be flattering, as it was designed to show off womanly curves. But slinky fabrics like silk and satin highlight any lumps and bumps. If you have a pear-shaped figure, try dresses in heavier fabrics, like linen or velvet, for a more forgiving look. Pretty chiffon tea dresses suit most figures and come in a good range of sizes.

FORTIES: The boxy shapes of 1940s suits look striking on slim women, but can make the fuller figured look wide all over. If you are curvy, try the softer shapes of the 1940s dresses, which skim over any problem areas. Women who are bottom heavy should avoid suits and dresses with peplums, which draw attention to the hips. The shorter skirt lengths look best on slim legs, as they tend to hit the widest part of the calf.

FIFTIES: The styles of the 1950s are a curvy girl's dream, because they were designed to celebrate the hourglass figure. Full skirts skim beautifully over hips and thighs, while a fitted bodice highlights the waist, making these styles perfect also for the pear shaped. If you're slim, try the fitted shifts, pedal pushers and cheongsams popular later in the decade.

SIXTIES: Like the waistless shapes of the 1920s, 1960s clothes look best on boyish figures. A-line dresses can be particularly flattering, but unless you have slim legs, approach mini skirts with caution. Petite women look especially good in early 1960s coats, with their scaled-down cut and details. The fuller figured should look out for tunic-style dresses that can be worn over trousers.

SEVENTIES: Pass by the polyester bell-bottoms and you will find a 1970s style to suit most figures. Slim women look pretty in the peasant styles, although the petite should guard against being swamped by too many ruffles and flounces. Draped jersey dresses flatter a curvy figure, while shirt dresses can be worn over a top and trousers for a slimming look. This decade had a wide variety of hemlines; try a few out until you find the most flattering length for you. But beware of the kaftan – it might seem like it will hide a multitude of sins, but if you are fuller

figured, you run the risk of looking like you are wearing a tent.

EIGHTIES: The 1980s were not the most flattering decade of the century; designs were very exaggerated, and can magnify any figure faults. Unless you are slim, stick to separates and accessories, mixing them with modern clothing for a flattering look. But if you are lucky enough to have a body to die for, by all means show it off in stretchy tube dresses and skintight jeans. However, everyone should steer clear of leggings – they belong only in the gym.

Ten figure faults and how to fix them

1 Short neck: boat or slash-necklines make your neck even shorter, visually speaking, so choose lower scoop- or V-shaped necklines instead, for a lengthening effect.

2 Wide shoulders: avoid jackets and dresses with shoulder pads – or remove them. And steer clear of halter necks, which can make you look like a rugby player. Choose soft fabrics and shapes, such as fitted sweaters or cotton shirts.

3 Small or large bust: strapless tops and halter necks will give an added boost to a small bust, but may add too much to a large bust – unless you want to create a Jayne Mansfield look. If you have a large bust, opt instead for flattering small scoop necks and wrap tops.

4 Chubby arms: three-quarter-length sleeves are universally flattering, and soft fabrics such as voile and chiffon float over problem arms.

5 Thick waist: go with the flow, and use the waistless styles of the 1960s – or even the 1920s if you are otherwise slim – to conceal a thick waist. Choose dresses rather than separates, which cut your figure in half visually at its worst point.

6 Pot belly: try the corset-style dresses of the 1950s – they might suck that belly right in. If you'd rather conceal, choose a soft peasant top or a flowing wrap dress.

7 Wide hips: pleated skirts, tunics and long baggy tops will make your hips look wider. Jersey wrap dresses or A-line shifts will hide them, and a well-cut 1950s dress can skim over the hips, making them look slimmer. Heavier fabrics tend to be more flattering, especially if you are wearing a fitted dress.

8 Large bottom: as Jennifer Lopez has proved, when it comes to bottoms, it's better to enhance than to hide. Choose fitted dresses that accentuate your rear, and wear them with heels. If this makes you too self-conscious, try a long coat or jacket, worn over slim trousers and top. Avoid pleated skirts, or bias-cut dresses.

9 Heavy thighs: avoid minis, unless you wear them over trousers – a very funky way to camouflage problem thighs. Make sure clothing isn't too tight or stretched over your thighs, and beware of wide-legged trousers, which can make thighs look bigger.

10 Short legs: if you have good legs, albeit short ones, lengthen them with a shorter skirt and heels. Otherwise, cover up with heel-skimming trousers, and wear heels to add the illusion of length. You may find that hipster trousers fit better.

vintage value

If you buy vintage clothing to wear, its value may seem negligible; after all, you're choosing it based on taste and style, rather than monetary worth. But it's still useful to be able to judge the value of a garment – it will help you to decide how much to pay for it, perhaps give you some bargaining power, and you may have the exciting experience of finding a real gem at a great price.

It's important at this point to state that establishing the financial value of a vintage item is virtually impossible; there are so many variables that an item's worth can vary from one month to the next. Famous names will always command higher prices, but even these can fluctuate wildly depending on current fashions. Establishing an item's value means much more than pinning a price to it; it's about recognising quality and long-lasting appeal. It requires looking past the label – or lack of – to the garment itself: its construction, cut and fabric. In the end, you decide the value of a garment – and the price you are willing to pay becomes its worth. So how can you judge the value of a vintage item? Look out for these ten measures of value:

1. Cut

Although vintage clothes are usually of a better quality and cut than modern garments, their standards still vary, especially with garments from the second half of the 20th century. It is worth paying more for garments with a great cut – they should repay you with the number of times you will want to wear them. Cheaper

Identifying quality by the seams

Even the most basic of home-made vintage pieces will have some sort of finishing on the seams – otherwise it would never have stood the test of time. But the better quality clothes have better quality seams, finished neatly and without hanging or loose threads. Look out in particular for: bound seams, a time-consuming method in which the raw edges are wrapped with a thin strip of matching fabric; overlocked seams, which use a special stitch to prevent the edges from fraying; and French seams, which are often used on lightweight fabric and neatly conceal the raw ends with clever folding.

Above: Overlocked seam Below: French seam. The edges are sewn together, folded back on themselves and sewn again.

garments, with a poorer cut, can be fun for occasional wear, but you shouldn't pay high prices for them.

When you first pick up an item in a shop, the quality of its cut may be obvious: the garment will be well proportioned and balanced; the hemlines should be even; and any pleats will lie flat and crisp. But you will be able to judge the standard of cut best when you try on a garment and see how it looks on the curves and lines of your body. Assess how flattering it is and how comfortable you feel in it. A well-cut garment will make you look and feel good – and that's worth paying extra for.

2. Construction

As with cut, garment construction tends to increase in quality as you go back through the decades, and it is one of the reasons that so many women love vintage clothing. In a time when fashion was less demanding and clothes were worn for longer, care in construction was very important, and garments show signs of the pride that seamstresses took in their work. A well-constructed garment will be lined where necessary, and the lining will be generous enough to cover the stitching at the hems, but not so generous that it is visible. In certain dresses integral boning and supports will help to preserve the shape of the garment – as well as your dignity in sleeveless dresses.

Fastenings should be as discreet as possible, with buttonhole edges neatly finished, and fabric zip guards to protect the skin from zippers. Look carefully at the stitching on seams and hems – the smaller the stitches, the higher the quality of construction.

Look also at the trims on a garment. The more ornamentation on a garment, the higher the value usually is. If you look at the "wrong" side of

On well-cut garments the pattern of the fabric will match up across seams.

Hand-sewn embroidery and buttons that have been carefully made or chosen to match are a true sign of quality.

embroidery, beading or sequin work, slightly irregular stitching that is larger than you might get from a machine will indicate that these features have been hand sewn – a true sign of quality. Any lace trimmings should feel soft and smooth, not scratchy.

3. Fabric

High quality fabrics make high quality garments, and are worth paying a little extra for. You can learn to judge how good the fabric is just by feeling it between your fingers. Sought-after fabrics – usually natural ones such as silk, linen, cashmere and cotton – feel like quality, they may be rich and smooth, light and silky or heavy and crisp, depending on the type of garment and the effect that the manufacturer was trying to achieve. For example, high quality wool suits will feel lighter and more refined than cheaper counterparts, expensive silk scarves will feel smoother and more supple than inferior versions. In general, cheaper fabrics tend to have a rougher texture, and may have a shiny look to them.

4. Condition

The general state of repair of a piece drastically affects its value, because whether you are planning to wear it or simply display it, you want it to be in the best condition possible. Sadly, some of the most desirable vintage pieces, such as the ornately beaded flapper dresses of the

1920s, tend to have disintegrated with age, so when you find one that is in good condition, you can expect to pay quite a price for it.

Unlike some of the subtler indications of value, the condition of a garment is obvious to all, and so sellers often price an item based solely on its condition. If you see a garment that appears to be substantially under priced, look carefully – you have probably overlooked a major flaw.

Never be tempted to pay a high price for an item that is in poor condition, just because it is by a famous name. That Arnold Scaasi dress might be gorgeous, but if it is so full of moth holes that it's fit only to be turned into cushion covers, then the price must be adjusted accordingly. Items that are in a fragile condition may only stand the occasional wear; so bear this in mind when considering the price you want to pay.

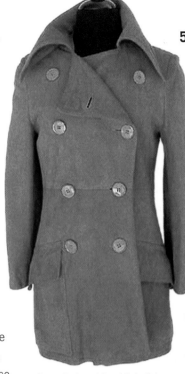

An enduring style adds to the appeal of this Gucci jacket.

5. Designer

Famous labels will always command higher prices than their anonymous counterparts, partly because of their quality, and partly because of their snob value: "Love your jacket!" – "Thanks, it's vintage Chanel." Whether the price of a designer garment is reasonable depends on the knowledge of the seller. A seller with very little knowledge of vintage fashion may recognise a famous name and bump up the price accordingly. A wiser seller takes into account the current popularity of that label, the type of garment, and whether it was produced as haute couture – the Holy Grail of vintage shopping – or as part of a diffusion line, a lower-priced and lower-quality collection.

Don't be misled into paying a higher price for a garment that the seller assures you is a

Knowing whether it's an original

When buying vintage clothing, you are unlikely to come across fake designer items, as this is a post-1980s problem. But what you might find is unscrupulous dealers who remove a designer label from one item – perhaps because it is badly damaged – and sew it into an ordinary garment, hoping to pass it off as designer. This rarely happens, but do be on the watch. If you find a vintage garment with a designer label in it, check whether the quality of the garment comes up to designer standards. Is it well sewn, with neatly constructed seams and hand-finished buttonholes and trimmings? Is it fully lined, and does the lining seem to be good quality fabric? If the designer has signature touches to their clothes – such as the Emilio signature on Pucci designs or the C's on Chanel's buttons – are they part of the garment, or is the label the only thing that's telling you it's designer? Look carefully at the label as well – designer labels are always stitched or woven, never printed.

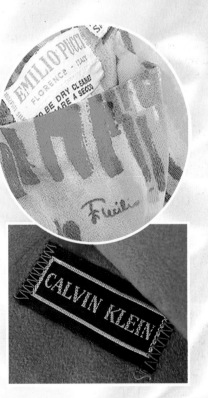

designer piece if it doesn't have a label or some other identifying mark on it. That dress may bear all the hallmarks of an original Halston, but without its label it loses much of its monetary value, so you shouldn't be persuaded into paying too high a price for it. Conversely, you may spot an item that you can tell was from a designer, even with its labels missing, but the seller has overlooked it and priced it ridiculously low. Well done, you've found a bargain – now snap it up.

6. Age

As with any antiques, the older an item is, the higher the value. There are far fewer 1920s evening gowns on the market than 1970s evening gowns, and as rarity increases, so does price. Clothing from the first half of the 20th century appeals also to collectors, who may not necessarily wear the garments but are usually prepared to pay more for them. To find out how to establish the age of clothing, turn to Discovering the Age (page 17).

7. Location

If you are shopping in a city, you can expect to pay higher prices than in a small town. But even in cities, prices vary, depending on the area in which you're shopping. Vintage – also called "retro" – shops that are located among the quirkier Bohemian areas tend to be significantly cheaper than vintage boutiques in the city centre. Of course, the standard of stock may also reflect the area in which the shop is situated. Vintage shops in smaller towns are generally cheaper, as their overheads are much less than city shops.

On the Internet all the vintage clothing websites are in direct competition, which keeps prices low. This more than compensates for any shipping charge that you may have to pay, and many online sellers are flexible with their prices and shipping costs.

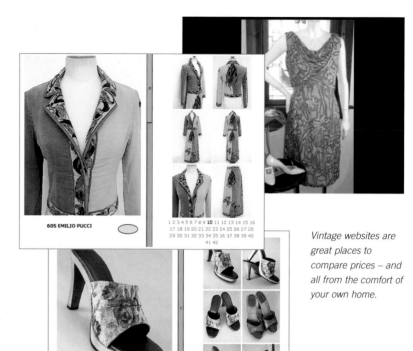

60S EMILIO PUCCI

1 2 3 4 5 6 7 8 9 **10** 11 12 13 14 15 16
17 18 19 20 21 22 23 24 25 26 27 28
29 30 31 32 33 34 35 36 37 38 39 40
41 42

1 2 3 4 5 6 7 8 9 10 11 12 13 14 15 16
17

Vintage websites are great places to compare prices – and all from the comfort of your own home.

8. Occasion

Considering that a sumptuous ball gown may only be worn once or twice, whereas a 1950s cotton skirt can be worn every day, it's ironic that occasion wear is more expensive than casual wear. But occasion wear is more expensive to produce, with luxurious fabrics, dramatic cuts and more embellishments. Vintage wedding gowns, in particular, are gorgeously made, with layers and layers of linings, boning and petticoats, beautiful embroidery and the finest silks and lace.

When considering the price of a vintage gown, try to compare it to the cost of a modern alternative. If you are used to buying cheap

A 1930s wedding gown (below) is worth the expense for details such as hand-sewn beading and lace.

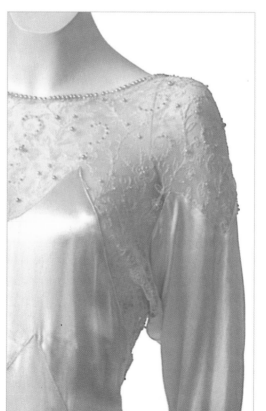

Never allow a seller to bully you into buying an item that you feel is worth less than she's asking. Whatever she says about its value, you have to be happy, and you'll never really enjoy wearing an item that cost more than you were willing to pay. If you aren't sure, take some breathing space – get a coffee, go to another shop, or even come back another day. If it plays on your mind, it's probably worth it.

vintage causal wear, the price tag on an evening gown may seem extreme, but compared to the cost of a similar modern gown, it really is a bargain, and will also be an investment.

9. Trends

If you look at any fashion magazine, you'll notice how often modern designers dip into the past for inspiration. This, in turn, creates trends within vintage fashions – one year everyone is wearing 1950s clothing, the next they have switched to 1970s peasant styles. The 1960s, and even the 1980s, which were less popular decades for several years, have recently swung back into favour, so pieces from these decades are beginning to rise in price.

Vintage may also become popular for other, more indirect reasons. For example, if there's a current fashion for the Gothic look or for a prim schoolgirl style, any vintage garments or accessories that suit that particular trend will tend to increase in price for that season. If you like to follow trends then you probably won't mind paying a little extra to be in vogue. But if you're not so bothered then you can get a bargain by waiting a few months until the look has come and gone.

10. Appeal

At the end of the day, the main factor in how much you are willing to pay for an item will be how much you want it. If you've been looking for a particular item for a long time, say a black, cashmere sweater dress, then when you find one, you may be happy to spend a little extra on it because you want it so much. If you spot a gorgeous leather coat, and its price is a little out of your league, but you know that you'll wear it every day, then go for it – the cost per wear will justify the extra expense. If, on the other hand, you see a pretty dress, but you just aren't sure whether it is worth the price tag, then you're probably better off leaving it behind. If in doubt, move on out. Or, try offering the seller the price that you'd be willing to pay for it – if she says yes, you've got a bargain, and if she says no, then you haven't lost anything.

Five instant indicators of quality

1 Pattern matching: if the garment is made from a patterned fabric, the pattern should match up across seams, pockets and front fastenings.

2 Hidden zippers and fastenings: these show that the manufacturer has made an effort to preserve the clean look and lines of a garment.

3 Carefully matched thread: at joins and seams the thread should be closely colour matched to the fabric.

4 Matching buttons and fastenings: look for fastenings that match or complement the patterns and colours of the fabric or look for those with an unusual design.

5 Interlining: this is an extra lining between the lining and the main cloth, which is used in strategic spots to stiffen or shape a garment. It's a sign of excellent quality.

Hollywood style

The 1930s started under a cloud; the Wall Street stock market crash of 1929 had reverberated around the Western world, resulting in the depression that would last for the first half of the decade. Very few were left untouched by this grim period, as stocks and shares lost all value, and unemployment caused widespread despair. Governments urged people to economise, and spending hit an all-time low.

1930s

The hard artificiality of the 1920s was no longer appropriate; society wanted romance, hope and a softening of reality. People wanted to forget about their problems, and cinema, with its escapism and happy endings, soared in popularity. Movie stars were idolised, and everything from their hairstyles to their clothes were detailed in magazines and copied by women everywhere.

As the decade went on, the depression started to lift. But another cloud loomed: the threat of war in Europe. The world, still shaken from the last war, squared its shoulders and prepared to face more horror and loss.

Fashion magazines in 1929 had reported a dramatic drop in hemlines, from the knee-length, flapper styles to a more modest lower-calf length. By 1930 this change had filtered down into most women's wardrobes, and daywear stayed at this length for the rest of the decade. The other major change in fashion was the return of the waist. The ideal silhouette was still slim, but with womanly curves, unlike the androgynous figure of the 1920s. Underwear, restrictive and confining for so many centuries, became soft and comfortable, allowing a woman's natural shape to emerge. Designers created lingerie – camisoles, slips and French knickers – in sugared-almond tinted silk and crêpe de Chine.

After the boyish '20s, the womanly curves of Bette Davis (right) and Carole Lombard (opposite) were back in fashion.

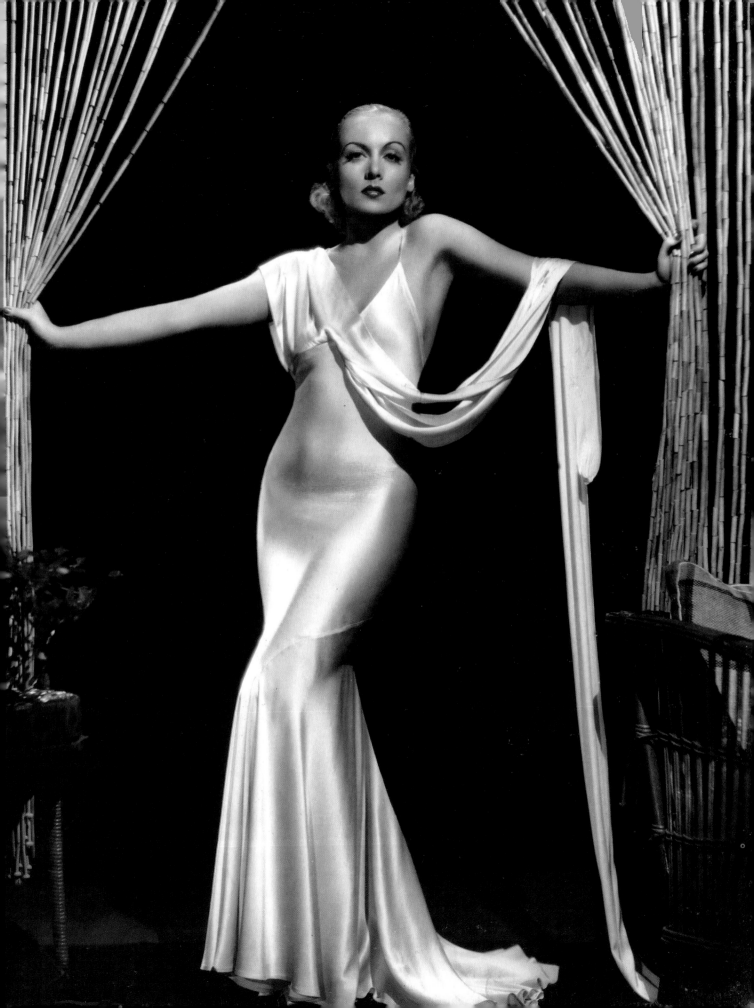

Daytime choices

The increasing number of career girls, making their way in a male-dominated world, needed to present a smart, efficient image. This influenced daywear designs, which became elegant and tailored, relying on inventive details such as unusual buttons or stitched panels to liven up simply cut suits and dresses. Shoulders were built up with padding and pleats, giving a squarer look to jackets and dresses. Underneath a tailored suit, a sheer blouse with generously frilled collar and cuffs, or a large drooping bow at the neck, added a touch of prettiness.

Colours were demure neutrals – black, grey, navy and brown – with touches of white or cream at the neck or cuff. Prints were small: tiny polka dots or floral sprigs.

The tea dress, which had lost popularity during the 1920s, was revived. A feminine, floaty dress, which bridged the gap between day and evening, it was perfect for an afternoon "tea dance". Made from floral silk, chiffon or organdie, tea dresses were a little longer than day dresses and had a romantic design, with flounced sleeves, ruffles trimming the skirt, or a cluster of artificial flowers at the shoulder. Trousers, no longer confined to the beach or the house, looked fresh and flattering. In summer they were made from crisp linen or cotton, and teamed with a striped T-shirt and jacket; while winter versions made from tweed or wool were worn with a twinset or coordinating jacket.

As society continued its obsession with health and fitness, women started to wear shorts – perfect for everything from sunbathing to hiking. A suntan was the best accessory a woman could have, and swimwear became briefer and lighter, enabling the wearer to tan the maximum amount of skin.

Tailored suits emphasised the waist, and skirts were slim, with pleated panels near the hem.

Fashionable women watch clothes being modelled in Harrods, London 1934.

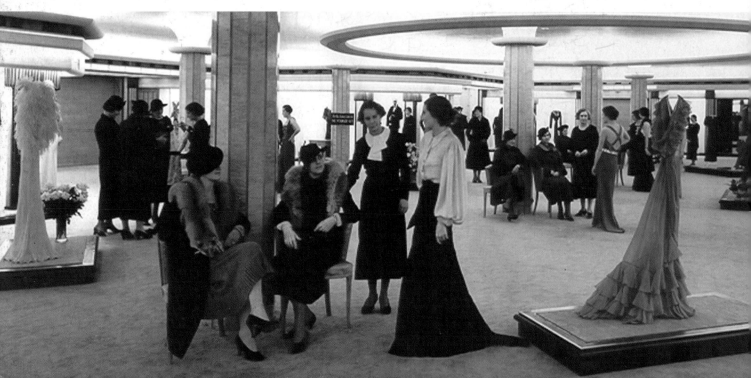

Evening style

The gowns of the early 1930s were simpler than eveningwear had ever been, relying on cut and construction instead of ornamentation. The dressmaker Madeleine Vionnet pioneered the method of bias cutting, and this created gowns that draped and hung in seductive folds. Designers also experimented with devoré velvet, which had burnt-out designs on the fabric, to create a luxurious and sophisticated look.

Evening gowns were now always floor length, often with fishtail trains that pooled out behind. Bows, subtle rhinestone clasps or bias ruffles were the only decoration. Most dresses were sleeveless, with a scooped cowl neck or back. The alluring went a step further, with backless dresses, cut to the waist.

Glamorous nightgowns differed little from evening dresses, with luxurious panels of bias-cut silk falling to floor length. The fabric of these nightgowns tends to be thinner, and the cut more décolleté, but these make a wonderful alternative for the vintage dresser who wants a bias-cut gown, as they are often in better condition than eveningwear.

A softer look than the sleek lines of the bias-cut column dress was the ruffled organdie or chiffon gown, often worn by younger girls. These dresses had tiered skirts, or pleated puffed sleeves and collars that drew attention to the face. Pin tucking and concertina pleats created a soft romantic silhouette.

Colours were still usually fairly subdued, with white and cream being popular to show off suntanned skin. But bold shades were also used – scarlet, cobalt blue, lime green and orange – and younger girls were still dressed in pastels. Eveningwear fabric was kept plain, with the occasional tiny floral or dot print.

Sumptuous fur wraps and jackets covered bare backs and arms, and contrasted with the sleek lines of the dresses. Full-length, velvet evening coats were both opulent and stylish, and added a bold splash of colour to an outfit. A prettier and more delicate cover-up was the

Despite the bleakness of the decade, its fashions are soft, pretty and very wearable. The 1930s styles have a timeless look, which inspires modern-day designers season after season.

shoulder-length cape, in wispy chiffon or embroidered linen or velvet.

Towards the end of the 1930s, styles began to change. Designers turned away from the simple elegance of the bias-cut gown, and favoured a romantic neo-Victorian look. The silhouette was more voluptuous, drawing attention to the bust with integral corseting, and enhancing the waist and hips with voluminous skirts. Beading, lace and clusters of velvet flowers embellished the bodice, which was either off the shoulder or strapless, while huge bows created a bustle effect on the skirt.

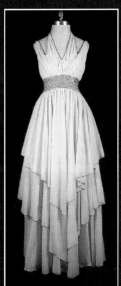

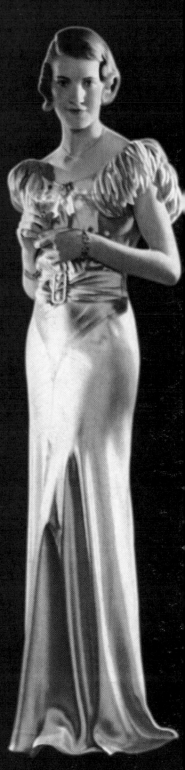

Bias-cut evening gowns, made from silk and satin, flowed like liquid over the curves of the wearer (right). V-shaped panels and seaming echoed the geometric lines of the Art Deco period (left).

For the fashionable bride

1930s wedding gowns are characterised by their glamorous lines and subtle details. Bias-cut silk or satin created a sleek dress that flowed to floor length. Fishtail hems balanced out the slim silhouette, and were often finished off with a small train. Tiny buttons, in mother-of-pearl or satin, became a feature on the back of the gown and cuffs.

Art Deco details appear on gowns from this decade, from diamond-shaped panels at the bust to the classic sunburst headdress. Fabric seaming also reflects the angular Art Deco look, with V-shaped seams at the hips or hem.

Most wedding gowns had long, tightly fitted sleeves, finishing in a point over the hand. The bodice was usually fitted, and the shoulders puffed. A matching jacket or bolero could be worn for the ceremony and then taken off for the reception, to reveal a sleeveless dress underneath. Veils were still long, but were placed further back on the head, with a headband or Juliet cap. Towards the end of the decade the mantilla veil became popular – this was a long lace veil worn over a high Spanish comb.

Bridesmaids' dresses were made from printed chiffon or organdie, with tulip-shaped skirts and a matching bolero jacket. Many dresses were designed to be worn later as evening gowns, and their simple cut reflects this. The outfit was usually finished off with a wide-brimmed hat and plenty of flowers.

Finishing touches

Despite increasing informality of dress, it was still considered bad etiquette to be seen out without hat, gloves and bag, so accessories played a key role in the wardrobe of a well-dressed 1930s woman.

Since many women had less to spend on clothes, items had to last longer, and this created a trend for sturdier shoes, with wedge heels or platform soles. Another craze was the co-respondent shoe, a two-toned brogue, usually in tan and cream. This masculine style, softened with a low heel, looked elegant with the tailored daywear. The open-toe or strappy shoe, in soft kid or suede, set off seductive evening gowns. Bags were small and simple: leather for the day and chain-mail clutches for evening.

After the plain cloches of the 1920s, hats were now a fashion area with which women could have some fun. Hats ranged from wide picture hats wreathed in silk flowers, to tiny pillboxes with eye-shading veils and Oriental "coolie" hats. Later in the decade the beret was hugely popular, worn with slouchy panache over one eye. The Surrealist art movement was a heavy influence on many milliners, who created bizarre, yet chic hats modelled on anything from a plant pot to a mutton chop.

Costume jewellery, pioneered by Chanel in the 1920s, grew in popularity; in a world where many couldn't afford three meals a day it seemed gauche to spend vast amounts on trinkets. A novelty enamel brooch looked sweet on a blouse, an armful of clunky bangles added a modish touch to beach wear, and a simple string of pearls – real or fake – was elegant with a tailored suit. For eveningwear, jewellery was real, but simple: perhaps a diamond clasp or bracelet and a pair of discreet clip earrings.

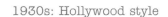

The thirties meant ...

bias-cut gowns, chiffon tea dresses,
belted day dresses, twinsets,
wide-legged trousers, frilled blouses,
tailored suits, shoulder capes,
peep-toe shoes, berets

*Trousers, as worn by Marlene Dietrich, became a
sophisticated addition to eveningwear.*

Adrian, Alix, Cristobal Balenciaga, Pierre Balmain, Hattie Carnegie, Coco Chanel, Charles Creed, Jean Desses, Lucien Lelong, Mainbocher, Edward Molyneux, Jean Patou, Nina Ricci, Elsa Schiaparelli, Victor Stiebel, Madeleine Vionnet

fault finding

The signs of age are inescapable: sagging, blotches, wrinkles and increasing fragility – not to mention moth holes, mildew and rusty zips. That's right, we're talking about clothes, not people. Vintage shopping requires you to focus on the clothes' imperfections, not your own, making an end to changing-room tears – unless you squeeze into a dress too carelessly.

When vintage shopping, you have a choice. You can go to the top vintage shops, which specialise in flawless pieces, and spend a month's wages on one dress. Or you can rummage through all the other vintage shops, surf the Net, visit flea markets, and choose from a huge selection of vintage clothing and accessories, ranging from the battered to the beautiful. The second way involves time, persistence, imagination and a bit of hard work. But it's also a lot of fun, and much more rewarding.

Some people have unrealistic expectations about vintage clothing. They go into a vintage shop, look around and are horrified because they see a dress with a broken shoulder strap, or a skirt with a dropped hem. They walk away, convinced that vintage clothing is grubby and falling to bits, nothing more than second-hand tat. In their insistence on perfection, they are missing out on so much. Don't be fooled by fashion snobs who dismiss vintage clothing as shabby – it is precisely its age and history that make it so appealing, like a woman whose face becomes more beautiful with age.

Naturally, you want to find clothes that are in the best condition possible, but you don't need to be put off if you notice a minor fault on a garment. Many faults are easily fixed, others can be masked, and only a few make a garment not worth buying. The key is to know the type of faults that you are looking for and what to do if you find them.

So let's assume that you've seen the perfect dress, and it's your size. What do you do now? Take it off the rack and examine it carefully, using your fingers and your nose, as well as your eyes. Look inside the garment; check the seams and the hems. Vintage shops can be quite dark, so try holding the dress up to the light or the window, which will help you to see any flaws. Take your time and check the dress thoroughly. If you find any problems with it, talk to the seller; she may know the background of the dress and might be able to tell you more specifically what that stain is, or why the hem is ripped. Don't be embarrassed and worry that the seller will think you are being "picky" – after all, she will have done exactly the same thing when she bought it.

If you are very, very lucky, that dress might be perfect. But it's more likely that you will have spotted something wrong with it – now you need to decide whether the problem can be fixed, or whether you need to find another dress. Here is a list of some of the most common problems, and how fixable they are, to help you decide.

Stains

It is surprising, and frustrating, how many women put clothes away with stains on them – dinner dresses with food spots, dance dresses with perspiration stains, blouses with lipstick marks. Sadly, many stains become ingrained over time, making it impossible to remove them from the fabric. If you notice a stain on a

garment, ask the seller if the item has been washed or dry-cleaned – if it has, then the stain is there to stay. However, don't give up immediately. If the mark is small, you could consider covering it with a brooch, a piece of lace, appliqué or embroidery.

If the stain hasn't been washed and set into the garment, ask the seller to help you to identify what it is, as there may be a way of removing it (see page 109). Pen ink, cosmetics and many types of food stain can be removed fairly easily from certain types of fabric. Old perspiration, rust and more stubborn food stains, such as tomato, red wine and curry, may come off with careful and determined treatment or with a trip to the dry-cleaner's.

However, it's likely that you will only be able to treat more robust fabrics, such as cotton, as stain-removing products are often harsh and may damage the fabric.

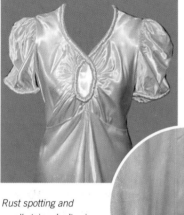

Rust spotting and small stains don't ruin the overall look of this vintage wedding dress and can be covered if the dress is dyed professionally.

Holes, rips and tears

The other common problem with vintage clothing is some kind of hole or tear. Holding the garment up to the light may reveal lots of tiny holes from the dreaded moth. Other problem areas are ripped seams, torn buttonholes, frayed shoulder straps or tears near the hems of skirts or dresses, where a high heel may have gone through the fabric.

Dropped hems

Dresses or skirts with rips near the hem can be rescued by taking the hem up a few inches, if the style allows. Other tears and rips can usually be fixed easily and quickly; if you don't feel confident making the repairs yourself, your dry-cleaner should be able to arrange for a professional to do it for you. Make any repairs before washing or wearing the garment, to avoid making the tear worse.

Frayed cuffs

Many vintage blouses have worn cuffs, but they are fixable. You could either take the item to a dry-cleaner, or, if you feel confident about making the repairs yourself, you could darn the worn patch. Alternatively, shorten the cuff slightly; this also fixes cuffs that have dirt ingrained along the edges.

Moth holes

Lots of tiny holes clustered together are a sign of moths – the worst fault you could find. Moth holes are almost impossible to repair. However, if the holes are in an area where a sequinned motif or piece of appliqué would look pretty, then that is an alternative. Otherwise, you may have to leave the garment, however reluctantly.

If you do buy a garment with moth holes, have it dry-cleaned before taking it home – you never know if there might be some eggs or larvae still lurking in the fabric.

Broken fastenings

Metal zippers have a tendency to rust if the storage environment is at all damp. This can easily be fixed by having the zip replaced. If a garment has a button missing, and it is from a prominent area, it's simple to replace all the buttons with a vintage-looking set. You can keep the original buttons to use on another garment. Missing hooks and eyes or snap fastenings are also easy to replace, and since they are normally hidden, you don't need to worry about using modern replacements.

Missing trim

Many vintage garments have beautiful beading, sequinned designs, embroidery or lace. As these are delicate, often they don't survive the passage of time intact, but that doesn't necessarily mean that the item should be discarded. Look carefully at the problem area – is it really very noticeable? If it is bead or sequin work, a professional may be able to replace the missing trim. If there are areas of lace missing, could another part of the garment, perhaps the cuffs, supply enough lace to patch the gap? If the problem is just in one part of the garment, could it be altered in some way, for example, turning an evening gown into a beautiful skirt? Major alterations like this will require the services of an expert, but if you really love the item, then it's worth it.

Odours

Because smells tend to cling to fabric, you will find that most vintage clothing has some odour to it. Light smells, such as perfume or the mustiness of storage, can usually be aired out of the garment. If the fabric is not too delicate, you might also be able to use a fabric freshener.

Stronger smells, such as mothballs or stale perspiration, are more pervasive and harder to remove. Dry-cleaning may help, but you will have to decide whether you can live with the smell if it doesn't. If the smell is only on a portion of the garment, such as its lining, you could consider replacing this part.

Creasing

Few vintage sellers have the time or the energy to iron all their stock – they simply hang it up and hope gravity will do the trick. Unfortunately, the natural fabrics from which many vintage garments are made, such as cotton, silk and linen, crease very easily. Don't be discouraged;

all they require is a gentle pressing to freshen them up. If you hate ironing, you may be better off looking for non-creasable garments. A badly creased garment may need pressing at a dry-cleaner's to smooth all its wrinkles out.

However, if a garment made from suede or leather is creased, you may have to let it go – unless the creasing is minimal and you can live with it. It is virtually impossible to rescue suede and leather once creases have set in. Similarly, a man-made fabric, such as a polyester crêpe, may be badly creased if it has been washed at too high a temperature. This seals the creases into the fabric, making it impossible to get them out. Learn the lesson and move on.

Fabric faults

Age can cause some fabrics, especially silk, chiffon and velvet, to become fragile. For example, if you see fine tears along the grain of silk, the fabric has "shattered". This means that the slightest pressure will rip the fabric. Many beautiful garments have been lost because of this fatal problem. The pile of velvet, particularly silk velvet, is easily worn, becoming shiny in patches. If this is very noticeable then pass by, sadly there is nothing that can be done.

Vintage knitwear is particularly prone to damage. If wool survives the moth, it can be damaged by washing at high temperatures; this causes the wool to mat, which means that the fibres have become tangled, and the fabric will feel more like felt than soft, fluffy wool. Occasionally matting can be remedied by washing again, but this may not always work. An easier problem to fix on knits is "pilling". These tiny bobbles of wool can be removed with a pill shaver or a pair of sharp scissors.

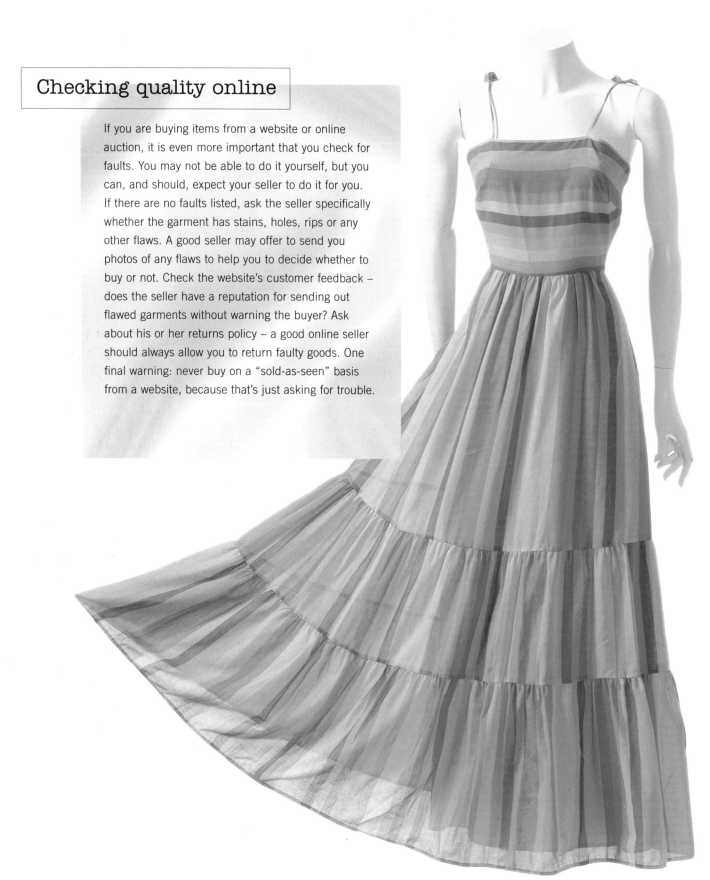

Checking quality online

If you are buying items from a website or online auction, it is even more important that you check for faults. You may not be able to do it yourself, but you can, and should, expect your seller to do it for you. If there are no faults listed, ask the seller specifically whether the garment has stains, holes, rips or any other flaws. A good seller may offer to send you photos of any flaws to help you to decide whether to buy or not. Check the website's customer feedback – does the seller have a reputation for sending out flawed garments without warning the buyer? Ask about his or her returns policy – a good online seller should always allow you to return faulty goods. One final warning: never buy on a "sold-as-seen" basis from a website, because that's just asking for trouble.

how to haggle

Try going into a ordinary womenswear store, picking out a dress that is priced at £40, and offering the sales assistant £30 for it. You might get a few outraged looks. Now go into a vintage shop and do the same thing. The chances are, you'll get your dress, especially if you ask in the right way. Vintage sellers are used to haggling, and all are flexible with their prices, to some extent.

Because the modern consumer society is obsessed with speed and convenience, the art of bargaining has dwindled to the point where many people are afraid to even try negotiating the price on an item. If the thought of haggling makes you uncomfortable or nervous, then you don't have to try it; but you'll be missing out on a fun and integral part of vintage shopping if you don't.

Unlike most fashion shops, which have their prices decided by their suppliers or their head offices, vintage shops sell one-off items, which are priced individually, according to their condition, desirability and original cost. A vintage seller almost always has the power to adjust the prices and many are happy to do so if you ask in the right way. After all, sellers want you to enjoy shopping with them, to recommend their shops to your friends and, most of all, to shop with them again.

Bear in mind, however, that if you are shopping for vintage in a charity or thrift shop, you will be less likely to get prices slashed – after all, the cost of each garment is going to charity. Most items are very cheaply priced in any case, so it is unnecessary, and a little unscrupulous, to try. People who run vintage websites also can be reluctant to negotiate their prices, as they tend to have a lower volume of sales, but they may be happy to offer free or discounted shipping.

If you want to give haggling a go, here are five tips on how to do it successfully.

1. Be reasonable

Sellers want happy customers, but they also need to make a profit – if you ask for outrageous discounts they will be justifiably annoyed, and you run the risk of getting no discount at all. Unless there is something wrong with the item, you can reasonably hope to get a discount of between 10 and 20 per cent if you haggle well. The higher the cost of the garment, the better your chance of a good discount. A floor-length coat priced at £85 is more likely to get a good discount than a £10 shirt.

2. Be polite

This is probably your rule when shopping anyway, but it's especially important if you are hoping to knock the prices down. Smiling and saying "hello" when you enter the shop can be a good start. Don't demand a sales assistant's attention if she is busy serving someone else, and if you have any negative comments about the shop or its stock, they're best kept to yourself. If you are unable to agree on the discount you want, smile and thank the person for her help before leaving. After all, the next time you visit, she will be more inclined to help if you left a good impression. If the shop has a "no discount policy" displayed, respect it – it's a bad seller who does this, but it's a bad buyer who ignores it.

3. Use cash

Some vintage sellers are unable to accept credit card payments because of the high levels of charges these incur, but most sellers do accept cheque payments. Sellers do this because it is more convenient to the customers, but all sellers prefer cash, as it cuts down on bank charges and the risk of fraud. Offering to pay in cash is always welcome, and may result in a small discount on your purchases.

4. Bulk buy

The more items you buy, the better your bargaining power. If you don't plan to spend much money, take along a shopping partner and pool your purchases. Sellers are usually keen to help out customers who buy several things each time they visit, perhaps by offering generous discounts or by throwing in free smaller items. If you only find one or two items that you want, but they are fairly expensive, ask what kind of discount a seller can offer if you spend over a certain amount.

5. Be discreet

When you are ready to discuss prices with the shop assistant, make sure that the shop is quiet and that she isn't dealing with anyone else, even if this means coming back later in the day. For one thing, a sales person may be too busy and flustered to give your request any proper attention, and you may be dismissed abruptly. Also, if you ask for a discount in front of other customers, they also might expect a discount, so the seller may turn you down flat. You need to use your initiative; if there is more than one shop assistant, speak to the senior one, or the one who appears to be in charge. Try not to haggle with more than one shop assistant at once – it's usually easier to persuade one person than two.

Trudie's top tip

Most vintage shops buy items as well as sell them, so another way to cut down the cost of your vintage shopping trip is to take in some of your own vintage garments that you no longer want, and use those to bargain with. This is a fantastic way to constantly update your wardrobe without spending a fortune.

Suggested phrases for haggling:

"How flexible can you be with these prices?"

"I'm interested in quite a few items – can you offer me a discount?"

"This dress is lovely, but it's a little more than I can afford. Would you be able to bring down the price?"

"Would you be able to give me a discount for cash?"

"This item is priced at X amount but that's more than I can pay. Will you take Y for it?"

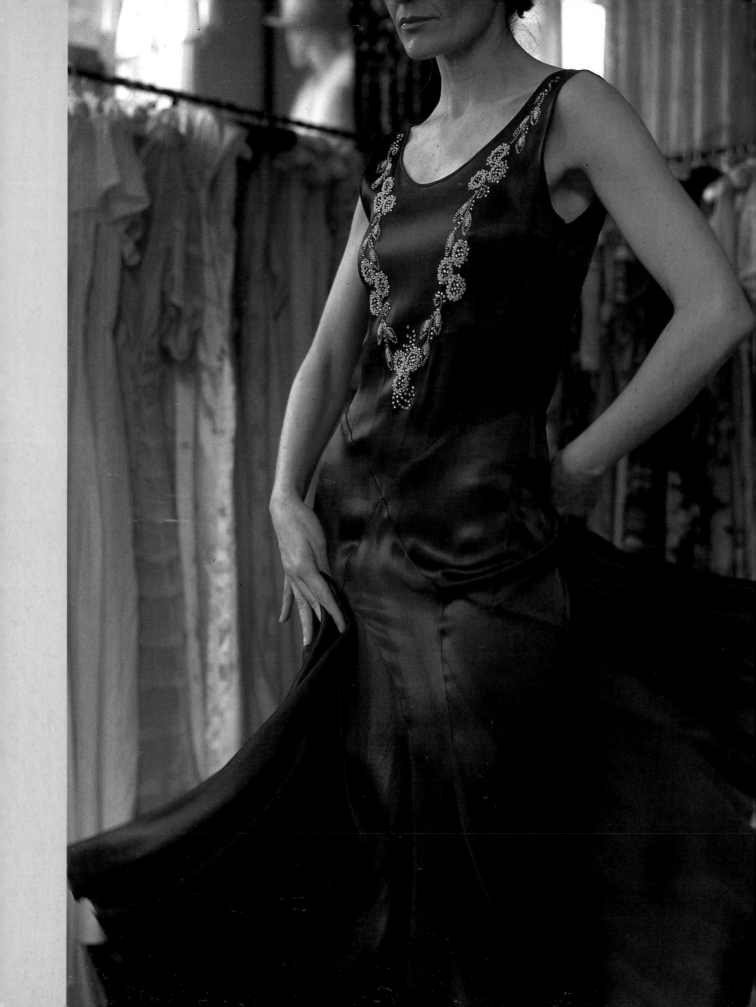

& wear it!

you wear it well

Don't muddle up vintage clothing with the notion of "old-fashioned": many of the items have been worn before, but they're not outdated. When you wear vintage, you don't have to look like you've been digging around in a costume department – unless you want to. Vintage clothing brings diversity, glamour and charm, but it always looks fresh and unique.

Whoever you are, whatever your style, age or size, vintage clothing has something to offer you. Do you want to look like an elegant businesswoman? The chic styles of a more feminine age will be perfect for you. Are you young and trying to create a look that is all your own? You'll have the time of your life playing with all the different vintage styles, each one unique and unforgettable. Are you looking for that dress of a lifetime, for your wedding, graduation or other big event? You're bound to find what you are looking for among the glamorous evening gowns of the past.

How you wear your vintage purchases is as individual as how you wear your modern clothes. But, as some women can feel nervous about trying out a new style, this section will give you some ideas on how to introduce vintage clothes into your everyday and special occasion wardrobes. Also, if you're any larger than the average woman of the early 20th century – which most of us are by virtue of better food and health – you can discover how to find vintage clothing that will fit you (see page 80) or that you can alter (see page 85).

Gaining perfect balance
Rather than sticking to any hard and fast rules about what should and shouldn't be worn together, keep in mind general fashion guidelines – or common sense – when putting outfits together, and you won't go far wrong. One mistake that many women make when dressing is not balancing out their outfits. For example, wearing a slouchy jumper over a long, full skirt often looks frumpy and unflattering. A better choice would be to balance out the bagginess of the jumper with slim jeans or to contrast the fullness of the skirt with a fitted top. Smart women realise that there is a certain amount of yin-yang in dressing: tight clothes are best contrasted with baggy, prints can be balanced with plain, smart sometimes needs a touch of casual. However, don't be afraid to try out unusual combinations; you'll soon learn what looks right together, and which pieces would look better with something else.

One of the advantages of vintage clothing is that you can use it to balance out the shapes of your existing wardrobe. If you find that you have lots of show-stopping separates but nothing to tie them together, choose timeless vintage styles, such as the pencil skirt, pleated trousers, the shift dress and the twinset. If your wardrobe is quite conservative already, with lots of classic pieces, use quirky vintage clothes and accessories to add some fun. Freshen up a stylish suit, for example, with a quirkily painted box bag or a bright, contrasting neck scarf.

Although not from a big "name" designer, suits such as this 1960s piece by Davidow are beautifully constructed and make an elegant addition to any wardrobe.

Considering colours and patterns

One of the treats of vintage shopping is the feast of colours and designs that are found on older fabrics. From the classic little florals of the 1930s and 1940s, to the quirky scenic prints of the 1950s, and not forgetting the wonderful swirling psychedelia of the 1960s and 1970s, vintage fabric designs are one of the things that makes vintage clothing so special.

What suits you?

When assembling your outfits, consider which colours and prints suit your eye, hair and skin colouring as well your personal style. Try different colours against your skin and see which make you glow and which leave you looking washed out. For example, a classic English Rose, with blonde hair and pale skin, can look sweet in ditzy prints and traditional florals. Someone with more dramatic looks – dark hair and eyes and tanned skin – could look better in the hot shades of 1970s disco wear. But don't get typecast. If you generally wear pretty prints in pastel shades, swapping them for a shocking print or colour will create a dramatic impression. Likewise, the girl who usually wears bright colours and busy prints might want to try softer shades and romantic prints for a special occasion.

Mix and experiment: set off the floaty fullness of a vintage top with some slim-fit Capri pants or combine a funky skirt and shirt from a similar era.

Combining colours

Whatever your favourite colours or patterns, it's rare that you're going to wear them all over. Apart from knowing which shades and patterns suit you it's great to know what you can combine. Bright colours, whether greens, reds, blues or purples, can look dramatic against strong neutrals such as black, white or navy, while softer colours, such as pale pinks, sky blues or pastel yellows, can be complemented by gentle shades of cream, beige or dove grey. If you want to wear two very different colours, try pulling the look together by the clever use of accessories. For example, if you want to wear a pair of blue trousers with a purple top, try tying a scarf that includes both these shades around your waist to complete the look.

Mixing prints can also be fun, although only the confident can carry it off successfully. If you want to try this, keep in mind that yin-yang balance – wear a pale gingham shirt with floral Capri pants, or a stripy T-shirt with a dotty skirt. Avoid wearing two large print patterns together, and keep colours complementary for the best effect.

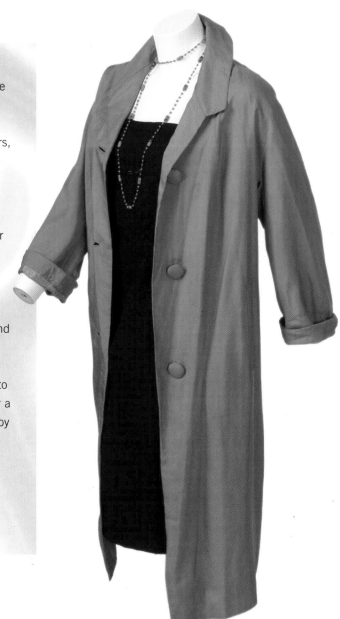

Forget about "age limits"

Some women think that if they wore vintage the first time round, they are too old to wear it now. Rubbish. No one is ever too old to be glamorous, quirky or striking. Vintage clothing can be subtly stylish; you don't have to dig out those polyester flares and platform boots, you can stick to elegant outfits that look contemporary and unique.

If you ever go vintage shopping with your daughter or a younger friend, don't just stand there, have a look through the goods for yourself. Look for chic, simple clothes: fitted shift dresses, sleek wrap dresses, cashmere sweaters. If you feel conspicuous in vintage, choose neutral colours like black, cream and navy, and introduce colour with accessories.

You might even be lucky enough to have some lovely clothes tucked away in the back of your wardrobe, just waiting to be resurrected. If so, get them out and try them on with modern accessories. If you can still fit into them, then they'll probably make you feel great and bring back a few happy memories.

Black looks great with strong colours (opposite), while softer patterns can work well with slightly faded denim (below).

Seven deadly vintage sins

1 Trying too hard: unless you really want to pull out all the stops to create an authentic look (see page 69), you don't have to be authentic from head to toe. Use your imagination, play around with different outfits, and don't be afraid to get it wrong once in a while.

2 Buying a vintage garment, then leaving it in your wardrobe until "the right moment": every day is a good day for wearing vintage; so don't keep it just for special occasions.

3 Buying something that is far too small/big/short for you: if you want to look good, clothes need to fit you properly. If a halter neck is gaping at your armpits or if trousers are sagging around your bottom, you probably won't be able to alter them (see page 85) and they'll never create the look you were after.

4 Ignoring the rules of good taste: in general, fashion rules are quite arbitrary. Who says that you can't wear white shoes in winter, and how can navy be the "new brown", if last season brown was the "new black"? Forget about fashion rules, but don't ignore the rules of good taste. Be cautious around mini skirts, hot pants, tube tops and anything stretchy. Be chic, be quirky – but always be tasteful.

5 Mixing too many looks: what comes across as eclectic on Gwen Stefani can look bizarre on the rest of womankind. Consider the combination of a vintage camouflage jacket, a bright pink, fluffy cap, a velour tracksuit, a red handbag and pointed gold shoes ... You see the danger?

6 Following fashion slavishly: the whole point of vintage clothing is its diversity and individuality. So unless you like a particular trend, don't buy something just because it's "trendy"; buy a garment because you love the style, because it looks great on you, and because it appeals to your taste.

7 Buying for the sake of it: if you are having a retail-therapy urge, and you can't bear to leave the shop without something, buy something small, like a scarf or a piece of jewellery. Don't buy an item of clothing that you'll regret later and never wear. There'll be other days and other shops.

everyday vintage

Head-to-toe vintage can look amazing in the right circumstances (see page 66), but in everyday life it looks, at best, like you've tried too hard, and at worst, as though you've stepped out of a period drama. Mixing vintage and modern clothing gives a confident, eclectic look that is almost impossible to achieve wearing modern clothing alone.

Combining vintage separates with modern pieces has a subtle effect, which, if you're new to wearing vintage, can ensure that you'll feel comfortable in what you're wearing. Use complementing styles for an understated look and contrasting styles for a more striking effect. For example, a stylish vintage coat gives a subtle twist to modern jeans. On the other hand, wearing a funky mini dress over the same jeans can look daring and edgy, because the combination is unexpected. Experiment with the contents of your wardrobe, hold clothes up together, and see how your vintage pieces can create a variety of looks with different garments and accessories.

Sometimes your circumstances might make it difficult to wear much vintage, perhaps if you are in a very conservative or uniformed work environment, but vintage accessories can be so subtle that you can add individuality to even the plainest outfit. Vintage bags are a wonderful way to do this, and will blend into any outfit. Also, look out for jewellery, scarves, wraps and hats to jazz up your wardrobe.

A pretty 1960s, mod-style coat will blend easily into many outfits.

More vintage than modern

Once you're confident about wearing vintage, you might want to go a step further, putting a complete vintage outfit together with just the contrast of modern accessories. This allows you to explore your vintage style, while still keeping a modern edge. Again, accessories with a similar style to the vintage clothing will give a more elegant look, while contrasting accessories will look funkier. For example, a slinky 1970s wrap dress combined with strappy heels and a sleek clutch bag will give an authentic disco-diva look. Or you could dress it down with wedge sandals and kitschy plastic jewellery. Or a floaty 1930s tea gown will look quietly elegant with feminine sandals and a large-brimmed hat; funky cowboy boots and a battered denim jacket will give it a completely different style.

Enjoy experimenting and learn to trust your instincts. Spend time playing around with your own clothes – you never know, pea-green shoes may be just the things to set off that hot pink mini dress. And keep your eyes open, as inspiration is all around you: in that off-beat, but cool, student on the train, on the pages of a fashion magazine, in an old, black-and-white film. Notice how other women put outfits together, absorb their successes into your own style and learn from their mistakes. Above all, learn to listen to your own fashion judgement. It doesn't matter if *Vogue* says that flares are "sooo last season", if you like them, wear them. And if your mother/sister/boyfriend says that you look weird when you think you look fabulous, who cares? Make the most of the freedom that vintage clothing gives you, the freedom to choose and to experiment. After all, it's better to be distinctive than to blend into the crowd.

Styles to suit: a mix of vintage and modern

A VICTORIAN-STYLE BLOUSE: This prim look, popular in the 1970s, can be teamed with a denim mini and killer heels for a look that's anything but demure.

A VINTAGE SILK CHEONGSAM: Look sexy and exotic by wearing a cheongsam with stilettos and an armful of bangles. A denim jacket and flat ballet slippers will make it much more funky.

A VINTAGE SHAWL: Worn with a lacy camisole and long skirt, a shawl can look ethereal and sweet. Wrapped around your head, and worn with jeans and a strappy top, a shawl can look strikingly hip.

AN OLD VELVET BLAZER: This could look Bohemian worn with a ruffled cotton skirt or more laid-back teamed with a pair of modern jeans.

A SUEDE WAISTCOAT: Relax into the hippy style with some loose trousers and a fitted vest.

A 1950s CIRCULAR SKIRT: Dress up this flirty classic with a fitted top and heels; or dress down with a plain T-shirt and denim jacket.

A 1960s MINI SKIRT: Go for an authentic look with knee-high boots and a polo neck jumper. Or a slouchy, sweatshirt top and battered sneakers will give it a grungy twist.

Rationed fashion

1940s

The 1940s was the bleakest decade of the 20th century. The war cast a pall of austerity over this period and women were once again called to work. Despite this, people made the best of the situation — staying cheerful seemed the best way to show patriotism.

As in the First World War, women became the bulk of the workforce, as the men went off to fight. Some women worked on the land or in munitions factories, while others volunteered at hospitals or raised funds. Work responsibilities had to be juggled with the work of looking after a home and family, which fell completely on the woman's shoulders. The combination of too much work and too little food proved too much for some women, whose health broke down completely; but the majority battled on, growing thinner and wearier as the decade went on.

With every available supply going towards the war effort, the fashion industry became severely restricted. Governments urged people to be resourceful and to "make do and mend", while severe rationing laws left them little choice but to obey. Even after the war ended, rationing was still in place, as the world struggled back to its feet. Of course, those with more money than scruples could obtain anything they wanted on the black market, but most women were conscientious, suffering the deprivation with dignity.

Because of the constraints of clothes rationing, it is much harder to find 1940s clothes that are still in good condition, as most garments were worn and worn, remade and altered until they disintegrated. But this shouldn't put off the vintage dresser, as it's well worth searching for these feminine and functional styles.

Even in publicity shots for film stars such as Greta Garbo (left) and Lauren Bacall (opposite, top), functional elegance replaced the glamour of previous years.

Daytime choices

The 1930s had ended with a new stronger silhouette, and this proved suitable for the functional clothes of the war years. Shoulders were highlighted with padding and a wider cut, creating a triangular effect, with dresses and suits tapering into a fitted waist. Skirts were shorter, around knee length, with just enough fullness to allow ease of movement. Colours were drab – brown, green, grey and navy – and patterns were small florals or abstract prints.

Designers had to comply with Government restrictions, which dictated everything from the amount of cloth used to the number of buttons and amount of stitching. Rather than being daunted by such limitations, designers responded with inventive cutting and piecing techniques, which created the impression of a generous cut while still obeying regulations.

Trousers were welcomed as the practical and comfortable alternative to skirts, especially for working women. In Britain, the siren suit, with blouson top and trousers all in one, created a stylish and practical solution for wear during nighttime air raids.

The overall look was neat and tailored, heavily influenced by the crisp lines of uniforms. Military details (left) were used.

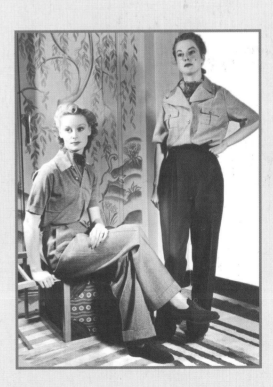

Most women chose to make the majority of their clothes themselves, as fabric cost fewer points than ready-made garments. When they couldn't obtain suitable fabric, they improvised, using anything from blackout curtains to old blankets. Wool was severely rationed, but old sweaters could be unravelled and reknitted, and patterned designs such as Fair Isle were both attractive and perfect for using up leftover wool.

As garments began to wear out, they were turned and patched, cut down into children's clothes, or used as scraps for home-made quilts and rugs. Women prided themselves on their ability to conserve, feeling that this was another contribution to the war effort. But underneath this façade of bravery, women mourned the loss of the feminine styles of the past, and struggled to keep up their morales.

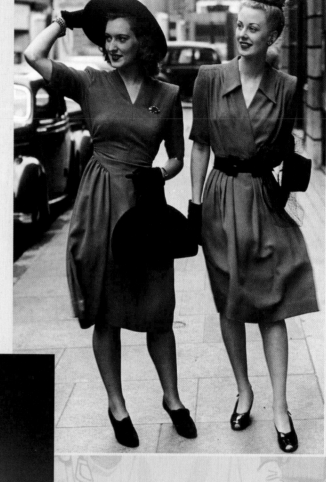

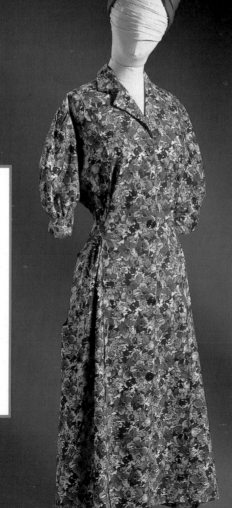

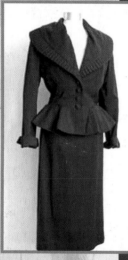

This Lilli Ann gabardine suit shows the peplum waist so characteristic of 1940s designs.

When designers such as Christian Dior unveiled their new collections in the post-war world, women were delighted. Even though most could not afford to adopt the styles immediately, they could look forward to feeling womanly and beautiful again. Dior's "New Look" celebrated the female form, with nipped-in waists and extravagantly full skirts, and it looked sensational after the straight, serviceable styles of the war. Some women, keen to try out the full-skirted dresses, used old material such as bed sheets to make their own versions. By the end of the 1940s, women were revelling in their femininity, thankful to leave the uniformity of the decade behind.

To boost morale, the Incorporated Society of London Fashion Designers, including Molyneux, Norman Hartnell, and Victor Stiebel created Utility Clothing designs such as this day dress (left) in 1942.

Evening style

As the 1930s had drawn to a close, designers had created extravagant, romantic evening gowns, inspired by period dramas such as *Gone with the Wind*. The progress of this style was cut short by the restrictions of the war, as not only was rationing implemented, but also traditional evening fabrics such as silk were commandeered for war needs. Designers turned to fine, wool jersey instead, creating draped gowns with long sleeves and elegant lines. But soon wool was in short supply as well, as so much of it was needed for the Services' uniforms. Rayon, viewed in the past as a poor mans' silk, now became an acceptable alternative; it was easy to work with, draped well and came in bright floral prints, which made simple styles look prettier.

Despite the privations of the war period – or maybe because of them – socialising was more popular than ever. Whether at an intimate dinner party or a Big Band dance, people were determined to enjoy themselves, so an evening outfit was just as important as ever. As with daywear, many women made their own evening clothes, or altered old dresses to look more up to date. Styles were necessarily simple, with short, puffed sleeves, fitted bodices and gored skirts, which included triangular panels to add a fluted fullness. For special occasions women somehow managed to find full-length dresses, but for everyday use most women had to compromise with calf length.

Draping, ruching and clever cutting gave eveningwear a graceful look. The sweetheart neckline was extremely popular; it used less fabric, and gave an attractive look to the plainest of dresses. Embroidery and beading were out of the question, but a gentle fall of lace at the neck or the cuffs, or a corsage of artificial flowers pinned to the bodice, added a pretty touch. The peplum, a flounce of fabric sewn at the hips over a dress, was another elegant way to add interest to a straight evening gown.

In the later years of the decade, the luxurious styles of the New Look filtered into eveningwear, leading to full-skirted dresses that were flattering, feminine and perfect for dancing in. But such dresses required yards of fabric, so until the very end of the 1940s, most women had to content themselves with watching their favourite movie stars float across the screen in these wonderful gowns.

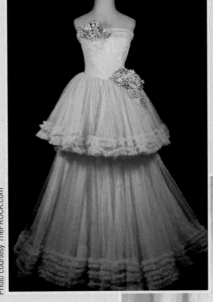

Photo courtesy TheFROCK.com

A late 1940s tulle gown with fitted bodice and full skirt (left).

Paris designers in 1949 started using decoration to emphasise bosoms and necks (below).

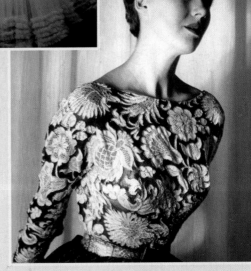

For the fashionable bride

The constraints of the war years meant that few brides were able to have the dress of their dreams; often they had to make do with what they could get, especially for last-minute weddings.

Some women managed to get hold of enough fabric to make a proper wedding gown, either from pre-war hoards, or by using extra coupons donated by friends and family. After the war, some even used the silk from parachutes to create a traditional gown. But, for the most part, only the very lucky could have a silk wedding dress; most women were content with rayon, satin or net.

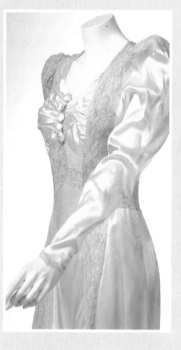

The sweetheart neckline was extremely popular, and a princess-line cut made the most of limited fabric. Fitted bodices went down into a basque or peplum over the waist, and then flared out into a long skirt. Sleeves were usually long, with puffs at the shoulder and pointed cuffs. Lace trimmed the neckline, or was appliquéd to the bodice and sleeves.

Veils became shorter, falling to fingertip or elbow length. The mantilla-style headdress was still popular, as was a heart-shaped headdress, which echoed the sweetheart neckline of the dress. Some brides used the tulle veil itself as a headdress, gathering it into a ruffled halo, or tying it behind in a large bow.

For an informal or last-minute wedding, a fitted suit was considered appropriate, worn with a neat hat and short gloves. These outfits had the advantage of being suitable for wearing after the wedding – a necessary practicality for many wartime women.

Finishing touches

As women struggled to look good despite the war, accessories played a vital role. Where restrictions threatened choice and style, women became creative, coming up with imaginative alternatives.

One area that worried many was the supply of stockings. In the past only the bohemian or the very poor had gone without stockings – now women of all levels were faced with being unable to fill their stocking needs. Some overcame this problem by wearing socks or thick stockings – often home-made – which would last longer than sheer ones. Others, especially younger women, went bare-legged, using cosmetics or gravy browning to tint their legs, then drawing a line down the back to look like stockings.

Hats were not included in rationing laws, giving milliners the opportunity to produce large, flamboyant styles – but despite this, the prevailing fashion was for tiny hats that could be perched at a jaunty angle. For the many women who worked the land or in factories, a hat was not practical, and snoods, headscarves and turbans became chic. Gloves were still considered essential formal wear, although now they were more likely to be made from cotton or open-weave netting than from kid or suede.

The boxy, efficient lines of 1940s clothes needed softening, and costume jewellery was one area in which women could treat themselves without much expenditure. Large clip-on earrings and decorative

brooches gave a feminine touch to austere suits, while a simple string of pearls looked charming against a demure dress.

The forties meant ...

wide-shouldered jackets, fitted skirts, floral-print dresses, trench coats, hand-knit twinsets, platform shoes, pillbox hats, wide-legged trousers, narrow belts, snoods

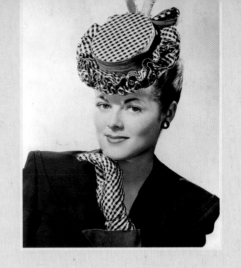

Adrian, Cristobal Balenciaga, Pierre Balmain, Marie-Louise Bruyere, Hattie Carnegie, Coco Chanel, Charles Creed, Jean Desses, Christian Dior, Norman Hartnell, Irene, Charles James, Mainbocher, Vera Maxwell, Edward Molyneux, Norman Norell, Elsa Schiaparelli, Victor Stiebel, Valentina

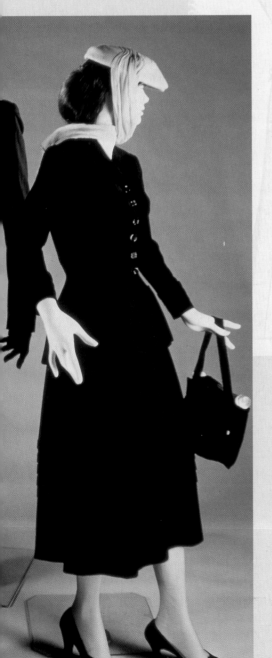

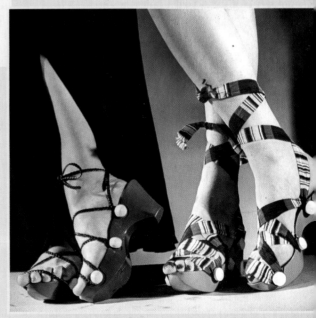

Dior's rediscovery of the feminine form (left), revealed in Paris in 1947, created a fashion sensation that carried well into the next decade.

The wedge and platform shoes of the 1930s, were adapted to rationing with soles made from cork or wood (right).

special occasion vintage

In times when life was more formal, even the poorest women had one special outfit, saved for events such as parties, dances and weddings. Evening dresses were treasured, both worn and stored carefully. Because of this, and because they were worn less frequently than everyday clothes, it's easy to find vintage occasion wear in good condition today.

Trudie's top tip

Make sure everything is balanced; if your dress is ornate, for example, choose simple jewellery, and vice versa. Don't clutter up your outfit with too many accessories. Special occasions are an opportunity to be glamorous, but don't pile it on to the point where you look like you've been dressed by a drag queen.

Wearing vintage clothing at a special occasion will make it – and you – more memorable. Imagine you're at a cocktail party, among a sea of little black dresses, and you're wearing a 1970s, scarlet, plunge-neck dress; who is the woman everyone will notice? Change the scene to a formal dinner dance, where all the women are in this season's gowns. In you sweep, in a 1930s, bias-cut silk gown, your train pooling out behind you; wouldn't you feel like the belle of the ball? Whatever the occasion, whether it's formal or informal, and whether you're the host or a guest, you can make it extra special by wearing something vintage.

Dressing the part

The vintage outfit you choose to wear will largely depend on the type of event and where it's held – some ideas are given in the box on page 68. But it's also a good idea to check with your host before making a final selection. Today, even formal events are much less formal than they were in the past. Your invitation may say "eveningwear", but if you turn up in a taffeta ball gown, only to find the other women in glitzy tops and jeans, you'll feel distinctly out of place. If you know the other guests, ask around to see what kind of clothes they'll be wearing. Adapt your outfit accordingly. After all, you want to stand out, but you don't want to be so overdressed – or underdressed – that you look like you thought the invite said "fancy dress".

Look for quality

If you're looking for something elaborate, you have to be prepared to pay a little more than you would for a modern equivalent. You're paying for a garment that is unique and is of the highest quality fabric and construction, perhaps with hand-sewn beading or integral boning for support. View a vintage dress as an investment: if you take good care of it, it will be with you for many more special occasions in the future.

The condition of the item is also important, because people will be looking more closely at your dress than they would do normally – you

Understanding the dress code

If you've ever looked at an invitation and wondered how smart "smart/casual" is or what exactly "black tie" means, this guide to dress codes will ensure you set the right tone.

Probably the least formal dress code you might see on an invitation is "casual". But don't take this too literally, bear in mind that you'd probably feel more comfortable at a party if you were slightly overdressed than if you looked like the poor relation. For just a hint of glamour, why not try a vintage sequinned or embroidered top with jeans or a skirt.

A slightly more formal code is "smart/casual". For men, this usually means a shirt and tie, so feel appropriately smart yet comfortable in a dress, skirt or smart pair of trousers teamed with a glamorous top. If you're going out straight from the office, jazz up your work wear with some jewellery and heels.

For more formal events, judge your dress code by the men's requirements. "Black tie" might appear on the invitations for formal parties, evening weddings and dances. For men, it means a dinner suit, dress shirt and bow tie, so think classy and sexy when choosing your outfit. A cocktail dress from any era would be ideal, worn with heels and perhaps a wrap. "White tie" is traditionally reserved for the most formal of occasions, such as banquets or balls. Men at such events will be wearing full tails and sometimes even top hats. For women, "white tie" definitely means a long evening gown – three-quarter length at shortest.

want them to look because they admire it, not because it's yellow under the arms from 50-year-old perspiration. Consider having the outfit dry-cleaned so that it's in pristine condition.

Feeling the part

Just as important as suiting your dress to the occasion is making sure that it's suited to you. If you feel comfortable with what you're wearing, you'll be able to relax and enjoy yourself. Don't ignore your instincts when you're choosing your clothes – if you feel awkward trying on an outfit in a shop changing room, you'll feel a lot worse in a room full of people. Special occasions are not really the time to try out a new image; stick to styles in which you feel confident.

Make sure it fits

Don't think that because you'll only be wearing a dress for a few hours the fit doesn't matter as much – if anything, it matters more. The last thing you should be thinking about on a special occasion is how much you want to unzip your dress because it's pinching so badly. And it doesn't look attractive if you're tugging it into place all evening because you're falling out of the bodice or it's too tight over your hips. Dancing, eating and getting in and out of cars all should be taken into account. That '50s cocktail dress might look amazing on, but if you can't sit down in it for fear of splitting the seams, be wise, and find another dress.

Be practical

It's never glamorous to shiver. If you're going to be outdoors, make sure that you have a shawl or a wrap to keep you warm. Think about the venue; if you are attending a garden party then a trailing gown and spiked heels may not be your wisest choice. Also take into consideration

Styles to suit: special occasions

ANNIVERSARY PARTIES: If you know a couple who are celebrating a golden wedding anniversary, what better opportunity for choosing a 1950s theme? A 1950s shift dress worn with modern accessories will give just the right touch of retro style.

WEDDINGS: Gorgeous flower prints and beautiful vintage hats look great at weddings – but be careful that you don't outshine the bride.

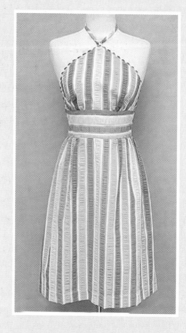

OUTDOOR PARTIES: Make the most of the opportunity to bare some skin, with strappy sundresses, daring mini skirts or funky all-in-one playsuits. Or, at a pool party you could play the part of a 1950s starlet with a ruched swimming costume and cat's-eye sunglasses. For a more formal garden event, picture sipping on Pimm's while wearing a floaty tea dress and a large, floppy hat.

BALLS: The perfect opportunity to dress up without feeling conspicuous, a ball is also a wonderful chance to use some of the lovely accessories that you can find in vintage shops, such as fans, feather boas or pretty headdresses – just not all at once. If you want to feel like a princess, the fabulous dresses of the 1950s are an appealing choice. Look out especially for beaded or sequinned dresses that will sparkle in the light as you dance.

INDOOR PARTIES: If you're feeling flirty, use your outfit to highlight your best features: great legs could be shown off with a 1980s Lycra dress; a seductive cleavage can be enhanced with a cowl-necked 1930s gown; while pretty shoulders show to good effect in a glitzy 1970s halterneck. However, don't wear anything too precious – it would be a pity if that original Balenciaga gown were ruined by one careless spill.

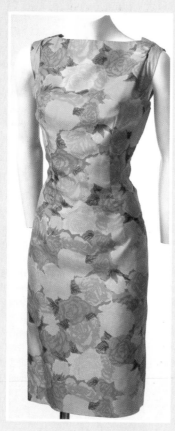

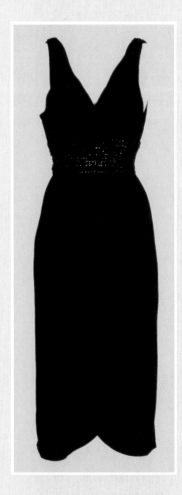

DINNER DATES: Use your outfit to tell your date about the sort of person you are. But be wary of going over the top on a first date – large, pouffy dresses are too reminiscent of wedding gowns. And don't be too kooky – you don't want him to remember your outfit long after he's forgotten your name. Think sleek, sophisticated and alluring. A little black number is always reliable, while colour can ensure a knockout entrance.

other people's feelings; a plunge-neck jersey dress may look fabulous for a wedding reception, but you will need to cover up if the ceremony is in a church.

Finishing the look

If the event is really special, there's no harm in giving yourself a dress rehearsal, doing your hair and make-up as you are planning to for the event. This might seem a bit over the top, but in the end you'll be glad you did it. You might discover that the shoes you were planning to wear look completely wrong, or that your make-up looks too bland for the dramatic style of the dress. And when would you rather find that out – now, when you can fix it, or just before you leave, when it's too late to do anything about it?

Recreating an authentic look

Teaming your vintage pieces with accessories from the same era, as well as suitable hair and make-up, can project a playful sense of style and will make you stand out in any crowd. For example, you might decide to create a 1960s outfit complete with towering beehive and vinyl boots. For a party, with a mix of friends and cocktails, this can make you look, and feel, like the funkiest girl there. However, there are times when the top-to-toe look needs to be toned down. At a more formal do, perhaps a corporate event, unless you replace the beehive and boots, you'll look more fool than cool.

In many cases subtlety is the best policy, and you can reflect the era's styles with just a hint of the appropriate hairstyles, make-up and accessories. For example, if you're wearing a 1950s outfit, a ponytail and a touch of winged black eyeliner is enough to bring the look into focus without it appearing too forced. Such careful dressing can still be fun, but also will ensure that your whole look doesn't overpower the beauty and individuality of your clothes.

a vintage wedding

Weddings are all about romance, and what could be more romantic than wearing a vintage gown, chosen by a happy bride decades ago? Whether you are planning a full-blown, no-holds-barred wedding, or you are looking for something a little more low-key, adding a vintage twist to your wedding will make it even more memorable.

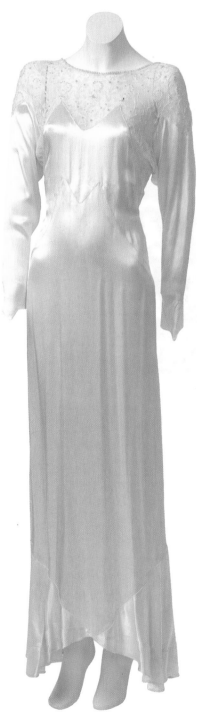

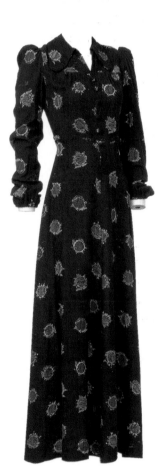

An Ossie Clark original (above) was a fashionable choice in the 1970s and would still flatter a modern bride.

Probably the most important – and the most enjoyable – choice you will have to make for your wedding is The Dress. Every bride is different: some want a traditional gown, some choose something more individual. Because vintage wedding gowns were only worn once, and were usually cleaned before being stored, you shouldn't find it difficult to find the dress of your dreams. Often you can find a beautifully crafted vintage dress at a much more reasonable price than its modern counterpart. Most vintage shops carry wedding gowns, and there are some websites that specialise in wedding apparel (see page 134). However, you don't have to restrict your choice to wedding gowns alone: vintage evening dresses and ball gowns can make wonderful wedding gowns, especially for a second wedding or for one located abroad.

The perfect dress

Unlike weddings of the first half of the 20th century, when dresses tended to follow the general fashions of the day, bridal "fashion" today is much more fluid, and women have a huge variety of styles from which to choose, including vintage. After all, if your dress doesn't conform to a passing fashion fad but flatters you in every way, you will still look great in your photos in 30 years' time, and not like a piece of fashion history.

Since you want to look your very best on your big day, the cut and fit of the dress are very

important, so go for a dress that will accentuate your assets. The general style guidelines on page 72 will give you an idea of what might suit you, but you'll only really find the right design by experimentation. And bear in mind that your options don't stop with dresses; you could set a smart tone in a classic, tailored suit or go for something sharp and funky with 1970s flares or hot pants. Whatever you choose, consider whether it complements your personality and the overall atmosphere you want to create on the day.

Whatever you go for, don't forget to be practical. You'll have a lot of running around to do, so you want to feel confident that nothing is going to pinch, slip or reveal too much. If you want to dance the night away, check that your outfit allows it. If you want a vintage-style dress but can't find the perfect fit, ask a dressmaker to create a modern version. If you don't have an actual dress to copy, look through books and websites on fashion history for inspiration.

Glorious accessories

Yesterday's brides carried more accessories than we do today, and originals, from prayer books to handkerchiefs, can bring a subtle touch of vintage to any wedding as well as that essential "something old". Alternatively, you might want to hunt for appropriate accessories to complete the look of a vintage dress. The special decade features give you an introduction to the bridal fashions of each era, and you can take your research further on the Internet or in fashion history books.

One accessory that most brides want to wear is the veil. If you are lucky enough to find a vintage veil in good condition, snap it up. Generally, old tulle is very fragile and most vintage veils have holes or tears. If this is the case, but you've just got to have it, take it to a dressmaker who may be able to copy the style, perhaps using parts of the veil you've found – no

one will ever know it isn't all original. If you can't find a vintage veil, don't worry; a simple tulle veil will go with most dresses.

If veils aren't quite your style, a vintage hat would be a lovely finishing touch. The hats of the 1930s and 1950s are especially suitable, as they are fairly small, but very pretty. Or look out for cocktail hats, which were often just a hair band or tiny skullcap, with feathers, netting or flowers attached.

Pictures of the era you have chosen may help your florist to make her contribution to the wedding as authentic as possible. Orange blossom, orchids and lily of the valley are some of the flowers that were popular for a 1920s bride, while bridesmaids often carried a loose bouquet of roses or sweet peas. Calla lilies or a neat nosegay of roses are the classic choices for a 1930s-style wedding. With a 1940s theme you could choose a bouquet of orchids or use a spray of orchids as a corsage. A 1950s-style bouquet should be small and neat, made from roses or tulips, trimmed with maidenhair fern. By the 1960s bouquets became much more informal; if this is your era of choice, ask your florist for a nosegay of daisies or carnations.

Whether you are in full bridalwear or a simple evening gown, vintage jewellery is another way of adding a touch of vintage charm to your outfit, Although pearls are the classic choice for weddings, many brides are now choosing diamonds – or diamanté – for a glamorous look.

Some of the other accessories on offer include shawls, parasols and garters. Stoles look luxurious at a winter wedding. Beaded bags are a lovely way of introducing a vintage look into your bridesmaids' outfits and make a handy thank-you gift for them, too.

wedding dress styles

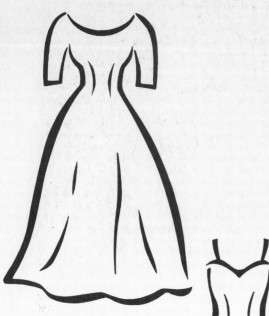

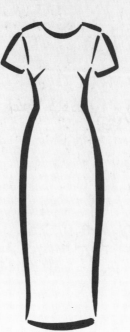

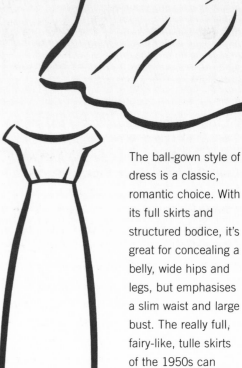

Fitted on top and flaring slightly to the hem, a princess line dress is good for concealing a large bust or hips. Many 1940s wedding dresses finished this shape with a sweetheart neckline and puffed sleeves for elegant effect.

An A-line dress or skirt suits most body types, but is especially good if you want to hide a thick waist or project the illusion of height. If you want to show off your legs, a shorter A-line mini from the 1960s can be sweet and quirky.

"Column" and "sheath" dresses are the straight up-and-down styles that were popular in both the 1920s and early 1960s. Most flattering to tall, slim girls, sheath dresses are perfect for a sophisticated, Audrey Hepburn look. "Fishtail" skirts are a figure-hugging variation on this style, tapering in around the thighs and flaring out at the hem. They're fabulous if you've got a flat belly and you're looking for something stylish and slinky.

Like the A-line shape but less flared at the bottom, the Empire line is good if you don't want anything too fitted. As the skirt starts at the bust, this style will flow around the body.

The ball-gown style of dress is a classic, romantic choice. With its full skirts and structured bodice, it's great for concealing a belly, wide hips and legs, but emphasises a slim waist and large bust. The really full, fairy-like, tulle skirts of the 1950s can make you look and feel like a princess.

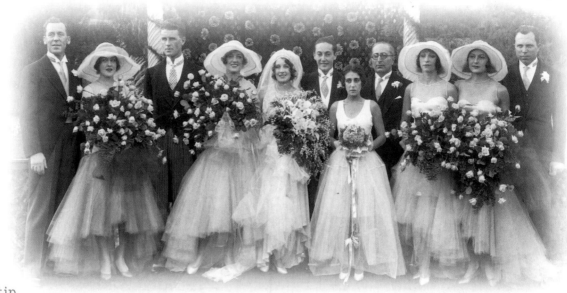

Trudie's top tip

Establishing a theme

Since you have so many other decisions to make besides that of what to wear – including choosing a venue, transport, flowers, menus, drinks and entertainment – going with a vintage theme for your wedding can make all these choices easier – and a lot of fun, too.

Choose the era that appeals to you most, perhaps one that has a personal significance to your family. If your mother or grandmother has a beautiful vintage wedding gown that fits you, this could influence the rest of your plans. An early 20th-century dress, for example, would look beautiful against the backdrop of a stately home, an old-fashioned church or an Art Deco hotel or restaurant. You could then pick up the theme with the drinks and entertainment, serving glamorous champagne cocktails accompanied either by Jazz Age music for a sophisticated Great Gatsby touch or a

bit of Cole Porter to get everyone on their feet. For a more relaxed wedding, why not choose a hippy theme; wearing a loose, late-1960s gown and flowers in your hair, you could get married barefoot in a beautiful garden.

If you want to extend the vintage theme to your guests, most will probably be happy to comply with a vintage dress code, and reluctant male guests only have to wear a smart suit to fit in with most eras. If you want your guests to dress in vintage clothing, bear in mind that the earlier the era you choose, the harder it will be for people to find the appropriate outfit.

Why not carry the vintage theme over into the wedding night by opting for a slinky vintage nightgown.

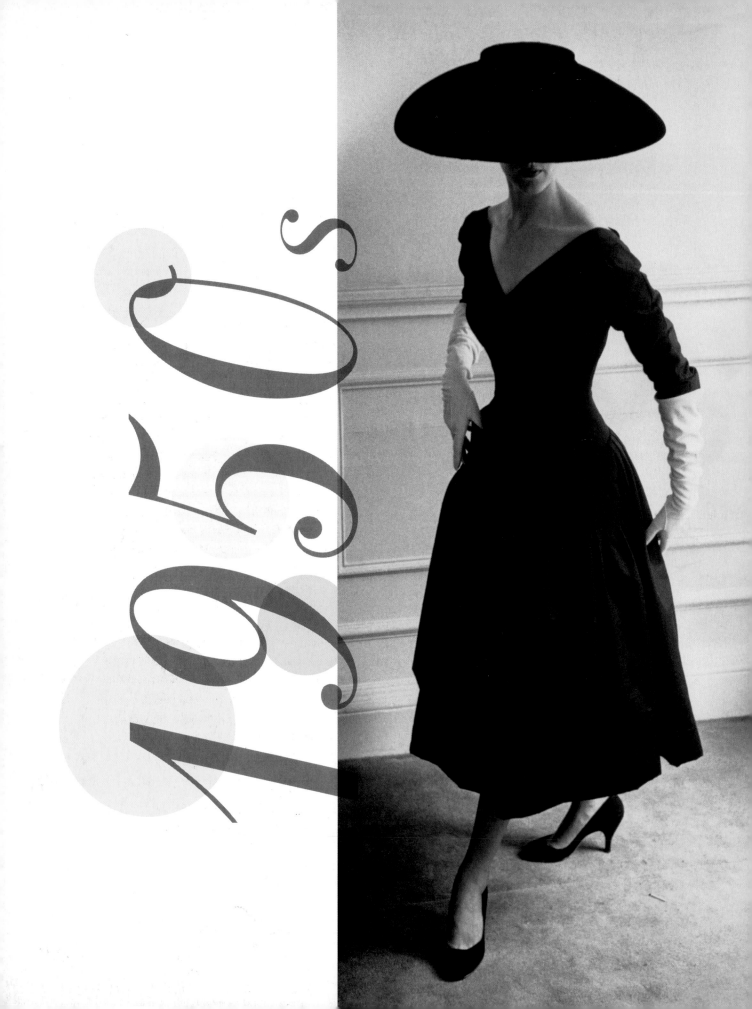

1950s

Return to glamour

The 1950s was a decade of hope, a decade that promised peace and prosperity for all. With global economies beginning to recover from the drain of war, people tried to forget the deprivation of the 1940s with as many luxuries as the new world could offer.

As society tried to recapture the security of a pre-war world, fashion took a rare step backwards. For decades women had enjoyed freedom of movement in clothes that reflected busier lifestyles; now designers took women back to the turn of the century with the boning, corsets and crinolines their grandmothers had rejected.

During the war years many women had been forced to wear utilitarian clothing, now they wanted to forget that, to re-establish their femininity. The new styles were delightfully impractical, they highlighted that a woman's place was not on the farm or at the factory, but at home, with no heavier responsibility than looking pretty for her husband.

The New Look had been introduced in 1947, when its creator, Christian Dior, said he wanted women to look like "flowers". As the 1950s progressed, women embraced the style enthusiastically. The hourglass silhouette became increasingly exaggerated, and fashion etiquette more and more detailed.

Daytime choices

As women stepped back into their roles as wives, mothers and homemakers, the focus of their wardrobes shifted from practical work wear to clothing that was as soft and pretty as the ideal woman. At home, women wore simple, button-through dresses or cotton dirndl skirts and blouses, in which it was easy to perform the household chores. They then changed into a fresh, daintier dress ready for when their husbands returned home from work.

Appearance was more important than ever, so formal daywear, worn for shopping, lunching or any form of business, was usually a tailored suit, fitted closely to the body, and almost always worn with a neat matching hat and bag, as well as wrist-length gloves.

For daywear, cotton was the favoured fabric, printed with anything from lusciously blooming

roses to fantastic scenery. Novelty prints were popular among younger women, especially when they were made into circular skirts, which were worn over crinoline petticoats to display their fullness. These skirts were sometimes made out of felt, and trimmed with fun, appliquéd designs, from poodles and Scottie dogs to telephones.

The twinset, a wardrobe staple for several decades, was revitalised with floral embroidery or beading, and made from cashmere, a luxury that was now available to most women. Perfect for daywear, the twinset was also useful for the evening, when a pretty cardigan could be slung over the shoulders for extra warmth.

As women had more time, and more leisure activities became possible, a range of clothes for recreational purposes became part of a woman's wardrobe. Halter-neck or strapless sundresses looked fresh and pretty at summer

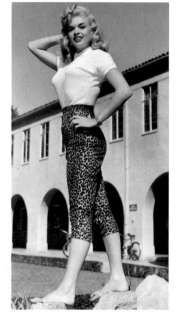

Jayne Mansfield models the "sweater girl" look in clinging knitwear.

picnics and barbecues; while younger women started to wear the Capri pants, shorts sets and sometimes even bikinis made popular by movie stars such as Sophia Loren.

Even when daywear was informal, underwear was not – the rigid bullet bra and confining girdle were worn every day to achieve the perfect hourglass shape. And waists were cinched even smaller with the help of wide belts.

Towards the end of the decade, designers started to get tired of the hourglass silhouette, and styles began to change. The shift dress, which had been worn fitted and sleek, began to get shorter and looser, losing some of its definition at the waistline. Prints became more abstract and stylised, while advances in fabric manufacture established a new range of man-made fabrics, which were easier to care for than their natural counterparts.

Teenagers started making their own fashion rules, breaking away from the twinsets of their mothers to a more rebellious style of their own. Denim jeans, tight pedal pushers and ballet flats marked a generation gap that was to culminate in the youth culture of the sixties. By the end of the 1950s, formal daywear was on its way out.

Evening style

In an understandable desire to forget the war years, women wanted to kick up their heels, to feel pretty and frivolous again – and designers responded with some of the most lavish garments of the century.

As prosperity increased, socialising was more popular than ever, requiring outfits to suit every occasion, from sophisticated cocktail dresses to grand ball gowns. Dressing appropriately was an important part of a woman's life; it helped her to

Daywear for most women was formal, but pretty prints and accessories could add a touch of femininity.

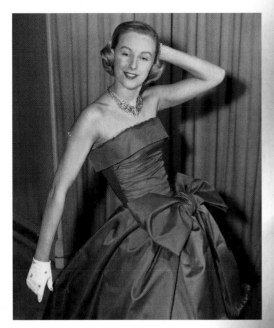

Few dresses are as extravagant as a 1950s ball gown; waists were tiny, while skirts and trimmings could be huge.

From the full, gingham skirts to ornately beaded eveningwear, the styles of the 1950s have an instant nostalgic appeal, which sums up this optimistic decade.

define the role she was playing. A busy housewife, caring for her family during the day, could be transformed into an alluring woman at night with the help of the right evening gown.

Because eveningwear was so important, women were prepared to pay more for it, and this is reflected in the amount of work that went into these sumptuous creations. Looking inside a 1950s ball gown you can see the care that went into its construction: the hand-sewn beading, the whalebone supporting the bodice, the layers of stiffening and petticoats that held the skirt out. The dresses are so beautifully made that it would be quite possible to wear them without a bra – although a 1950s woman would have been scandalised at the thought.

At the start of the decade, strapless dresses were popular and skirts were luxuriously full, ranging from the mid-calf styles of the cocktail dress to the floor-sweeping ball gown. As the decade wore on, designers began to experiment with draping and layers, producing dresses with sarong-style skirts or stiffened bell-shaped overskirts above a pencil-skirted dress. Straighter styles became more popular, ranging

from the va-va-voom of tight pencil skirts to the looser shift shape, seen in the late 1950s.

For eveningwear, fitted dresses were usually made from rich brocade, shantung silk or satin, and colours were rich and bold. "Illusion" dresses were also popular; these were made with a layer of lace over a flesh-coloured shell, for a dress that looked daringly revealing. For younger girls, pastel shades were considered appropriate, and layers of tulle, chiffon or voile created dainty, flower-like dresses.

Oriental influences can be seen throughout the decade, from the shimmering brocades used in so many evening dresses, to the cheongsam, a tightly fitted dress made from figured or embroidered satin, with a high, Mandarin collar and traditional frog fastenings. Bows were another favourite motif, trimming the waist, shoulder or hem. Intricate beading, sequins and rhinestones made even the simplest of dresses special.

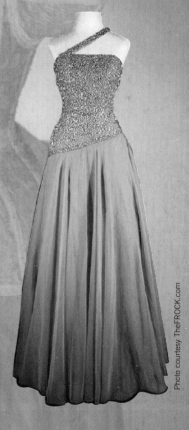

On sleeveless and strapless gowns, the bodice was often emphasised by beading or a contrasting panel.

For the fashionable bride

Most women want to look like a princess at their weddings, and the 1950s bride was able to do so, with the luxurious cuts and ornate decoration that characterise this period.

1950s bridalwear followed the feminine lines of the New Look, with a fitted bodice and waist, flaring out into a sumptuously full skirt. Corsets were used to achieve tiny waists, and layers of petticoats plumped out the skirts.

Strapless gowns were especially popular, and were often worn with a high-necked jacket for a more demure look. The ballerina-length dress became popular, especially when the skirt was made from layers of floaty tulle. Other dresses had full trains, for a more formal look.

Many gowns were made of silk or Chantilly lace, but man-made fabrics were also gaining popularity. Nylon tulle was light and airy, making it perfect for a fairy-like gown. Rhinestones, seed pearls and beading were used as decoration in floral or bow designs.

Veils were still short, around elbow length, and attached to cap-like headdresses or tiaras. A matching tulle stole could be worn around the shoulders over a strapless dress.

Bridesmaids' dresses were usually calf length, in the classic 1950s bell shape. They were often made with lace – in pale blue, pink or yellow – and designed to be used as an evening gown after the wedding.

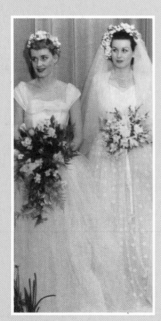

Finishing touches

From the formality of a daytime suit, to casual beach wear, accessories played a key role in 1950s style.

There was a hat to suit every occasion, from lavishly trimmed picture hats to the primmer pillboxes. And no lady went anywhere without her handbag, whether that was a quirkily painted wooden box bag or an expensive leather bag that matched her shoes. In line with the feminine fashions, shoes became daintier and higher, with the quintessential stiletto heel creating havoc with feet and floors alike. Sunglasses became part of every glamorous woman's wardrobe, teamed with an elegant headscarf for daywear.

Ornate eveningwear required striking jewellery. It was fortunate, therefore, that advances in costume jewellery manufacture enabled women to accessorise with "diamonds", whatever their budgets. Long gloves, in soft kid or cotton, were worn with evening dress. Tulle or organza wraps were draped around bare arms and shoulders, while fur stoles were the height of sophistication. Another style, popular towards the end of the decade, was the opera coat, a loose-fitting, three-quarter-length coat in satin or brocade, worn over a matching dress. Evening bags were sleek in shape, with beading or sequin embellishment echoing the lavish evening gowns.

Grace Kelly was an icon of fifties sophistication.

The fifties meant …

printed cotton circular skirts, fitted suits, beaded cardigans, halter-neck dresses, Capri pants, opera coats, cat's-eye sunglasses, silk print headscarves, stilettos

Circular skirts were perfectly suited to the new rock and roll dancing.

hardy amies, cristobal balenciaga, pierre balmain, hattie carnegie, coco chanel, christian dior, jacques fath, hubert de givenchy, charles james, mainbocher, norman norell, adele simpson, frederick starke, victor stiebel, pauline trigère

large and tall

Body size has changed over the years, and today's women are bigger in every way than earlier generations. Unfortunately, this means that the vast majority of vintage clothing comes in small sizes – fantastic news if you're petite, but not so great for the rest of us. If you're over 5 foot 6 (1.68m) and larger than a size 14, this section will help you find vintage clothing to fit you.

Healthy eating and a kinder living environment have contributed to this change in body shape and size; women in the 21st century are stronger, taller and more curvaceous than ever. Ask around your younger female friends and family members – how many of them have a 24-inch (60-cm) waist? Now ask your mother's or your grandmother's generation. Many of the women from these generations had waists that measured not much more than a hand-span, even without the help of corsets. This means that a lot of the vintage clothing that you see in shops and on websites will be small, especially items from the first half of the 20th century. But this doesn't mean that only the petite can enjoy wearing vintage clothing – if you love the styles and the quality of vintage, then you can wear it, no matter what your size.

Do you have a height advantage?

When models are quoted as saying that they dress in vintage all the time, it makes you wonder where they could be getting their clothes from. Do they have some secret sources of vintage clothes for the six-footer?

Shop, shop and shop some more

If you are tall, you may have felt the disappointment of finding a beautiful 1960s bouclé coat, only to discover that the sleeves finish a long way from your wrists; or you may know the frustration of trying on a pretty 1950s dress only to find the waistline hovering around your ribcage. There really isn't an answer to this problem – except more shopping. The more clothes you can browse through, the better your chance of finding some that fit.

Try some gender bending

If you're long limbed it can be well worth checking out the men's department. Some of the garments that tall women struggle to find in their sizes can be found in men's vintage – wide-legged trousers, T-shirts, jeans, coats, shirts and jackets, they're all there, and they will all fit. Don't worry about the clothes looking too masculine; often men's designs look better on women than our own clothes. And you can easily feminise them with the rest of your outfit – for example, you could try wearing a crisp man's shirt tied over gingham Capri pants, or vintage sailor's bell-bottoms teamed with a strappy top and high-heeled sandals.

Don't forget that while tall women might have to work a bit harder to find vintage clothes that fit them – if you can call shopping "work" – there are also advantages to being taller than the average woman. As model requirements show, many styles look best on leggy women, and tall girls can carry off more dramatic colours and prints than their shorter sisters (see box, opposite).

Trudie's top tip

Make sure that you check the seam allowances on clothes, especially on hems. Thrifty women in the past sometimes left generous hems on skirts and dresses for future alterations, and that extra couple of inches might be just what you need.

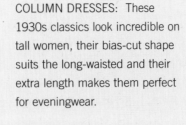

DRESSES OVER TROUSERS: Mini dresses and some cheongsams may be too brief for most tall women, but if you really love them, wear them over jeans or trousers for a funky look.

COLUMN DRESSES: These 1930s classics look incredible on tall women, their bias-cut shape suits the long-waisted and their extra length makes them perfect for eveningwear.

RAH-RAH SKIRTS: These fun 1980s designs were made for long legs. Finish off the look with a vest and a pair of sexy boots.

CAPRI PANTS: Shorter trousers look elegant on longer legs, so if you find your perfect trousers, but they aren't quite long enough, crop them to calf length.

FITTED SUITS OF THE 1950s: The skirts of these suits were intended to be mid-calf length, which will be knee length on taller women. And the style was for bracelet-length sleeves, so it won't matter if the sleeves fall short of your wristbones.

MAXI SKIRTS: These are a godsend to the tall woman, who can wear them with panache. Maxi coats are also ideal, as long as the sleeves are long enough.

ANYTHING WITH A PRINT: Wear prints with panache; your height means that patterns won't overwhelm you. From huge 1950s polka dots to psychedelic patterns, have fun playing around with the designs that appeal to you.

PONCHOS: Petite women can look swamped by a poncho, but the tall can carry them off. With these fun alternatives to vintage coats, there's no sleeve length to worry about.

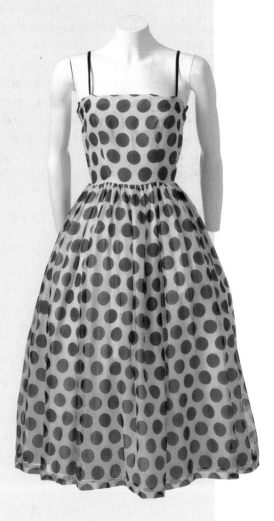

Styles to suit: curvy women

1950s CIRCULAR SKIRTS: Highlight an hourglass shape with a circular skirt and a fitted top, worn with heels to slim the legs. Fitted shift dresses from this era can also be very flattering, especially those made from heavier cotton or wool.

1960s MINI DRESSES: These groovy, psychedelic designs look cool worn over jeans, and have the advantage of camouflaging the common problem areas of bottom and thighs.

PEASANT STYLES: Romantic tops and skirts can look seductive, but don't go baggy from top to toe. A loose peasant top looks great with jeans or a slim denim skirt, while a tiered, hippie skirt looks good with a fitted vest and denim jacket. Avoid kaftans, unless you fancy the older Liz Taylor look.

FLARED TROUSERS AND A-LINE SKIRTS: Wider hems balance out a heavier figure, especially when worn with heels.

CHIFFON TEA DRESSES: These pretty styles of the late 1930s and 1940s are great if you want to show off delicate ankles. Make sure that there is some definition at your waist, a sash or a belt, for the best look.

SLINKY JERSEY DRESSES: These late 1970s and early 1980s classics skim the curves of the body and create a lean silhouette. Choose a dress that highlights the parts of your body you love: for example, if you have pretty shoulders and décolletage, wear a halter-neck dress, or, if you want to show off great legs, choose a salsa-inspired dress.

SHIRT DRESSES: These are flattering, and can look smart or funky, depending on how you wear them. Team a short shirt dress with a pair of smart black trousers and heels for office wear, swap the trousers for jeans, and add a striking belt and sandals for a more casual look.

VINTAGE SWIMWEAR: Many costumes are designed for a womanly figure, particularly those from the 1950s. Choose a stomach-flattening swimsuit with clever ruching for a slimming look, and finish off with a vintage sari or shawl, tied sarong-style.

LONG-LINE VINTAGE JACKETS: Styles that finish below the bottom create a sleek line over dresses and trousers, from the funky Afghan to an embroidered opera coat.

Do you have voluptuous curves?

Despite the fact that larger vintage is harder to find than small vintage clothes, it's good to bear in mind that there was a far healthier attitude to women's shapes in the past, with little, if any, pressure for women to fit into a certain size. The women who were role models, such as Marilyn Monroe or Betty Grable, were lauded for their beauty and their womanly shapes, not for the fact that they could wear size 6 jeans. Wearing vintage can help women to avoid falling into the trap of today's size-oriented society, perennially dissatisfied with their bodies, striving for someone else's idea of perfection. Vintage garments often have no size labels, because dressmakers and manufacturers were creating clothes for individual shapes and sizes, instead of expecting women to fit into certain ranges. Wearing vintage can encourage women to make clothes work for them, instead of working to fit into their clothes.

Speak to your seller

Most shops have larger-sized vintage tucked away among the piles of clothes, and there are even a few websites that specialise in larger sizes (see page 134). Have a chat with a friendly seller, she may be happy to put clothes in your size on one side as they come in, providing that you visit – and buy – regularly and ask very nicely.

Be flexible

One problem that you may find is that much of the larger-sized vintage clothing was made for older women – the cooler clothes tended to be worn by young women and girls, who are naturally thinner. But with some adaptations, you should be able to find what you want; it just takes a little effort. Separates is the best area in which to look, as the fits may be more flexible and they can easily be integrated into your own wardrobe. And make the most of the accessories department – vintage sunglasses give film-star style, scarves can be tied at the

neck, wrapped round the head, or worn as a sash belt, and a cute hat draws attention to a pretty face, whatever your shape or size.

Are you a mum-to-be?

If you love wearing vintage clothes, why should you stop when you're pregnant? The range of styles is perfect for the changing shape of a pregnant woman, and, as recent celebrities like Sarah Jessica Parker and Kate Moss have shown, vintage can keep a woman feeling glamorous throughout her pregnancy.

However, you shouldn't waste your time looking out for vintage maternity wear – there is very little of it on the market, and it does err on the side of the tent-like rather than the stylish. Focus instead on adaptable shapes and designs that will be comfortable to wear, and look for larger-sized clothes. Stick to natural fabrics if you can, and choose styles that can be incorporated into your postnatal wardrobe. Here are some flattering designs to look out for:

WRAP DRESSES: These flexible friends are a wonderful choice for pregnant bodies, as they are so easy to wear, and will grow as you do. The stretchy jersey designs of the 1970s are good for when your bump gets bigger, and the plunging necklines make them a seductive choice for eveningwear. Or you could wear a wrap dress over a pair of jeans, on which you can undo the top button and no one will know.

BABY-DOLL STYLES: These funky dresses will easily accommodate a growing bump. Team a groovy, 1960s baby-doll dress with black, jersey trousers for an easy day-to-night look. However, avoid strapless baby-doll dresses, as these can make your maternally enhanced breasts look like an overstuffed sausage.

SEPARATES: This is another great area to investigate. Exotic, embroidered jackets and coats can jazz up anything from a basic black maternity dress to jeans. Or drape a pretty 1950s beaded cardigan over your shoulders, add some kitten heels and feel like a movie star. If you like the romantic look of tiered peasant skirts, try to find one with an elasticated or drawstring waist and you'll be able to wear it throughout your pregnancy.

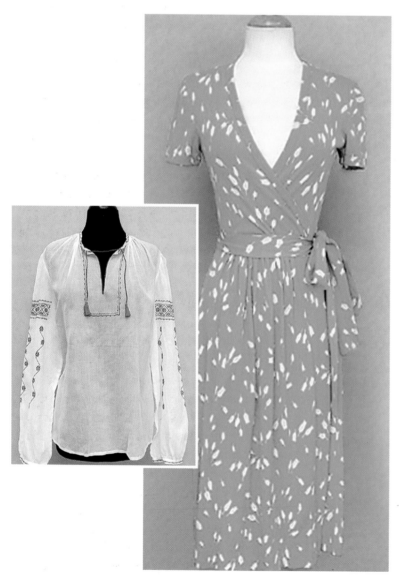

With its huge range of styles the 1970s is a great decade for mums-to-be, including loose peasant styles and sexy Diane von Furstenberg wrap dresses.

alteration dos and don'ts

Next time you're out shopping, take a look at one of the shop mannequins. They are model slim, perfectly proportioned, with an ideal figure, you might think. But take a closer look; not at the model, but at the outfit it's displaying; more than likely you'll see plenty of pins.

However "perfect" your figure, clothes usually need to be adjusted if they are to fit well and flatter the body, and, in the past, when most clothes were made-to-measure, this is something that women understood and appreciated. Even on mannequins, clothes need to be pinned, gathered and pegged for them to look their best. And if that's the case with an inanimate, size-10 dummy, imagine how much more necessary it is for flesh and bone people – and let's face it, many of us are more flesh than bone.

The rights and wrongs of alteration

Nowadays, few women think about having clothes altered for their personal needs; they just buy a garment in the size that is closest to their shape and hope for the best. Few have ever experienced an outfit that fits perfectly, so they don't know what they're missing. When you put on an outfit that fits well, you feel fabulous: confident, comfortable and downright gorgeous. When you put on an outfit that fits badly, you'll probably look in the mirror and wonder why you are so fat/short/bony in all the wrong places. Well, it's not your body's fault, it's the clothes. Clothes are supposed to fit you – not the other way around. Try this experiment: slip on a dress that looks great on the hanger but doesn't look quite right on you; take a box of pins, and try pinning, tucking and folding it. You may need to alter the dress only a fraction here and there for it to suit your shape and look good.

But what about altering vintage clothing, is that allowed? Or is it wrong to make changes to a piece of history? That depends on whose perspective you consider. A collector might say, "Yes, it is absolutely wrong to make any changes to a vintage garment, as it devalues it." Someone who buys vintage to wear would say, "No, it's not wrong to make alterations if it means you'll be able to wear the clothes and give them a new lease of life."

When it's too small...

All too often when vintage shopping you might spot your dream dress/skirt/coat only to discover that it's just a bit too small when you try it on. Of course, if you didn't breathe the

whole time you were wearing it, then you might be OK ... Well, there is another option – letting it out. When you're deciding whether to buy the garment, the first thing you need to do is check the seams. If there is a generous extra seam allowance, try to judge how much you need a seam to be let out and if there is enough fabric there to allow for it. The smallest seam allowance you can have is about 1 cm (½ inch), so take that into consideration. You need to check also if the fabric inside the seam is the same colour as the fabric of the dress, as it can sometimes be a little brighter or darker. If there is enough fabric, and the colours match, the garment is probably suitable for alteration.

Adding length

If the issue is that a garment is too short rather than too small, perhaps in the skirt length or the sleeves, you have a bigger problem. Some skirts and dresses have deep hems that can be let down. Or if the hem is fairly shallow, you may be able to add a false hem, which is a strip of fabric that you attach on the inside edge of the existing hem to give you more of a hem allowance. However, you need to make sure that the fabric you let down looks in good condition – not just where the fold was or where the fabric might have faded, but also with the stitching line. With some fabrics, like silk, the stitches make distinct holes, and when you let a hem down these holes show. If this is the case, there is little you can do to lengthen the garment, except perhaps sew on a contrasting border of fabric – an idea that works occasionally, but can look strange on some garments.

You are unlikely to be able to lengthen sleeves, especially if they are lined, so unless the style allows you to shorten the sleeve further – to bracelet or upper-arm length – there is little that you can do.

When it's too big ...

Although it can be gratifying to try something on and discover that it's too big, sometimes it can be very frustrating, particularly if you are petite and everything trails on the ground. Unless you have a perfectly proportioned figure – and is there really anyone out there with the "ideal" 34–24–34 statistics? – you may find that in order to get good fit in one area you have to suffer gaping in another. Perhaps you are pear-shaped, and trousers that fit your hips and bottom are huge around your waist. Or maybe you are top heavy, and a dress that fits your upper half swamps the rest of you. These are all areas where altering clothes can help; it's much easier to fix something that is too big than something that is too small.

Cutting length

One of the easiest problems to solve is skirts, dresses and trousers that are too long. As long as the waistline is in the right place, all you need to do is take the hem up. Similarly, you can easily take up sleeves that are too long – although if they have special shaping at the cuffs you may need expert help in order to keep the style in proportion.

Taking in

If a garment fits you everywhere but one area, for example around the waist, taking it in along the seams here should remedy the problem. However, this is harder than it sounds, especially in very fitted garments, so unless you are experienced in dressmaking, you may be better taking the item to a professional.

One area that is very difficult to alter is the area around the shoulders. If the garment is unstructured, for example a soft dress or blouse, an expert may be able to take the sleeve out and set it in further, which will make the shoulders narrower. But if the garment is more structured, for example a jacket or coat, and especially if it has shoulder pads, altering it will be very difficult, and may ruin its shape.

Trudie's top tip

If you've bought vintage knitwear that is too big, some might suggest that a hot wash and a spin in the tumble dryer will do the job. But don't be fooled – you're very unlikely to end up with a wearable garment that fits you properly, and much more likely to end up with a tiny, matted mess.

How to ... alter a hem

1 Gently unpick the existing hem. Use a pin or needle to lift a stitch and cut through the thread using sharp scissors. Be careful not to snip any of the fabric accidentally. Alternatively, use a special seam-ripping tool.

2 Try the garment on with the appropriate shoes and belt, if necessary, and do up all the fastenings. Ask a friend to mark the hem length you want by placing an even line of pins all around the garment. Keeping your line of marker pins in place, pin up the excess fabric on the inside to check that the length is correct. Adjust the line of marker pins, if necessary. Still keeping the marker pins in place, let the excess fabric down and remove the garment.

3 Lay the garment on a flat surface. Fold up the excess fabric on the inside of the garment so that your marker pins are positioned along the new hem edge. Use a running stitch to tack the hem in place all the way round. As these stitches will be removed once you've sewn the hem properly, this can be done quickly and loosely. Remove the pins, then, using the hottest temperature that the fabric allows, iron the folded edge of the hem for a neat and even finish. Trim the excess fabric to within 2 to 8

cm (1 to 3 inches) of the hemline – you need less for fine fabrics or flared hems.

4 Next, finish the raw edge of the fabric to prevent fraying. For many fabrics, you can simply "overcast" the edges by machine or hand. To do this by hand, place a line of small, evenly placed diagonal stitches on the edge of the fabric, as shown in the diagram.

5 Finally, to sew the two pieces together, roll back the finished edge of the hem with your left hand and hold it in place as you sew with your right hand – vice versa if you're left-handed. Sew around the hem by making a small horizontal stitch in the garment and then a larger horizontal stitch in the hem. When making stitches in the garment, pick up only a few threads of the fabric so that the line of stitching is almost invisible on the outside. Your stitches should look like those in the diagram right. Repeat these stitches all the way round the hem. Once you've sewn all around the garment, you can remove your tacking stitches. Press the hem again, if necessary.

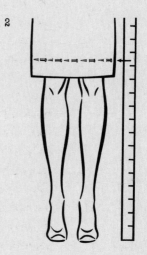

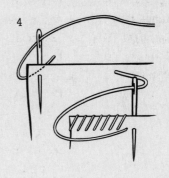

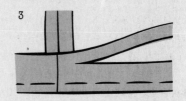

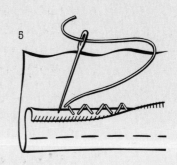

When it's too dowdy ...

Clothing alterations don't have to be restricted to garments that don't fit – sometimes the style might need a little tweaking. For example, you might see a gorgeous 1960s dress, all metallic psychedelic pattern and Mod design; it's got the scooped-out neck, it's got the bell sleeves, it's got glitz and glam, but it's also got a floor-length skirt, which makes you look more frump than fox. But if you shorten the skirt to knee length – or better still, thigh length – the dress will look fresher, more modern and maybe more you.
Or perhaps you have spotted a perfect 1950s dress, with fat cabbage roses sprawling over a polished cotton background – and it fits. But it has ugly elbow-length sleeves, and you want a cooler look. Take off the sleeves and reshape the armholes, or even better, take the dress to a professional and get him or her to make it into a spaghetti-strapped or strapless sun dress.

Seeing vintage garments from this point of view opens up a lot more choice. Rather than being restricted by size or shape, or searching for the perfect garment, you'll be able to browse more generally, and expand your vintage wardrobe. However, there are some warnings you need to keep in mind. There will be times when much as you want to have a garment altered, it's not a good idea. If one of the points in the box, opposite, applies to your garment, alteration is not the solution, shopping for a better fit is.

Should you do it yourself?

If you do decide to alter a garment, you need to decide whether to do it yourself or recruit the help of an expert. Unless you are a very proficient seamstress, it is usually best to get expert help – if you mess up the job your beautiful garment may be beyond reclamation. Simple jobs like taking up a hem can be done

at home easily if you have sewing experience, but more complex alterations should really be left to a professional.

To find a good professional, ask around; perhaps at the vintage store where you bought your garment or at your dry-cleaner's. When you find a good clothes repairer, be sure to ask about his or her experience and liability policies; if your delicate blouse falls apart at the first cut, you need to know whether he or she will cover the cost of replacing it, or whether it's your loss. Do take professional advice regarding alterations, as the experts know more about what is possible, and what is advisable, than you do. Whatever you decide, do be quite sure before you purchase an item that it is worth the effort and cost of making the alterations, and that you will get around to doing it. Unworn garments sitting forlornly in the back of a wardrobe are just a waste. Be realistic when considering a garment for alteration, and in return you will have a wardrobe full of clothes that look as good on you as they would on a mannequin – and not a pin in sight.

Five alteration no-nos

1 You can't take in something that's far too big: if an item of clothing would need to be taken in all over, it's best not to embark on alterations. You would be completely changing the shape of the dress, which is rarely worth it, and could ruin it.

2 Likewise, you can't do much if it's far too small: letting out all the seams may not be successful and may spoil the lines of the garment. Also, shortening or taking in a garment that is made from leather or suede is beyond the skills of the average seamstress. It may be possible if done by an expert, but letting out seams will usually leave a distinct line where the original seam was.

3 Heavily beaded or sequinned items can be tricky to alter: the beading or sequins may not be individually sewn, but sewn on with a continuous thread. If you cut the thread you will end up with a garment with bare patches and a floor covered in glitz. Taking seams in can result in bulky seams, and letting them out will bare fabric with no beading or sequins.

4 Some fabrics don't respond well to alterations: velvet tends to wear evenly all over the outside of a dress, but if you let out the seams or take down the hem, you will almost certainly have a portion of velvet showing that is a different colour or pile. Handmade lace quickly unravels if it is cut, as do crocheted pieces and hand knits. This doesn't mean that these fabrics can't be altered, but extra thought and care must go into it.

5 Don't alter a garment that's truly iconic: if you have a Warhol paper dress, a vinyl Quant tunic or a sweeping Schiaparelli gown, think twice before making drastic alterations. These sorts of items are an exception to the rule of wearability, and whoever owns them has a responsibility to preserve them in their original condition, as far as possible.

1960s

mini, midi, maxi

This was a decade of change, of revolution and progress. The post-war baby boom had created a new generation, and, as the 1960s progressed, this generation came of age and found its voice. No longer were teenagers willing to be younger versions of their parents; they wanted to break free, to be different, and this was reflected in the fashions, the music, even the language they used.

The older generation, used to the manners and formality of the squeaky clean 1950s, were confused and shocked. Their generation had worked hard to establish moral standards, to value the family, fear God and be fiercely patriotic – now their children were rejecting established society, questioning adult values and creating their own world, where freedom ruled. As society became more affluent, teenagers had money to spend on clothing, cosmetics, records or whatever they wanted. The fashion industry was quick to respond to this trend, creating small boutiques designed to appeal specifically to the young, with the latest clothes on the rails and the latest records blaring from loudspeakers. This made clothes-shopping into a form of recreation, and the boutiques became as much a place to socialise as the coffee shops and dance halls.

When the mini skirt appeared in the early 1960s, the reactions it provoked sum up perfectly the gap that was widening between the generations. Older people were outraged; the mini represented a slide in moral standards in a world they no longer understood. But the younger generation gleefully welcomed the mini as a symbol of freedom; it made them feel empowered and progressive. Youth reigned supreme and, as the decade progressed, fashion followed its lead.

The fashions of the 1960s retain a sense of fun and freshness, making them a fantastic source of clothing for vintage dressers. There are plenty of styles to choose from, and mass production means that there is still a good selection of 1960s clothes to be found today.

Daytime choices

By the end of the 1950s designers had already turned away from the ultra-fitted styles of earlier years to a looser A-line shape, and this was the shape that was to dominate the 1960s. The silhouette was triangular, with waistless dresses flaring out into short skirts. Coats were Empire line, with small

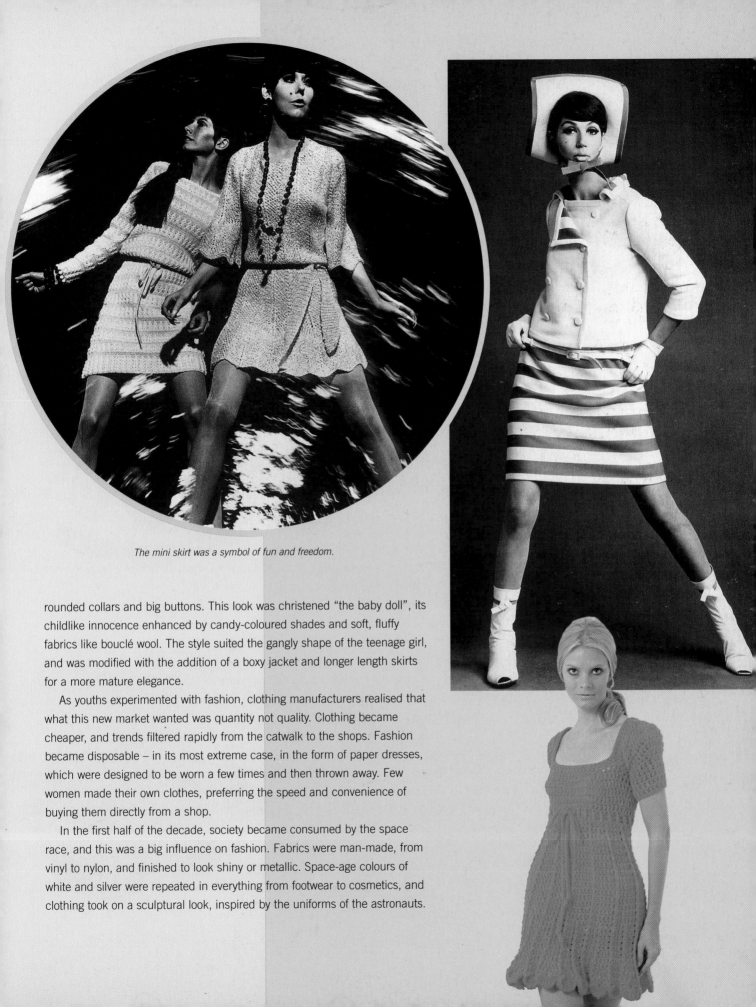

The mini skirt was a symbol of fun and freedom.

rounded collars and big buttons. This look was christened "the baby doll", its childlike innocence enhanced by candy-coloured shades and soft, fluffy fabrics like bouclé wool. The style suited the gangly shape of the teenage girl, and was modified with the addition of a boxy jacket and longer length skirts for a more mature elegance.

As youths experimented with fashion, clothing manufacturers realised that what this new market wanted was quantity not quality. Clothing became cheaper, and trends filtered rapidly from the catwalk to the shops. Fashion became disposable – in its most extreme case, in the form of paper dresses, which were designed to be worn a few times and then thrown away. Few women made their own clothes, preferring the speed and convenience of buying them directly from a shop.

In the first half of the decade, society became consumed by the space race, and this was a big influence on fashion. Fabrics were man-made, from vinyl to nylon, and finished to look shiny or metallic. Space-age colours of white and silver were repeated in everything from footwear to cosmetics, and clothing took on a sculptural look, inspired by the uniforms of the astronauts.

Designers such as Paco Rabanne took a completely new approach to clothing design, using discs of plastic or metal to create futuristic shift dresses.

In a decade obsessed with youth, young designers had more influence over the trends than long-established designers. In their desire to push back the boundaries, these designers experimented with more and more daring designs. Dresses were made with strategic cut-outs, or plastic rings joined the bodice to the skirt. Transparent fabrics, such as chiffon and vinyl, were made into blouses and dresses, designed to be worn with very little, if anything, underneath. The bikini, once a source of outrage, now seemed modest in comparison to the appearance of topless swimsuits on the catwalk. Although most of these designs were too extreme to become mainstream, they did influence trends, encouraging women to show off their bodies.

This look was christened "the baby doll", its childlike innocence enhanced by candy-coloured shades and soft, fluffy fabrics.

As the 1960s progressed, there was a backlash against consumer-led society, and the hippy movement began to hold sway. Clothes became more romantic and the fabrics natural, with synthetics being rejected in favour of cheesecloth, cotton and denim. Hemlines dropped, from the conservative midi-length to the floor-sweeping maxi. Clothes became prettier, with a handcrafted look, and crocheted dresses, heavily embroidered or appliquéd jeans, and hand-painted jackets created an ethereal look for the ultimate flower child.

Experimentation with drugs such as LSD led to the creation of intense psychedelic prints. In their most luxurious form they appear on the clothing of Emilio Pucci, who created swirling prints in silk jersey for his designs. The emphasis was on being individual, and by the end of the 1960s, there were so many contrasting trends that women could choose whichever one appealed most, rather than conforming to one set style.

Swirling patterns, influenced by experimentation with drugs, characterise the late 1960s

Evening style

The 1960s marked the end of formal eveningwear: as people's lifestyles changed, there was no longer such a need for evening clothes. Television had replaced socialising as the popular source of entertainment, and few changed out of daywear into something special unless they were going out to a formal event. In the very early years of the 1960s, older women wore the sophisticated designs portrayed in films like *Breakfast at Tiffany's*, but young girls wanted to look cool, not elegant, and the sleek style faded away.

Most eveningwear from the 1960s is similar in cut to the daywear, with shorter skirts and a waistless shape. The eveningwear was characterised by more daring details, such as sheer panels in dresses, or by eye-catching colours or fabrics, like metallics or chain mail. A simple shift dress was lifted out of the ordinary with the addition of a beaded border around the neck or hem. Chiffon baby-doll dresses, little different to nightwear, were worn over contrasting coloured slips. Designers also experimented with dresses that had flashing lights as part of their design, or outfits made from fabrics that were luminous in the dark – perfect for nightclubs and parties.

One interesting development in eveningwear towards the later years of the decade was the adoption of the trouser suit as a glamorous alternative to a dress. From the seductive tuxedo styles of Yves Saint Laurent to heavily embellished silk palazzo pants and tunics, trousers made a striking and exotic evening look.

The hippy culture at the end of the 1960s saw a return to the romantic styles of the past. Fluid chiffon was cut into ruffled and flounced dresses, with bell sleeves and low-scooped necks. Eveningwear became longer and more luxurious, glamourising daywear details like crochet with metallic thread for an opulent look. The inventive resurrected the dresses of previous eras for eveningwear, rediscovering slinky, bias-cut satin gowns, lace-trimmed petticoats or silk pyjamas.

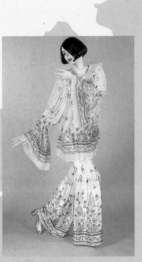

For the fashionable bride

Early 1960s bridal fashions were elegant and simple, relying on cut rather than embellishment. The style was princess line, with vertical seams for a flattering look, and this put less emphasis on the waist than in the previous decade.

A sleeveless sheath would be worn with a chic, matching coat, which could be taken off for the reception. Practical brides chose gowns that could be dyed after the wedding and worn again. Dresses were usually ankle length, and a mid-length veil was worn, with a Juliet cap headdress sitting neatly on top of an elaborate hairdo.

As the 1960s progressed, and the younger generation rejected the formality of the past, wedding gowns became less conventional and more governed by fashion. The mini dress was the choice of the hip bride, who wore it with matching white boots. Dresses looked young and girlish, trimmed with appliquéd daisies, or made entirely from crochet. The waist became Empire line, sitting just under the bust, then flaring out into an A-line skirt.

In the late 1960s long dresses became fashionable again; these were loose and flowing, with ruffled hems and sleeves, and were made from natural fabrics, such as cotton or voile. A scooped neck and bell-shaped sleeves were other features of the typical late-1960s bridal gown.

As weddings became less formal, veils lost their popularity, especially for the mini-skirted bride. Large floppy hats became popular, while the late-1960s hippy bride wore a simple wreath of flowers in her hair.

Finishing touches

As with clothing, the majority of 1960s accessories have a youthful, experimental feel to them. From PVC handbags and go-go boots, to the huge floppy hats of the hippies, accessories were eye catching and fun. While older women carried on the chic 1950s styles, with neat pillbox hats, clutch bags and short white gloves, younger women didn't have time for such formality. If they wore a hat or carried a bag, it was because it looked groovy, not because etiquette demanded it.

Flat, Mary Jane shoes gave the finishing touch to the baby-doll look, while chunky boots were hugely popular, balancing out the leggy look of the mini skirt. The mini skirt made stockings impractical, and tights took over, becoming an outfit feature of their own, with bold, primary colours or prints. Bags were whimsical and fun, carried more to complement the outfit than as a practical item.

Jewellery lost its popularity for most of the 1960s: when it was worn it was chunky and costume – plastic bangles, hoop earrings and novelty rings. But towards the close of the decade the interest in ethnic styles brought "real" jewellery back into fashion, with silver and semi-precious stones making the perfect complement to the hippy clothing styles. The romantic eveningwear of the late '60s called for glamorous jewellery, and chandelier earrings and necklaces matched the vintage styles.

hardy amies, biba, marc bohan, jean bouquin, pierre cardin, cassini, ossie clark, courrèges, givenchy, guy laroche, pucci, lilly pulitzer, mary quant, paco rabanne, yves saint laurent, ungaro

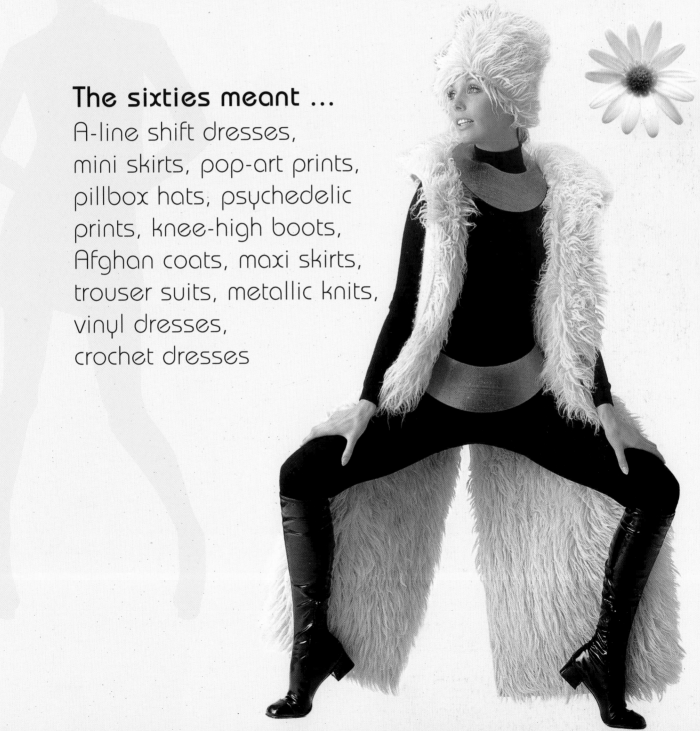

The sixties meant ...
A-line shift dresses,
mini skirts, pop-art prints,
pillbox hats, psychedelic
prints, knee-high boots,
Afghan coats, maxi skirts,
trouser suits, metallic knits,
vinyl dresses,
crochet dresses

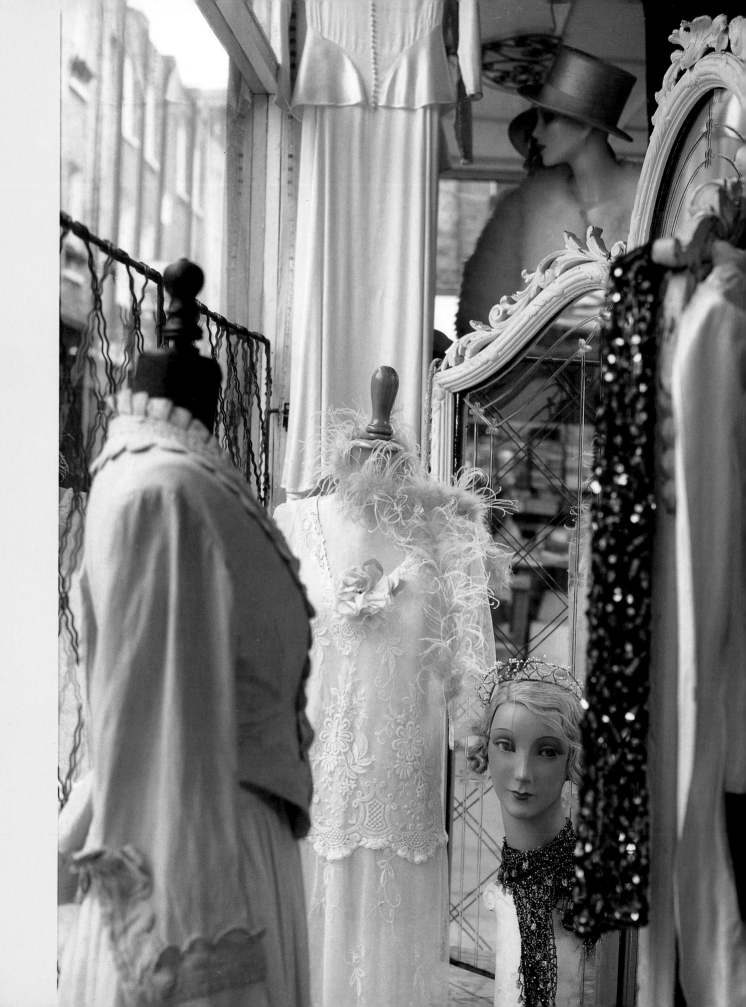

love it!

making repairs

In today's world, sewing skills have become almost extinct; after all, if the zip goes on your dress, it isn't really worth the effort of fixing it, when it'll be out of fashion next year and a replacement is so cheap. But if you intend to wear vintage clothes on a regular basis, it can be really useful to have some basic sewing skills – either that or a deep purse to pay someone else to do it for you.

Vintage garments in mint condition, although not rare, aren't common either, and you'll usually have to pay more for them. The majority of vintage garments are in good condition but have minor problems such as holes, rips, missing trim or fastenings that don't fasten. Unless you learn how to deal with these little problems, you will have to bypass a lot of beautiful clothes that need just a little attention to make them wearable again. If you are able to look at a garment in a shop, see its flaws and know that you are able to repair them, you will save yourself a great deal of money, and open up the whole range of vintage clothing that's available to you.

The first thing you need to learn is when you can repair a fault yourself, and when it's time to hand it over to an expert. What are your sewing skills like? Can you just about sew on a button, or are you an experienced needlewoman? Decide which category you fall into, and then read through the following list of faults, for advice on how to deal with them.

Basic repairs

Everyone can do simple repairs; all you need is a basic sewing kit and a little know-how. For your sewing kit, all you need is: a selection of sewing threads; some sewing needles of various sizes; a pair of sharp scissors; a tape measure; and an iron and ironing board. Here are some easy repairs, which will give your vintage garments a new lease of life:

Replacing buttons

Missing buttons are easily replaced, especially if they are concealed, such as on the waistband of a skirt. Try to find a complementary button – vintage shops and market stalls often have a selection of vintage buttons, so you can choose one that's appropriate to the style of the item – and pick some thread that matches it. If the button is conspicuous, or there is more than one missing, you may need to remove all the buttons, and start from scratch – unless you are lucky enough to find a button that looks like the others. If you do remove any buttons, keep hold of them, they may come in handy if you need to mend another garment.

Fixing holes at the seams

Wear and tear on seams can often cause "popping", which is where the seam comes undone, leaving a small hole. As long as the seam fabric is intact, you can easily fix this. Turn the garment inside out and, using a suitable stitch, sew along the seam in line with the original stitching.

It's important that you choose a thread that matches the fabric – not just in colour, but also in make-up. If the dress is made of 100 per cent cotton, and you use a polyester thread, or vice versa, there could be problems when you wash the garment, as man-made fabrics like polyester will shrink at the temperatures at which cotton is washed. If there is no fabric label on the item, and you aren't sure of the

How to ... sew on a button

1 Attach the thread to the fabric with a few back stitches where the missing button was sewn. Place the centre of the button over this fastening. If the button has a shank, simply pass a few stitches through the hole in the shank and finish securely on the wrong side of the fabric.

2 For buttons with holes, place a matchstick on top of the button between the holes. Pass the thread through one hole, across the matchstick and back through the second hole to the back of the fabric. Repeat this stitch several times, until you have enough stitches to hold the button firmly in place.

3 Remove the matchstick. You should be left with a loose loop of stitches, which can now form the shank of the button. Ease the button to the end of the shank, away from the fabric.

4 Wind the thread three or four times around the bottom of the shank stitches for strength. Then pass the thread through to the wrong side of the garment and finish off securely.

2

3

4

type of fabric, ask a specialist, such as the vintage seller or your dry-cleaner. Generally, items that date to before the 1950s are natural fabrics, but it's safest to check.

Fixing straps and trims

Broken straps and loose trims can be stitched back into place easily. Keep the stitching small and neat, and make sure that the thread colour you choose coordinates with the fabric. If you are using a sewing machine, choose a straight stitch for woven fabrics such as denim or cotton, and a zigzag stitch for knitted fabrics such as jersey.

Concealing snags

Woollen items are easily snagged, but small snags are also easily fixed. Simply take a pair of tweezers, the tip of a closed pen, or something similar and gently push the snag back through the knit to the inside of the item. Knot the snag on the inside, so it doesn't pop out again.

Mending hems invisibly

On inexpensive garments you can fix a dropped hem without even touching a needle. All haberdashery and sewing shops carry iron-on, fusible tape, which literally sticks the two sides of the hem back together again. Heat the iron to

the hottest temperature that the fabric will take (see page 108). Measure the amount of tape you need against the dropped portion of hem and cut the tape to size. Position the tape inside the hem, lining it up with the original hemline. Make sure that there's no tape sticking out from the fabric, as it could melt on the hot iron. Then iron the outside of the fabric, and that's it.

Advanced restoration

If you already have some experience in sewing, whether by hand or on a sewing machine, you may be able to do more advanced repairs and restoration on damaged garments. Before undertaking any repair work, the most important things to remember are to examine the garment very carefully and to plan exactly what you're going to do. Vintage garments are irreplaceable, and if you rush in enthusiastically and make a mistake, you may be unable to put it right.
Here are some problems that can be fixed by those with advanced sewing skills:

Replacing zippers

Broken or rusted zippers are such a common problem with vintage clothing that some shops are named "Rusty Zipper". Time and moisture cause metal zips to seize up, and the only thing

you can do is to carefully take out the zip and replace it with a new one. It's advisable to follow the stitching line of the original zip, as well as choosing a new one that matches the original in size, weight and material: if the original zip was made of metal, the new one should be, too.

Mending hems

If you are concerned about preserving the authenticity of a garment, sew the new hem in the same way that the original was sewn, either by hand or by machine, preferably using the same stitch. Pinning the new hem into place before sewing will ensure that you get an even hem, especially if you pin the garment while it is on a model or a tailor's dummy. For more information on taking up a hem, see page 87.

Repairing moth holes

Although it's delicate work, it is possible to mend small holes in knitted garments. Simply find a thread that matches the colour of the item, and gently make a small stitch that brings the two sides of the hole together, knotting it on the back of the garment. Don't make the stitch too tight; it should be just tight enough to bring the two sides of the hole together without pulling and distorting the surrounding fabric.

How to ... darn a hole

1 Darning is suitable for repairing holes in knitted or woven fabrics. Choose a thread as close as possible to the original in colour, texture and thickness – on woven fabrics, you may be able to pull a few threads out of a seam allowance. Trim the edges of the hole and place the area over a darning mushroom.

2 Cover the area of the hole, as well as some of the surrounding fabric, with long, vertical stitches that pick up a few base threads on either side of the hole.

3 Complete the mend with horizontal stitches. Anchor these a few millimetres from the edge of the hole, then sew over and under each of your vertical stitches so that you're literally weaving new material.

If you enjoy needlework, and you have a garment with a number of small moth holes or similar damage, you might consider embroidering or appliquéing the area, perhaps with a cluster of tiny flowers, made in wool or embroidery silk. But do make sure that the thread is colour fast, and that the shades and designs you choose look authentically vintage.

Repairing lace

If an item has fragile lace, with rips and tears in it, but you don't want to replace the lace altogether, you can try to limit the damage by reinforcing the lace. Take a piece of fine tulle – silk tulle if the lace is silk, polyester if the lace is man-made – and using very small stitches, sew the tulle to the back of the lace at the edges. Then attach the body of the fabric to the lace with tiny random stitches. This is painstaking work, but sometimes is the only way to keep a piece of lace intact.

Leave it for the experts

If a garment is valuable, you may wish to hand it over to experts for repairs, regardless of the problem. Amateurish repairs can drastically devalue an item; so if you own an original Schiaparelli, and it needs some work, think twice before tackling it yourself. An expert will not only have the skills, but also the resources to restore the garment in such a way that the repairs are invisible, and this can add to a piece's value, as well as its life span.

Even with less valuable items, if there is extensive damage, or the repairs are beyond your skills, an expert may be the best option. Seamstresses, tailors and clothing restoration experts are trained to do "invisible" mending to fix garments ripped or torn in a visible area. These experts can also undertake repairs to beading or sequin work, which can be tricky to do at home, and some very skilled needlewomen can even mend and restore vintage lace or crochet. Such services aren't cheap, but compared to the cost of replacing a treasured vintage item – if you could even replace it – the price is small indeed.

When choosing an expert to restore your vintage clothing, ask around fellow vintage enthusiasts, as well as at vintage shops, to find a skilled and reliable company. Dry-cleaners usually undertake basic repairs, and should have contact details for specialist clothing restoration experts for more skilled work. Try to establish a price before handing over the garment, and make sure that you discuss the possibility of any repair work going wrong and establish whose liability it is.

As you start to learn more about restoring and repairing vintage clothing, you will start to see garments in a new light. That pretty dress that no one will buy because it has a broken zipper, that embroidered twinset with the torn shoulder, or that stunning suit with the ripped lining will suddenly look more appealing, as you see past their flaws to their promise. After all, no one's perfect, we just need a little tender loving care to bring out our potential.

1970s

peace, love & rock & roll

If the 1960s were a time of excitement and revolution, the decade that followed was one long anti-climax. The Swinging Sixties had broken all the rules, ignored long-established moral and cultural boundaries, and preached the importance of individuality. But rather than resulting in a sense of freedom, all this created was a generation that was confused and dissatisfied, unsure where to go next.

The outcome among the younger generation of the 1970s was a splinter of groups and movements, often identified by the different types of music that they listened to, with each group seeking to find a new set of standards to live life by.

The hippies continued their search for peace and love, with the help of mystical religions, protest songs and mind-altering drugs. Glam rock, with its decadent androgyny, explored the realms of bad taste, mocking the conservative and the traditional. Funk celebrated the ongoing fight for racial equality, while the disco craze created a glamorous world of excess for those who wanted all-out hedonism. At the other extreme, the punk-rock scene screamed of anarchy and subversion, a means for youths to show their frustration with the world around them.

Because of this diversity of trends, the 1970s are a rich source for vintage dressers. Those who dismiss the 1970s as the decade of bad taste are missing out; its styles were inventive and unique, and are a continual source of inspiration for modern designers.

Hippy fashions continued from the '60s into the '70s, worn by the protesters of the decade's peace movements.

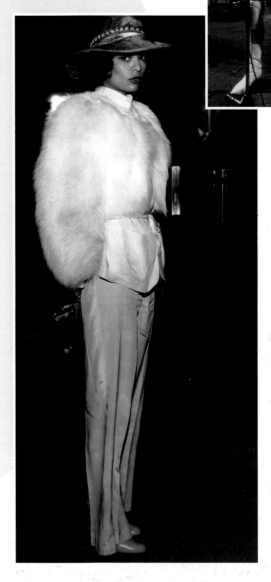

Each with a flamboyant sense of style, Debbie Harry (above) and Bianca Jagger (left) were icons of rock 'n' roll chic.

Daytime choices

The 1960s had put an end to fashion rules once and for all, and now women started to enjoy their style freedom. The improvements in clothing manufacture and the popularity of man-made fabrics meant cheaper clothes and more variety.

Although the hippies still clung to their cheesecloth and cotton, natural fabrics lost their status. Many women were busy pursuing careers; the appeal of a dress that could be thrown in the washing machine and needed little, if any, ironing was too great to resist. The better class man-made fabrics looked as good as their natural competitors, creating clothes that were

flattering and easy to care for. Manufacturers even created faux suede that looked and felt as luxurious as suede, but could be washed, making it practical as well as chic.

Daywear lines were sharp and exaggerated. Lapels were wide and pointed, skirts and trousers flared, and lengths were extreme – from the bottom-grazing hot pants to the floor-skimming maxi. Layering was important, whether on a tiered sundress or a novelty-print shirt worn under a V-neck sweater. A brightly coloured, shaggy jacket, a crisp, military-inspired coat, or the ubiquitous poncho gave the finishing touch to an outfit.

The interest in other cultures that spilled over from the hippy movement resulted in a heavy ethnic influence on fashion. Loose, printed kaftans were easy to wear, while fringing, beading and embroidery added an exotic look. Fabric prints were colourful and diverse, and lacy knits and crochet gave a delicate look to skirts, dresses and shawls.

Customising was a big trend, encouraging the stamp of individuality. Tie-dyed cheesecloth shirts, hand-embroidered jackets, and jeans turned into denim skirts or bags were all popular, while punks took customising to a new level, slashing and safety-pinning T-shirts, and writing obscene graffiti on leather jackets.

In a quest for the softness and romanticism of the past, many designers started to look to other eras for inspiration. Some recreated the romantic styles

Women's lib continued to break free from the constraints of women's fashions and this led to a trend for more masculine styles (left).

Farrah Fawcett (below), a star of the TV show Charlie's Angels, *projects an active image in bell-bottomed jeans and Nike-logo trainers.*

Paisleys and abstract designs appeared on loose-fitting clothes worn with beads and headscarves.

of the Victorian period, with long, tiered skirts and high-necked blouses, inset with lace and pin tucking. Hostess gowns, with quilted velvet panels and William Morris-style prints recalled the designs of the Art Nouveau period. Other designers used Art Deco images on fabric, for a 1970s take on the glamour of the 1930s.

Despite the popularity of trousers, the dress proved an ideal outfit for daywear for many women. One garment and your outfit was complete, simplifying morning wardrobe choices. It was comfortable to wear, flattering and could easily go from office to nightclub. One design that outshone them all was the wrap dress, pioneered by the American designer Diane Von Furstenberg. Made from silk, rayon or jersey, these dresses were cut to wrap around the body, with a belt to

*Saturday Night Fever,
released in 1977, both
captured the mood and set
a trend for disco dancing
and fashions everywhere.*

cinch in the waist. The result was a style that
was both feminine and practical.

Casual wear proved itself to be a
lucrative part of the market, with
fashion houses competing to produce
the hottest designer denim. With the
decade's emphasis on fitness and
health, sportswear began to emerge
as an important trend, no longer
limited to athletes and sportspeople.
Manufacturers created lines of leisure
wear that could be worn as much to
relax in as to get fit. Towelling and velour
shorts sets, tracksuits and tube tops looked
sporty and fresh, as well as being comfortable.

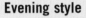

Evening style

In the decadent years of the 1970s, eveningwear
rose in importance again. Tired of looking like pre-
pubescent dolls or Earth mothers, women wanted
to look glamorous and sexy. Socialising, which
had taken a dip in the television-hungry years of
the 1960s, was suddenly in style again. With the
nightclub culture at its peak, and a renewed
interest in entertaining at home, a selection of
fabulous eveningwear was an
essential part of most wardrobes.

The disco culture, which spread
across the world, created a need for
skimpy, glitzy clothes in which to dance
and allure. Metallic fabrics, glitter and
sequins sparkled under strobe lights,
while light fabrics draped seductively
over the body and kept the wearer cool.
Dresses were revealing, with
shoestring straps, batwing sleeves or
an off-the-shoulder cut. Skirts were
either knee or calf length, often
with an asymmetric or
handkerchief hem, and trimmed
with ruffles or tiers, which
fluttered as the dancer moved.
The cut was either dramatically
sexy or romantic, and was
designed to draw attention to

*Bright colours and
shimmering threads shone
in the lights of the disco,
while necklines were low,
often held up by sexy
spaghetti straps.*

the figure. Other popular styles for dancing queens
were satin hot pants, stretchy tube tops and figure-
hugging jumpsuits.

More sophisticated were the draped jersey
evening gowns made famous by designers such as
Halston. Evoking a Grecian-goddess look, these
luxurious designs were simple and chic, as
appropriate in an expensive restaurant
as in a top nightclub. They clung to
the body in the right places, and
created a sleek silhouette. In contrast,
deluxe hippies dressed for evenings in
voluminous silk or chiffon kaftans,
embroidered, hand-painted or beaded, for
an exotic feel.

Eveningwear fabrics were usually
synthetic, polyester crêpes, jersey or
rayon. Colours tended to be either
neutral or shockingly bright, and silver
Lurex thread was woven through fabric
to give a subtle shimmer. Many dresses
came with matching shoulder capes,
while a fur wrap or stole – whether
real or fake – created a glamorous
1930s look.

For the fashionable bride

The flower-child styles of the late 1960s were a major influence on bridalwear for the early part of the 1970s. Dresses stayed at maxi length, and were ruffled and flounced for a pretty, feminine look. The Victoriana trend translated beautifully into wedding gowns, which copied the high necks and long sleeves of this romantic period. Medieval styles also inspired designers, who used long sweeps of fabric to dramatic effect.

As the 1970s progressed, traditional weddings became less and less popular, and many couples opted for a civil ceremony, rather than being married in a church. Modern brides rejected the white-wedding look, choosing a dress in whatever colour or fabric they wanted. Veils seemed outdated and irrelevant; but some brides wore large picture hats or floral headdresses.

One of the striking trends of the decade was the trouser suit, which was the choice of many brides. These suits followed fashion, with a wide-collared jacket and flared trousers, and were often made in velvet for a special-occasion feel. The very daring wore hot pants with a matching maxi coat, for the ultimate rock-star style wedding.

With the return to glamour of the second half of the decade, traditional wedding dresses regained some of their popularity.

Designers used jersey to create sophisticated draped gowns, which were trimmed with appliquéd lace and beading. A flower-trimmed comb was worn in the hair for a pretty, yet still informal, look.

Finishing touches

One main feature of the 1970s was its complete rejection of previous style rules. Although the youths of the 1960s had discarded the gloves, hat and bag that were considered essential in the past, older women had continued to wear these. Now, these seemed so outdated that even the conservative let them go. Accessorising was done on the basis of style, not etiquette.

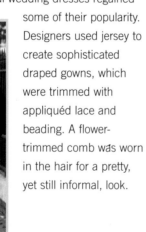

Ironically, hats became an essential accessory for the cool, from sophisticated fedoras, to crocheted skullcaps, and from jaunty baker-boy caps to huge "pancake" hats. Bags were compact and neat, usually with a shoulder strap for hands-free carrying. The glamorous adopted the sleek clutch, which appeared in a number of novelty guises, such as a folded-over fashion magazine. Few outfits were complete without a pair of platforms, as high and exotic as possible. Platforms created a balance with bell-bottom jeans or A-line skirts, as well as elongating the leg. Designers experimented with the glamorous and the kitsch, and with platforms of up to 10 inches (25 cm), shoes sum up the fashion excesses of the 1970s better than any other garment. However, sophisticated evening gowns needed a more elegant shoe, and the stiletto sandal, with floral trim or ribbon ties, made a grown-up alternative to the funky platform.

Jewellery was as eclectic as the clothing styles – everything went, from ethnically inspired necklaces and rings, to the glitzy glam of the disco diva. Novelty items, like enamel badges and huge, plastic earrings, appealed to the youthful, and were an inexpensive way to finish a look.

The seventies meant ...

kaftans, flares, maxi skirts, wrap dresses, tube tops, tiered skirts, peasant tops, maxi coats, platforms, ponchos, disco dresses, hot pants, bondage trousers, playsuits, Victorian blouses

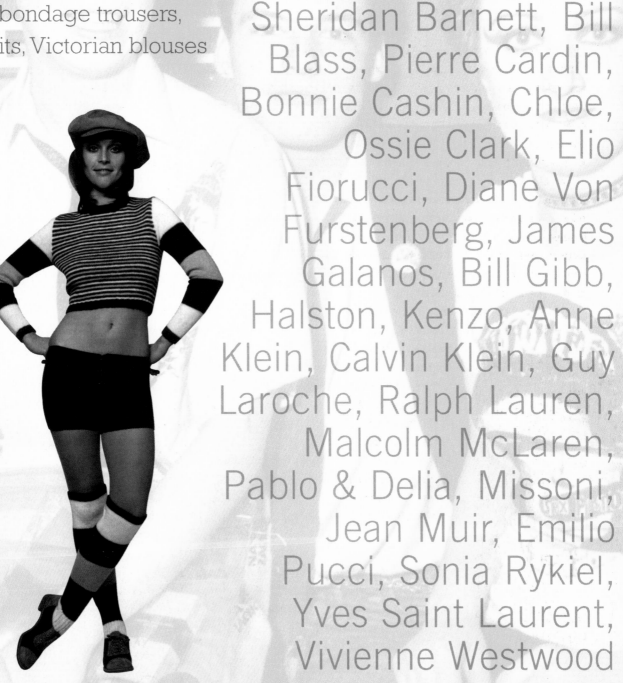

Adolfo, Walter Albini, Christiane Bailly, Sheridan Barnett, Bill Blass, Pierre Cardin, Bonnie Cashin, Chloe, Ossie Clark, Elio Fiorucci, Diane Von Furstenberg, James Galanos, Bill Gibb, Halston, Kenzo, Anne Klein, Calvin Klein, Guy Laroche, Ralph Lauren, Malcolm McLaren, Pablo & Delia, Missoni, Jean Muir, Emilio Pucci, Sonia Rykiel, Yves Saint Laurent, Vivienne Westwood

clean it up!

One of the things that puts some women off buying vintage is the myth that it's harder to clean. That this is a myth is obvious when you consider that the women who owned the clothes originally didn't have automatic washing machines, tumble dryers, chemical stain removers, steam irons, or any of the things that make laundry so easy today.

Although the condition of clothing varies from shop to shop, few shops wash or clean garments before selling them – and if they do, you can be sure that you'll pay a hefty price for them. Always assume that a garment needs cleaning when you buy it, and get into the habit of checking for stains (see page 110) and cleaning clothes before you wear them for the first time.

Deciding how to clean clothes

Few vintage items have a care label inside them; if they do, that will help you a great deal, but if not, you'll have to work out the best way to clean them for yourself. The first thing to establish is the type of fabric, as different fabrics need different types of care. If you aren't sure what type of fabric it is, ask the seller – he or she should be able to tell you. Here are some of the most common fabrics and how you should clean them:

ACRYLIC: Can be machine washed but cannot take high heat. Wash acrylic fabrics on a cool temperature, hang or lay items flat to dry, and iron them on the coolest setting.

CASHMERE: Is best dry-cleaned, but can be gently hand washed using a special wool detergent or baby shampoo. Dry garments flat to prevent any stretching or wrinkling.

CORDUROY: Can be machine washed on a warm temperature, but should be turned inside out to prevent the pile from damage. Line dry or tumble dry, and iron inside out.

COTTON: This includes fabrics such as muslin, terry towelling, cheesecloth, organdie, poplin and seersucker. White or natural cottons can be machine washed at high temperatures, but coloured cotton should be washed at lower temperatures to prevent the colour running. Line or tumble dry, and iron on a high heat.

DENIM: Can be machine washed on a high temperature, but it's safest to wash denim on its own, in case the colour runs. Also, turn garments inside out to prevent fading. Line or tumble dry, and iron on a hot heat, all with the garment inside out.

LEATHER: Must always be professionally cleaned, preferably by a dry-cleaner who specialises in leather goods.

LINEN: Can be washed at a high temperature, either by hand or in a machine. It's best to line dry linen, to minimise creasing. Should be ironed on a high heat.

NYLON: Can be machine-washed at low temperatures, although after a while this can cause pilling (where small bobbles form on the fabric). Avoid ironing if possible, but if it has to be ironed, use the coolest setting and iron on the wrong side of the fabric.

POLYESTER: Can be machine washed at low temperatures. Line or tumble dry, and iron on the coolest setting.

RAYON: This varies in type, from the sort that can be machine-washed to that which needs dry-cleaning. If there is no care label, play safe and take it to the dry-cleaners.

Twelve stain-busting secrets

If you have a washable garment that isn't too expensive, you can try some of these tips for removing common stains.

If you're unsure whether the liquid or solution you're using might damage the fabric, try it on a small, hidden part of the garment first, such as a seam. Bear in mind, too, that you have more chance of removing a stain if you treat it while it's fresh.

1 Antiperspirant: Mix together bicarbonate of soda and salt in cold water. Paste it onto the affected area and leave for 15 minutes. Wash the paste off with cold water, soak it in biological detergent and warm water, then wash as normal.

2 Blood: Pour a solution of liquid detergent and water through the spot. Then sponge it with a solution consisting of 1 spoonful of white wine vinegar in a cupful of water. Rinse and wash as normal.

3 Cosmetics: Modern stain removers are excellent for removing marks caused by lipstick and other cosmetics.

4 Fats, butter or margarine: Scrape off as much as possible from the surface. Rub washing-up liquid into the stain with your fingers, or use a commercial grease solvent. Sponge with warm water. Finally wash at the highest temperature the garment can take.

5 Grass: Soak the item in warm water containing biological detergent. If stains remain, dab them with methylated spirit – except if the fabric is acetate.

6 Nail varnish: On washable fabrics you may be able to remove the stain using a non-oily nail varnish remover dabbed on the wrong side of the fabric. However, test the effect of the nail varnish remover on the hem first and don't use it on acetate.

7 Newsprint: Sponge the affected area with methylated spirit – unless the fabric is acetate – then wash the garment as normal.

8 Pen ink: Liquid ink is fairly easy to remove. Simply wet the fabric with warm water, and then rub with a bar of soap. If the pen marks are inside a handbag, try dabbing with a cotton wool ball soaked in sour milk, then leave it to air.

9 Red wine: For a fresh stain, immediately pour salt on wine to absorb the colour. Then immerse in cold water containing biological detergent to soak, for as long as possible, preferably overnight. If the stain is old, do the same but with hot water. Wash as normal.

10 Rust: Jewellery, pins, even coat hangers can cause rust marks on fabric if left long enough. Try rubbing lemon juice onto the stain. Leave for an hour or so before washing. Or simply cover up tiny marks with embroidery or a brooch.

11 Shoe polish: Using a spoon, scrape off as much excess polish as possible then dab the area with white spirit. If the stain persists, dissolve some biological detergent in warm water and rub into the stain until it is removed. Wash as normal.

12 Sweat: Clothes suffered badly in the years before antiperspirant, and many still bear the scars. Try soaking the garment in a dilute solution of vinegar: 1 spoonful of white wine vinegar in a cupful of warm water.

SILK: This can be gently hand-washed with special detergent or baby shampoo, but may be better dry-cleaned. If you wash silk garments at home, treat them very gently: after washing, roll them in a towel to remove excess moisture, and then hang or lay them flat to dry. If ironing is necessary, iron on the coolest setting on the wrong side of the fabric.

SUEDE: As with leather, suede should be dry-cleaned only.

VELVET: This is best dry-cleaned, as the pile can be damaged easily.

WOOL: Can be gently hand washed, using a wool detergent or baby shampoo. Dry flat, and iron on a cool setting using steam, on the reverse side of the fabric.

Cleaning at home

The first time you clean a garment is the most crucial and the trickiest. If you get the process right, you'll find it easy to clean that garment in future – but if you get it wrong you may ruin it. Scared? Don't be. Proceed cautiously, assume that every garment is more delicate than it actually is, and use your common sense.

Removing stains

Before you begin any type of cleaning, check the garment thoroughly for any stains. If you don't remove stains before you clean an item, they could "set" and become harder – or impossible – to remove. If a stain has already set into the garment from a previous wash, it's probably best to take it to a dry-cleaner for advice, but be warned: he or she may not be able to do anything about it either.

Be very wary of using proprietary stain removers, which, although effective, can be too harsh for old fabrics. You can usually find more gentle, sometimes natural, stain removers around the house (see page 109). Only use a proprietary stain remover on very robust garments, or those with a low value, as the chemicals in stain removers can damage delicate fabric. You also need to be wary of home dry-cleaning kits, which can do more harm than good.

Washing the garment

If there is a care label on the garment, deciding how to wash it is easy, just follow the

How to ... hand wash and iron

1 Fill a bowl or sink with water at the correct temperature for the clothes you're going to wash. Add the washing powder or liquid and make sure that it has completely dissolved before you add any clothes. Don't rub the fabric, but press the soapsuds through gently. Swish the garment around in a large container of clean water – a bath is ideal – to rinse them.

2 Remove excess water from delicate items by rolling them in a towel – wringing can distort them out of shape. Woollen items should be dried flat, by laying them on a towel on a flat surface, such as a glass table top, or on a towel over a drying rack. Gently pull the garment into the shape it should be when dry.

3 On fabrics that can be ironed, use a cool heat, iron on the wrong side if possible, and consider using an ironing cloth (a soft lint-free cloth, which is placed between the iron and the garment). Cotton, linen and wool are best ironed when slightly damp. Silk and man-made fabrics generally don't need moisture. Try to iron with or along the grain of the fabric when possible.

instructions. If not, you have to decide whether to hand or machine wash. Most vintage garments are best hand washed. Even if the fabric is robust enough to stand machine washing, there may be embroidery, beading, lace or other trims that can be damaged by the rough movements of a machine. One factor that will affect whether you hand or machine wash is the value of the item. If it is a cheap and cheerful 1970s shirt, then you might be happy to risk washing it in the machine – although you still need to follow the fabric guidelines on page 108. If you're dealing with a hand-embroidered peasant blouse, then, despite the fact that it is cotton and can be machine washed, you may choose to hand wash it, to be on the safe side.

Whatever your choice of method, make sure that you empty the pockets of the garment before washing, as well as removing any pins, jewellery or detachable trims. Fasten all the buttons, snaps and zips to avoid snagging during the wash. Use a detergent that is formulated for delicate items, preferably a non-biological one – biological detergents can eat into old fabrics. Err on the side of coolness: with washing water, drying method and the temperature of the iron. Wash vintage garments separately from normal clothing, and make sure that coloured items are washed alone, until you are sure that the dyes won't run.

Drying methods

Most garments are best dried on a line, unless they are very heavily beaded or a knitted fabric, in which case dry them flat. If you are drying it outside, make sure that it isn't in direct sunlight, as the sun will fade any colours – however, if it is a white garment the sun will brighten it. If you use a tumble dryer, make sure that you only leave the item in for as long as it takes to dry it – any longer and the heat will start to create wrinkles that will "set" into the fabric.

Ironing techniques

Be very gentle when ironing a vintage garment. Make sure that your iron and ironing board are both scrupulously clean before you start ironing anything, as the heat from the iron will drive any dirt right into the fibres of the fabric.

Taking clothes to the dry-cleaner

Before taking an item to be cleaned professionally, you need to know that the company is reliable and skilled – and yes, this may cost you, but it's not an area in which you can skimp. Ask around, with friends, relatives and your local vintage seller, to find a reputable dry-cleaner. Find out if the company is experienced in cleaning delicate vintage items, and what its policy is on damage that results from the cleaning process. If the garment is very important or valuable to you, take it to a theatrical dry-cleaner – these specialists are used to treating old or unusual clothing.

Check over the item before taking it in, making sure that you empty any pockets, remove jewellery, and check its condition thoroughly. If the garment is very precious, do this again in the presence of the dry-cleaner, so that you are both sure of its condition before cleaning. Don't forget to point out any stains that the dry-cleaner will need to treat.

If the garment is a delicate fabric such as silk or cashmere, you might want to ask if the dry-cleaner can use a wet-cleaning process. This is a gentle form of cleaning, which protects items

Dyeing badly stained items

Sometimes the prettiest garments have stubborn stains or marks that you just can't remove – but you don't need to discard them altogether. Dyeing a garment can give it a new lease of life, and since the item is unwearable in its present condition, you can afford to take the risk of dyeing the fabric. However, do try all ways of cleaning first, including professional cleaning, to be sure the stain really is indelible.

Make sure that the type of dye you use is right for the fabric. The temperature at which the dye needs to set can't be hotter than the temperature at which you can wash the fabric – for example, if you use a hot-water dye on a wool sweater, you'll be in for a nasty surprise when you take it out of the machine.

If the garment is beaded or sequinned, dyeing may not be such a good idea, as the trim might absorb the dye at a different rate from the rest of the fabric. Test the dye on a little piece that doesn't show, before dyeing the whole item.

If the stain is fairly light or you have managed to lift most of it out, just dye the garment a few shades darker. This won't change the look of the garment too drastically, but will camouflage the mark.

If you think the garment's style would suit tie-dying, give it a try. Tie-dying is fun to do and gives garments a completely different – and very psychedelic – look. It can look particularly pretty on slips and camisoles.

Pinch a section of fabric and tightly tie rubberbands or pieces of string around it (top). Dye the item following the packet instructions. When you remove the bindings you'll have a classic sunburst pattern (above).

that are too delicate for the harsher, chemical dry-cleaning process or that have stains that will respond better to water. Sequinned or beaded items are particularly suitable for this type of cleaning. Discuss your concerns with the dry-cleaner, and listen to his or her advice – after all, he or she is the expert.

Keep it clean

Once you've done the hard work of getting a garment clean, you want to keep it that way. Here are some tips to help you to care for your clothes, vintage or otherwise:

AIR YOUR CLOTHES: Rather than putting them away immediately after wearing them, leave clothes hanging outside your closet overnight. This allows air to circulate around them and dispels perspiration that might otherwise eat into the fabric, creating a stale smell and maybe even damaging the fabric. For the same reason, it's not a good idea to wear the same garment two days running. Give it a chance to breathe and recover, especially if it is delicate.

BRUSH OFF YOUR CLOTHES: It's good practice to brush off your clothes before storing them, instead of doing it five minutes before you walk out the door. Not only does this save time, but also keeps the fabric surface clean, which helps to preserve it. Use a natural-bristle clothes brush, which can gently remove hair, dust and surface dirt. Animal hair might be harder to remove, so try a dampened sponge.

TACKLE STAINS IMMEDIATELY: This can mean the difference between success and failure. It's a good idea to have a range of stain-removal materials handy in the house, in case of emergency. If you're unable to deal with a stain immediately – after all, your date might be unimpressed if you rush home halfway through your meal – keep the stain wet by dabbing it with water. This can help to stop it from "setting" before you can treat it.

Dressed for success

The 1980s were all about money – getting it, spending it, flaunting it, losing it. As economies boomed and technology advanced, people wanted "more, more, more" and were prepared to work harder for it. Success was measured by the size of your house and your car, the number of exotic holidays you took, even the restaurants you went to. Image was everything, and money was power.

Women, who had been battling for more than 50 years to break through the glass ceiling of the male-oriented workplace, began to make their marks in the 1980s, winning top positions in politics, finance, law and retail. Feminists declared that it was finally possible to "have it all", although in the real world, most women struggled to balance home, work and family commitments.

The spirit of "conspicuous consumerism" dominates the fashions of the 1980s. The only label worth having was a designer label, and it wasn't tucked discreetly inside a garment, but emblazoned all over it like an insignia. Fashion was no longer about what you wore, but who you wore, and for those who couldn't afford the real thing, there were plenty of fakes.

Many women remember the 1980s with horror – the big shoulder pads, the big hair – but there were some great styles, which today's designers and vintage dressers are reviving.

Daytime choices

If you wanted to succeed in the workplace, you had to dress to impress, and the "power suit" became the uniform of the 1980s career woman. The jacket echoed the masculine shapes of the 1940s, with exaggerated shoulder pads, and either a loose, boxy shape, or a cropped, fitted design. The skirt was as short and tight as possible. This style gave women a feeling of power and strength, while reminding onlookers that they were still feminine and sexy. Suits were often in subdued shades, such as black, navy and grey, but they were also made in shocking primaries, as well as gentle pastel tweeds. Blouses were neat and unobtrusive, with perhaps a floppy bow at the neck.

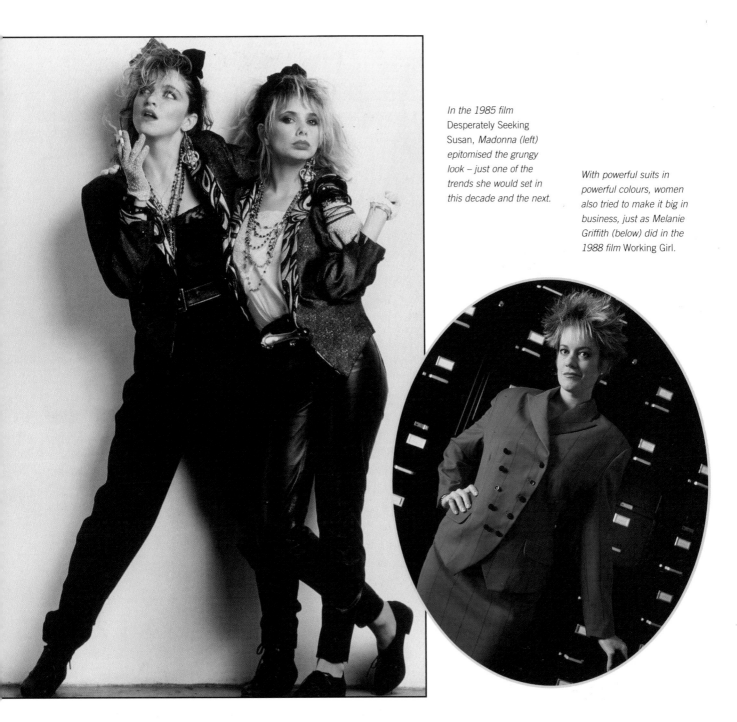

In the 1985 film Desperately Seeking Susan, *Madonna (left)* epitomised the grungy look – just one of the trends she would set in this decade and the next.

With powerful suits in powerful colours, women also tried to make it big in business, just as Melanie Griffith (below) did in the 1988 film Working Girl.

Shoulder pads are an inescapable part of the decade's style, appearing not only in suits, but also in knitwear, dresses, even sweatshirts. The silhouette was an upturned triangle, strong and broad at the top, tapering into a slim bottom. Peplums drew attention to a nipped-in waist, and softened angular styles.

The fitness obsession, which had begun in the late 1970s, really took over in the 1980s. This was the age of the supermodels, with their beautiful faces and flawless bodies. As well as the perfect job, the perfect family and the perfect home, women were expected to have the perfect body, slim and gym

toned. From jogging to aerobics, keeping fit was an essential part of a woman's schedule, and sportswear designers began to cater specifically for this new market. Pastel-toned jogging suits, streamlined leotards, and shock-resistant underwear were just some of the innovations that designers came up with for the body-conscious woman.

An offshoot of the fitness craze was the interest in dance and gymnastics, which spawned a range of styles for daywear. Slouchy sweatshirts were cropped and worn off the shoulder, striped legwarmers were paired with jeans and trainers, and flat ballet slippers became the rage. Leggings, once strictly for the athlete, were worn under huge sloppy jumpers, or under tiered rah-rah skirts. Sportswear even entered the boardroom, with leotard-inspired bodysuits, which created a sleek line under suits.

The classic T-shirt, never really appreciated by fashion, became the number-one way to make a statement, with slogans declaring everything from politics to sexual preference. These T-shirts were worn long and baggy, with many girls wearing them as dresses over tights or leggings. Knitwear

The prim skirts, blouses and cardigans of social climbers (above) contrasted sharply with the sexy, body-hugging fitness craze launched by stars such as Jane Fonda (below).

was another area where women could have some fun. Chunky sweaters with bright, novelty prints were hugely popular, worn with leggings or over jeans. A more glamorous version had batwing sleeves, a cowl or slash neck, and beading, sequin or appliqué trim.

Some women rejected the masculine styles of the 1980s in favour of an old-fashioned traditional look. Pie-frill blouses, in sheer chiffon or crêpe, were worn with mid-calf length, pleated skirts and flat shoes. This look, despite being drab and unflattering, was popular among social climbers, who saw it as the uniform of the upper classes.

Despite the general conservatism of 1980s styles, the avant garde continued to experiment with fashion and individuality. The New Romantics took inspiration from dandies of the 18th century, teaming ruffled shirts with pantaloons, military coats and knee-high boots. The punk look of the 1970s morphed into the grungy, sexy look of 1980s girls, who combined bustiers, lace skirts, fishnet tights, fingerless gloves and masses of jewellery for an eclectic look.

An off-the-shoulder dress in striking pink and blue from Yves Saint Laurent.

Evening style

The creed of the 1980s was: work hard, play hard. Exclusive restaurants offered nouveau cuisine, members-only clubs flourished, and flamboyant nightclubs gained cult status.

1980s eveningwear went from one extreme to the other. Either it was lavish, over the top and extravagant in cut, or it was extremely short, skin tight and minimally trimmed, allowing the curves of the body to be the decoration.

For balls and other formal functions, elaborate evening dresses were perfect, recalling the sumptuous creations of the 1950s. Made from taffeta, silk, velvet and tulle, they were usually floor length, using vast amounts of fabric in flounces, puffs and tiers. The colours were rich, and the dresses were heavily decorated with beading, sequins, lace or embroidery. Often with a strapless or off-the-shoulder cut, the bodice was fitted, with a full, pleated skirt. An inventive variation was the puffball, a full skirt that was caught in at the hem, creating a charming puffed effect.

For more informal occasions, the tubular mini dress was the perfect way to show off a gym-honed body. With the assistance of Lycra, these dresses moulded themselves to the wearer, leaving little to the imagination. Usually simple in cut, they were sleeveless with a scoop neck, or one-shouldered, and ended about mid-thigh. In plain black velvet they made chic cocktail dresses; in scarlet jersey, they were supremely sexy and perfect for a night on the town.

Those who didn't wish to show off their bodies could dress chicly in draped harem pants and bandeau tops. Twisted and wrapped around the body, these evening outfits were alluring without being blatant, giving a subtly elegant look.

This couture gown combines stretch fabric, a huge taffeta ruffle and an asymmetrical cut.

New Romantic influences appeared in details such as lace and high collars (left).

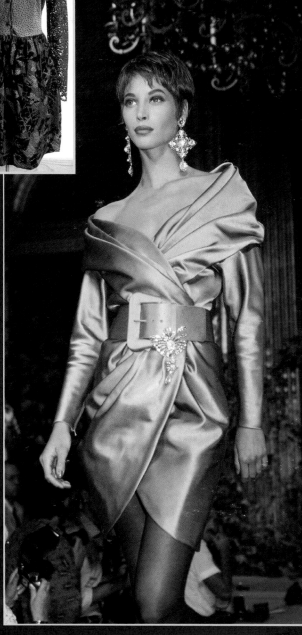

A shimmering off-the-shoulder gown by Christian Lacroix, a key designer of late-1980s eveningwear.

For the fashionable bride

The wedding of Lady Diana Spencer to Prince Charles in 1981 set bridal trends around the world. Her dress was the sort that little girls dream of: yards of rustling silk, trimmed with beading and lace flounces and with a 25-foot (7.6-metre) train – ornate, sumptuous, and fit for a princess. Suddenly, everyone wanted to get married in a dress like that – in complete contrast to the minimalism of the last two decades.

The bridalwear of the 1980s was more lavish and extravagant than at any other time in history, with no holds barred in either cut or decoration. Dresses had fitted bodices, trimmed with lace and ruffles, and sleeves were exaggerated puffs, or worn off the shoulder. Skirts were floor length, with long trains, and worn over netted petticoats for extra fullness.

Veils matched dresses in their magnificence, sweeping the floor in length, and trimmed with beads or sequins. Ornate, pearl-drop headdresses were popular, as well as more simple floral wreaths.

As the decade developed, dresses became slimmer, but no less extravagant. A fitted bodice with long sleeves topped a tulip-shaped skirt, with every part of it pearl- or sequin-encrusted. Lace and chiffon suits in a mid-calf length were worn for more informal weddings.

The grander the wedding, the more bridesmaids there were, ranging from the older matron of honour to tiny flower girls. All wore elaborate dresses in matching colours, which were often chosen to coordinate with the bride's bouquet.

Finishing touches

The power suit of the 1980s required equally impressive shoes, and stiletto heels were fully revived. Lengthening the leg and adding height, they were essential both with daywear and the leg-baring evening dresses. Trainers were another vital accessory; businesswomen power walked to work in them, and off-duty girls wore them with jeans and sweatshirts. Loafers were a smart alternative for the casual-chic look. Sheer or opaque tights were necessary with smart suits, but outside work, women chose jazzier hosiery, from lacy tights to stockings with a diamanté design at the ankle.

Hats were rarely worn except on formal occasions, when they were either neat pillboxes or wider-brimmed boaters. As designers tried their best to capture every aspect of the fashion world, sunglasses became another status symbol, the bigger and more expensive, the better. Wide,

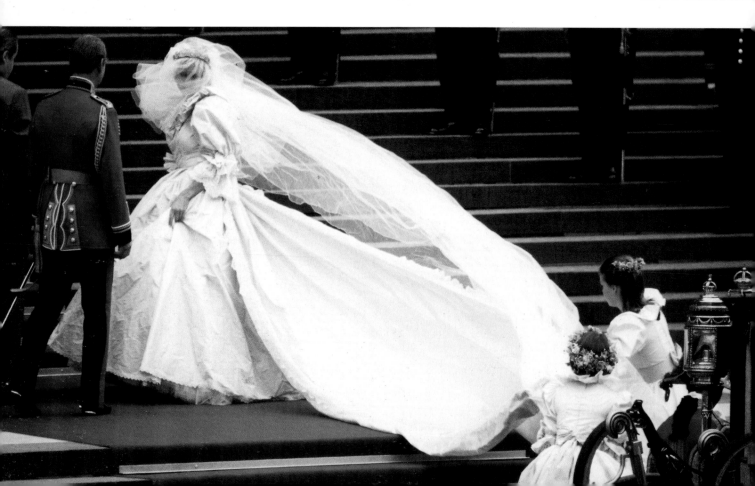

A bag was a cheaper way of buying into the designer lifestyle – especially if it was a fake from a market stall. Bag styles ranged from the small quilted designs popularised by Chanel, to larger leather holdalls, necessary for carrying Filofax, spare shoes and mobile phone. For evenings, a leather clutch bag and matching court shoes was considered chic.

The bold shapes of the 1980s styles required striking jewellery, and glitz was firmly back in fashion. Diamanté novelty brooches adorned the businesswoman's lapel, and an expensive designer watch – or copy – was on her wrist. Costume jewellery was loud and proud, with large gold and "pearl" earrings for daywear and glitzy earrings and necklace for the evening.

elasticated belts with decorative buckles highlighted nipped-in waists, and chain belts emphasised the sleek lines of a Lycra dress.

Business suits could look austere; one way of feminising them was with a shawl wrapped around the shoulders. Made from fine wool or silk, in traditional prints, these shawls added a polished look to an outfit. A smaller scarf was worn tied around the neck for a more informal look.

The craze for designer labels reached its peak with handbags and luggage, which were covered in logos and insignia.

The eighties meant ...

power suits, puffball skirts, Lycra mini dresses, leggings, slogan T-shirts, pie-frill blouses, rah-rah skirts, bodysuits, harem pants, novelty-print sweaters, wide belts, logo print bags

Azzedine Alaïa, Giorgio Armani, Bill Blass, Liza Bruce, Chloé, Perry Ellis, Escada, Nicole Farhi, Romeo Gigli, Georgina Godley, Katherine Hamnett, Betty Jackson, Betsey Johnson, Comme des Garçons, Patrick Kelly, Calvin Klein, Christian Lacroix, Karl Lagerfeld, Ralph Lauren, Thierry Mugler, Bruce Oldfield, Rifat Ozbek, Zandra Rhodes, Body Map, Gloria Vanderbilt, Vivienne Westwood

storage solutions

If your wardrobe looks like a mini vintage shop, with 1950s dresses crushed up against hand-screened kimonos, cashmere twinsets and silk slips spilling out of drawers, and hordes of shoes tangled up with bags on the floor, it's time you rethought your clothing storage.

The ultimate dream – a walk-in, custom-built closet, in which you can see everything at a glance – is beyond most of us, who are restricted by money and lack of space. However, with a little planning and some careful reorganisation, you can make the most of the wardrobe resources you have, which will be better for your clothes and for you. Although these guidelines are specifically for vintage clothing, they should be applied to all clothing and accessories – after all, if you take care of your clothes, future generations will be able to enjoy their "vintage" style.

So, take a look inside your wardrobe. Is there space between each hanging item, or are they crushed up together? Are knitted items neatly folded and stacked in small piles, or are they in teetering mounds, ready to topple over at a glance, with the odd garment rolled up in a creased ball at the back of the shelf? Are shoes carefully stuffed with tissue paper, and stored in shoe bags, or are they tossed all over the floor, in mixed doubles? Most women's wardrobes fall somewhere between these two pictures.

However, a well-organised wardrobe, in which everything is in its place, with room to breathe, is important for every kind of clothing and essential for vintage garments. Time takes its toll on fabric, especially the delicate silks, velvets and chiffons from which so many vintage garments are made. If you want to continue to enjoy wearing them for years to come, you need to take good care of them, and proper storage is an important factor in that.

Finding the ideal spaces

Wherever you store your clothes, whether you have a walk-in closet, built-in wardrobe or a simple hanging rail, it's important that the area doesn't suffer extremes of temperature or humidity. The ideal storage condition is dark, dry and cool. If stored garments are exposed to sunlight, the colours will fade quickly, and delicate fabrics may even perish. Heat and humidity encourage insect infestation and mildew, which can ruin leather goods, such as bags, belts and shoes. At times, you may need extra storage space for seasonal clothes, but attics, basements, garages and bathrooms, while they may seem convenient, are bad for vintage clothing, as the temperatures in these places can vary and they may contain fumes that can damage clothes.

Make sure that there's enough room between hanging garments – air should be able to flow freely around them. Cramming encourages creasing and can even cause distortion in bias-cut items or those made from delicate fabrics. Make sure that each garment has a hanger to itself. If your storage space is limited, and it's impossible to follow these rules, either pare down your wardrobe or find a new storage facility. Self-assembly clothes rails are cheap to buy, or you could hunt through junk shops for hatboxes, trunks or old suitcases, which look stylish under the bed or on top of a wardrobe.

Don't save wardrobe sorting for an annual spring clean. Check on clothes every six months, looking for signs of strain, insect

Seven storage sins

1 Never put away dirty or stained clothing. Not only will the dirt eat into the fabric and the stain set indelibly, but also the dirt will attract insects and pests. Besides, who wants to pull a dress out of the wardrobe just before a special party, only to find that it smells smoky and sweaty from the last time it was worn?

2 Don't put carpet in wardrobes or closets. Carpet harbours dust and dirt that can affect your clothes, and it invites insects and pests. A smooth wooden or tiled floor is much better and easier to keep clean.

3 Don't hang fragile garments made from lace, chiffon or thin silk. The weight of the garment pulls on the hanger, and can cause lumpy misshapen areas. Fold the garment instead, and store it on a shelf or in a box.

4 Don't leave pins or brooches in garments when you put them away. The metal can cause rust spots, and the weight of a brooch can create a hole in the garment.

5 Never fold leather or suede – the creases will never come out. If you need to pack leather garments away, roll them loosely with tissue paper, rather than folding.

6 Never leave belts in the belt loops of clothes - the weight of the belt can cause damage to the garment, and the belt could become distorted and wrinkled.

7 Don't leave items in pockets when storing clothes. The weight can cause strain on the pocket, resulting in torn seams or distortion.

infestation or damp problems. This gives you a good opportunity to sort through all your clothes, and weed out those that you no longer wear or that don't fit any more. Consider rearranging your clothing, by season, colour, outfit or type. Categorising the clothes in your wardrobe isn't just for someone who's bored or a control freak – it saves time and effort, and makes sure that you don't overlook items when you are putting outfits together.

Fold your knits

Knitted garments, whether sweaters or dresses, should always be folded, as hanging can cause them to stretch out of shape very quickly. Never fold them lengthwise, as the resulting crease can be almost impossible to get out. Don't pile folded items too high, as those on the bottom will be under too much strain; likewise, avoid placing heavier items on lighter ones, as this will cause unnecessary creasing. If you're storing folded items for long periods, take them out occasionally and refold them in a different way, so that any creases don't become too ingrained and ruin the fabric fibres.

Look after delicate items

If you have a very fragile item, perhaps a delicate lace wedding gown or a chiffon dress from the 1930s, you might want to consider giving it a special storage space. Archival garment boxes are a good way to store delicate items, which should be wrapped with acid-free tissue paper between the layers to prevent creasing. You can also store delicate items in cotton or muslin bags, which can then be placed in trunks or boxes – just make sure that these are stored in a dry area.

Protect your shoes

Most women adore shoes, but few take the time to store them correctly. There are many ways

you can store shoes: clear plastic shoeboxes, shoe trees, fabric shoe bags, built-in shoe shelves, shoe boxes with a snap of the shoe outside. Whatever option you choose, make sure that your shoes have enough room around them for air to circulate, that they are protected from dust and dirt, and that their shape is preserved with tissue paper stuffing or shoe trees.

Storage essentials

If you love your vintage clothes, you'll want to keep them in as good a condition as possible. Investing in a few little extra storage items will help you to do just that.

Padded hangers

When you are storing vintage clothing, don't rely on the cheap plastic or wire coat hangers you get free with modern purchases. Invest in some good quality hangers, preferably wood or padded fabric, but well-shaped plastic will do, as long as it doesn't have any rough areas that could snag fabric. Try not to use metal hangers, which can rust and mark the clothes. Few vintage garments have loops inside for hanging, so you will need some hangers with rubber clips for hanging skirts and trousers.

Moth repellent

Moths aren't such a problem as they once were, but it is still wise to guard against them. Traditional mothballs are extremely effective, but they smell revolting, and will cause damage to clothes if they touch them. Cedar wood is also a good moth repellent, and smells far more pleasant, but it can cause yellowing if it comes into contact with fabric.

Garment bags

Never, never, store vintage garments in plastic bags, particularly the ones you get at dry-cleaners. The plastic doesn't allow the fabric to breathe and this can encourage mildew problems. If you want to protect a delicate item with a bag, buy a canvas one that has been specially made for storing garments, or make your own out of fine cotton or muslin.

Archival boxes

If a dress is bias cut, the weight of the fabric can cause it to stretch out of shape, resulting in a rippled hem. If it is heavily beaded, such as some of the 1920s evening dresses, the weight of the beads could pull the dress down and tear the fabric. This is why very fragile items are better stored in garment boxes with lids. Archival boxes are made from acid-free cardboard – ordinary cardboard is too acidic and may cause fabric damage.

Contact paper

Always line drawers and shelves with acid-free contact paper. This will prevent fabric from absorbing oils from untreated wood and from snagging on any rough areas. Be wary of scented papers, which may damage very delicate fabrics, and never use oils, scents or herbs in any area where they will be in direct contact with fabric.

"new" from old: recycling vintage

There's nothing quite as frustrating as finding a gorgeous dress, then discovering it has faults you can't fix. It's even worse than finding a lovely dress that's too small, as at least you know someone will be able to wear it. Sadly, some faults are unfixable, but if a piece is beautiful, and it pulls at your heart to let it go, there are other ways you can continue to enjoy its beauty.

When you look at damaged vintage garments, don't be quick to discard them. Sometimes all they need is a little imagination and some TLC. In return, you will get the satisfaction of knowing that you have breathed new life into a gorgeous piece of history, for your enjoyment, and maybe even for future generations. Here are some suggestions to get your creative juices flowing:

Creating a display ...

Vintage textiles are a wonderful way to add character to a room, and there are plenty of fabrics and designs to choose from, ranging from antique quilts and hand-embroidered linens, to faded old rugs or kitsch print curtains. Damaged vintage clothing can be used in the same way, to add a splash of colour and style, to create a sense of decadence, or to give a room a lived-in feel.

Draping a shawl

Fringed shawls were popular throughout the early years of the 20th century, but often the dyes used in the embroidery thread were not colour-fast, and as a consequence many shawls on today's market have been spoilt by dye stains. However, this won't show from a distance, and the rich embroidery and fringing will create a luxurious look in any room. Why not drape an embroidered shawl over a sheer curtain for a casually chic window dressing? If the shawl is stain free, but has moth holes,

drape it over a table or nightstand, so that the damage is less noticeable, but the embroidery is on display.

Exhibiting a delicate dress

Although beautiful, some dresses just aren't in a wearable condition. The groovy paper dresses of the 1960s were delicate when they were first made, and beaded dresses, particularly those from the 1920s and 1930s often show signs of age, because the weight of the beads tends to tear the fabric over time. But such items are far too interesting and beautiful to be packed away in a trunk. If you have a treasured item, why not think of it as a piece of art, and display it on a wall? Exotic vintage kimonos make superb display items, especially hung from a special wall-mounted pole, threaded through the sleeves. Alternatively, you could hang a dress on a padded hanger on a wardrobe door or display it on a dress form, in the corner of a bedroom or dressing room. The overall effect will be one of nostalgic glamour, distracting the eye from any flaws of the dress.

One word of warning: displaying a beaded dress like this can put strain on the fabric. This isn't a problem if you simply want to enjoy it as an ornament. However, if you want to preserve the dress to wear it, you may wish to take some of the weight off the fabric by laying it over the back of a sofa or chaise longue.

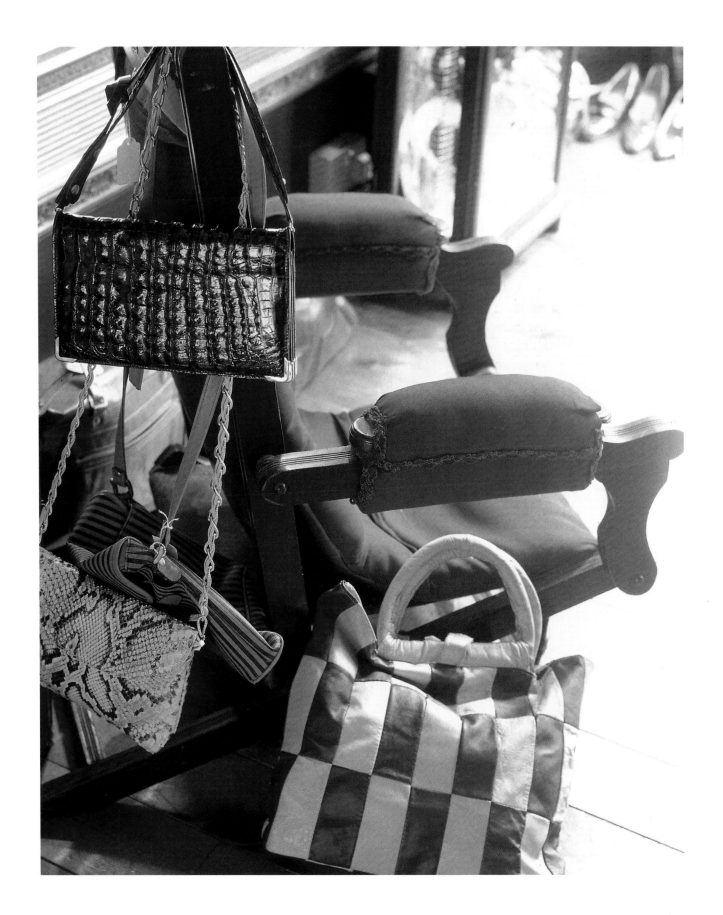

Arranging shoes

If you are a shoe lover, why keep your babies hidden away in a wardrobe, when they could be brightening up your home? A shoe collection can be displayed simply, with a row of shoes on the floor in a bedroom or hallway, or in a more structured way, in a custom-built display unit, with square compartments for each pair. Mix up your modern shoes with vintage pairs, which can be displayed regardless of size or condition. This a very satisfying way of finding a use for all those tempting pairs of vintage shoes you come across but can't fit into, and gives a sophisticated, yet quirky, look to a room. Be careful of displaying shoes in a bathroom, as the humidity and damp can ruin leather.

A fun and unusual bra top, stitched together from three pairs of Levis and a pair of Lee jeans.

Scattering knitwear

Moth-eaten sweaters and cardigans folded cleverly can be used to add a splash of colour to a room, and, if you use luxurious cashmeres or beaded and sequinned designs, they can give a very decadent feel. Look out for colours that complement or contrast with your room's colour scheme, and drape them over the arm of a sofa or the back of a chair, or fold them and lay them on an ottoman. Think of them as mini throws, and layer them for extra pizzazz.

Showing off handbags

Vintage bags are irresistible, but not all are in usable condition. Many bags have gorgeous beaded or hand-painted designs that are badly damaged on one side, making them perfect for leaning against the wall, sitting on a hallway table or hanging from a peg rack. Others have broken straps or fastenings, and if they are casual bags, perhaps made from jaunty coloured raffia or straw, they could be well suited to life as an unusual fruit bowl or plant-pot cover, or look good filled with books or magazines. If you have a smarter bag, you could fill it with a complementary coloured silk scarf and display it on a dressing table, or you could use it beside the bed as a glamorous nightgown case.

Born again as ...

If you enjoy sewing, customising or creating, damaged vintage garments hold a wealth of opportunities for you. Some vintage sellers and collectors hold their hands up in horror at the

Trudie's top tip

Introducing your child to the world of vintage clothing can help him or her to realise the importance of individuality, and shows that there is an alternative to the mass-produced clothes of the chain stores. Vintage shops rarely carry much children's clothing, so if you have daughters or younger friends or relatives, why not make clothes for them by cutting down your damaged garments? Most fabrics should be suitable for children's clothes, but you may want to avoid using large or sophisticated patterns. For older girls, the womenswear ranges in vintage shops are a rich resource, as many of the prettiest clothes are still on the shelves because they are so tiny.

thought of cutting into a vintage dress, but if that means that its life span is extended, then isn't that the kindest thing to do? Think twice before making drastic changes to any vintage garment that is in good condition, as you may regret it or prevent someone else from enjoying it. But if an item is unwearable because of its faults, then let your imagination go wild.

New clothes

With a little thought and effort, you can turn vintage clothes into something completely new: a pretty dress with a torn hem can be shortened; a perspiration-stained dress can be cut down into a skirt; or a garment can be completely unpicked, and its fabric used to make a different garment, with a retro twist.

A professionally reconstructed dress made from a Pucci fabric.

Restructuring clothing isn't a new idea, and designs like this top, left, were the height of fashion in the 1970s.

Pretty vintage fabrics can be used to make gorgeous summer bags.

are several good books available on making bags, from quick and easy totes to more structured handbags.

Home furnishings

Some vintage fabrics are so gorgeous that they just cry out to be used as home décor accessories. If you want cushion covers, you could turn a silk evening gown into a glamorous design, trimmed with tasselled corners, or you could go for a funkier look by turning psychedelic prints into multicoloured throw cushions. Even vintage knitwear can be used in this way: if you have a lovely cardigan, but it is riddled with moth holes, try washing it on a very hot wash to create a felted feel to the wool, then make it into cosy cushion covers.

Think creatively about other areas in the home that would benefit from a splash of vintage colour and design. The fabric from damaged garments can be turned into lampshades, blinds or napkins, or used as funky borders on pillowcases, duvet covers, tablecloths or curtains. If you are very crafty, you can utilise the smallest scraps of fabric to make patchwork cushions and quilts. Men's vintage striped and checked shirts that have become threadbare at collar and cuffs lend themselves particularly well to this, or if you want a prettier feel, go for the lush florals of 1950s dresses and skirts.

Sheepskin is another material that can be reworked into items for the home – if you have a sheepskin coat that is badly stained on the outside, you could use it to re-cover dining chairs.or to make gorgeously tactile cushions. And while you might not be able to get away with wearing fur coats in public, they can be used to create a look of opulence in the home, perhaps turned into throws, used to cover footstools, or even made into the ultimate pet bed. Bear in mind, however, that fur isn't easy to work with, so you may wish to have an expert rework the coats for you.

Vintage jeans, for example, are often unflattering in design, or have too much wear at the hems or knees. But they look wonderful turned into denim skirts, either using the denim to fill in the triangle at the hem, or using a contrasting piece of fabric. To make a completely new garment, open up all the seams and then base the new dress or skirt on a pattern you can buy in a sewing shop. Consider using the "wrong" side of the fabric if it looks brighter and fresher. Hide holes or stains with pockets or trimmings.

Bags and purses

Several modern entrepreneurs have made good money creating bags and purses out of vintage garments, and accessories made from vintage fabric are completely unique, brightening up the plainest of outfits. If you are handy with a sewing machine – or you can persuade someone who is – this is a wonderful way to use the fabric from a flawed garment, as it allows you to save the good fabric and discard the damaged. Vintage jeans that are too badly ripped for anything else make particularly cute bags, with the front pockets as the front of the bag, and the back pockets as the rear. There

Lingerie

Delicate garments, made from wisps of chiffon or fine silk, are often too damaged to wear, but if the fabric in them is mainly good, they can be remade into the prettiest lingerie. Use sensuous silks and satins to make French knickers and camisoles, and floral-printed chiffon and voile to make slips or special-occasion nightgowns.

If you want to recreate the vintage lingerie styles, look out for vintage patterns in shops and on websites – many women used to make their own underwear, especially in the first half of the 20th century, so you should be able to find suitable patterns.

Book coverings

Some garments have beautiful beaded or sequinned designs that you might want to keep even if the rest of the garment is no good. However, to save the beading, you will have to cut out the backing fabric too, which limits its later uses. If the fabric is a rich silk, velvet or satin, you could use it to cover special notebooks or photo albums, with the beading as a focal design. These make wonderful gifts – if you can bear to part with them.

starting to sell

Does your wardrobe rail keep collapsing under the weight of all those clothes you've been buying? Or are you looking for a career change and fancy opening up your own shop – real or virtual? If you love vintage clothing, why not indulge your passion and consider selling it?

Selling vintage clothing is tremendous fun: you get to meet lots of fellow vintage addicts; you learn more about the clothing for yourself; and, depending on your self-control, you can either make some money, or add to that revolving wardrobe of yours.

Becoming a casual seller

So you've gone through your wardrobe and weeded out the stuff you don't wear/fit into any more, and you're ready to hand it on to its new home. What next?

Selling clothes on a casual basis is easy: you can take them into a shop and swap them for cash – or more clothes; you could sell them in a car boot sale; or you could use an online auction site. If you choose to take your stuff to a shop, be prepared to get less for it than you think its worth; however, swap it for stock and you'll probably get a better deal. If you want to be more involved, a car boot sale might be the thing for you. But be prepared for a long day, people who pick through your clothes as though they're flea infested, and low profit margins. Alternatively, if you are computer savvy you could try selling over the Internet. You're more likely to get good prices, and you don't even have to leave home. The keys to online selling are information and honesty. List measurements use lots of pictures, and describe any flaws.

Going full time

This book will have given you an overview of the vintage clothing business, but there's no substitute for learning as you go along. So what makes a good seller? Encyclopaedic knowledge of fashion history? Great contacts? An eye for fashion? Well, those are all bonuses, but the really important thing is that you love vintage clothing. All the other things come with time and experience, but if you don't love vintage fashion, you won't be enthusiastic with your customers, and that's the one thing you need the most – and that you can't fake.

Where to sell

The first thing is to decide how you're going to sell. A stylish shop? An eclectic market stall? A funky website? You need to choose the right one for you. Do you need to be at home much of the time, or are you free to come and go as you please? Do you have the money to buy large amounts of stock, or can you afford only a small range? And what about your personality – do you work best alone, or are you outgoing and love to meet people? Here are some pros and cons of each way of selling:

VINTAGE SHOP: On the plus side, a shop enables you to see your customers face to face and to build relationships. If you choose a good location, the shop will promote itself. Some of your buying can be done through the shop, as people will bring clothes in for you to purchase. On the minus side: you need to maintain a substantial level of stock – no one wants to walk into a half empty shop. Your overheads will be high, especially if you need to employ staff, which you will, unless you never need a day off.

MARKET STALL: The overheads of a stall are much cheaper than for a shop, but you still get to meet your customers. You should have a quicker turnover and will need less stock in the beginning. On the other hand, if you want to sell full time, you'll have to travel to different markets each day in order to sell enough. Your customers may be put off by the lack of changing facilities. And your stock – as well as you – will be vulnerable to the elements.

ONLINE SHOP: The advantages of selling online are many. Once you've set up the site, your running costs will be minimal. You can work from home and at hours that please you. You need less stock to start with. And you can attract customers from around the world. However, there are disadvantages, too. You'll be working alone. Competition is fierce, so you'll have to work hard to get exposure. If you accept credit cards, you'll have to pay for the service and are open to fraud. If you don't, customers may be put off from making purchases.

What to research

Once you've decided on the best format for your business, do as much research as you can. Visit other shops or surf similar websites, and ask for advice from other sellers. Try to think of everything before plunging in – and make sure you've got enough capital to cover your plans. If you find the perfect shop, redecorate it and fill it with delicious clothes, but forget to budget for your rent, your expenses may end up gobbling up your profits. A business advisor can help you to plan out the financial side of things and may even help you to raise enough cash to make your plans a reality.

Where to get your stock

The big secret of the vintage world. Ask any vintage seller where they get their stock from and watch them shrivel up faster than a salted slug. The answer is, you have to find your own sources. If you truly enjoy vintage shopping, you'll enjoy the hunt, whether it takes you to

estate sales, second-hand market stalls, online auctions, or other vintage shops. If you resent the time you're spending on buying, maybe this business isn't for you. After all, the advantage – or disadvantage – of running a vintage clothing business is that you get to go shopping every day. And if you're lucky, you get paid as well – even if your weekly wage comprises two 1950s sweaters and a hand-painted swing coat.

How to sell

Whatever you do, don't get so bogged down in the business side of selling that you forget the point of doing it in the first place. Be organised, but enjoy what you are doing; be prudent, but don't forget to have fun. Go the extra mile to help your customers – don't just sell them a skirt, give them ideas on how to wear it. And never forget, customers are your best PR agents – they're the ones who'll spread the word about your fabulous shop and keep coming back for more. If you make a rule of spoiling each customer rotten, your business will flourish, and you'll have a wonderful time as well.

What you'll make

If you want to sell vintage thinking it'll be a glamorous money-spinner, you've got it all wrong. Unless you plan to open a boutique in an exclusive city spot and to get celebrity customers to make your shop famous, you aren't going to get rich in this business. If you are only in this business for the money, it will show and your real customers will drift away.

That's not to say you can't make a good living, but it shouldn't be your main goal. Aim to enjoy your job and to be the kind of seller you would like to deal with. You might be going home at the end of the week with less money than your high-flying contemporaries, but you'll have a delightful customer base, a constantly changing wardrobe, and a job that makes you glad it's Monday morning.

go get it!

4

where to shop

International Auction Houses

Sotheby's
34–35 New Bond Street
London
020 7293 5000

1334 York Avenue at 72nd St
New York
(1) 212 606 7000

Galerie Charpentier
76, rue du Faubourg Saint
Honoré
Paris 75008
(33) 1 53 05 53 05

Christie's
8 King Street
St. James's
London
020 7839 9060

20 Rockefeller Plaza
New York
(1) 212 636 2000

9 Avenue Matignon
Paris 75008
(33) 1 40 76 85 85

Bonham's
101 New Bond Street
London
020 629 6602

Widenmayerstr. 4
80538 München
Germany
(41) 22 300 3160

UK Vintage Shops

NORTH ENGLAND:
Attica
2 Old George Yard
Cloth Market
Newcastle
0191 2614062

Echoes
650a Halifax Road
Todmorden
Lancashire
01706 817505

ERA
1 Victoria Road
Saltaire
Shipley
West Yorkshire
01274 598777

Freshman's
6–8 Carver Street
Sheffield
0114 2728333

Positively 13 O'Clock
7A Crown Street
Leeds
0113 2432776

Priestley's
1 Norman Court
Grape Lane
York
01904 631565

Tube Mouse 55
Affleck's Palace
52 Church Street
Manchester
07951 929207

The Vintage Clothing Co.
Quiggans Centre
School Lane
Liverpool
0151 7070051

The Vintage Clothing Co.
Affleck's Palace
52 Church Street
Manchester
0161 8320548

MIDLANDS:
Back In Fashion
38 High Street
Tutbury
Burton-on-Trent
Staffordshire
01283 814964

Celia's Vintage Clothing
66–68 Derby Road
Nottingham
0115 9473036

SOUTH ENGLAND:
Agent 69
81 Victoria Road
Swindon
01793 511019

Bead Games
40 Cowley Road
Oxford
01865 251620

Bohemia
104 High Street
Hythe
Kent
01303 267020

Kitt's Couture
51 Chapel Street
Penzance
Cornwall
01736 364507

The Real McCoy
21 The Fore Street Centre
Fore Street
Exeter
01392 410481

Replay Period Clothing
7 Well Walk
Cheltenham
01242 238864

Re-Psycho
85 Gloucester Road
Bishopston
Bristol
0117 9830007

Revisions
3 Pool Valley
Brighton
01273 207728

Rock-A-Round
Unit 8
Bristol & West Arcade
Friar Street
Reading
0118 9560588

Rokit
23 Kensington Gardens
Brighton
01273 672053

Uncle Sam's
54 Park Street
West End
Bristol
0117 9299404

Vintage to Vogue
28 Milsom Street
Bath
01225 337323

Yellow Submarine
12 Kensington Gardens
Brighton
01273 626435

Yesterdaze
18 Southside Street
The Barbican
Plymouth
01752 256845

LONDON:
Annie's
12 Camden Passage
Islington
London
020 7359 0796

Beyond Retro
110–112 Cheshire Street
Shoreditch
London
020 7613 3636

Biba Lives
Unit 32a The Arches
Stables Market
Camden
London
020 7482 4994

Blackout II
51 Endell Street
Covent Garden
London
020 7240 5006

Cad Van Swankster
Alfies Antique Market
13–25 Church Street
Marylebone
London
020 7724 8984

Cenci
31 Monmouth Street
Covent Garden
London
020 87668564

Cloud Cuckoo Land
6 Charlton Place
Camden Passage
Islington
London
020 7354 3141

Cornucopia
12 Upper Tachbrook Street
Pimlico
London
020 7828 5752

Delta of Venus
151 Drummond Street
Euston
London
020 7387 3037

Dolly Diamond
51 Pembridge Road
Notting Hill Gate
London
020 7792 2479

Dolly Rockers
Stables Market
Camden
London
020 7482 0193

Emporium
330–332 Creek Road
Greenwich Village
London
020 8305 1670

Flying Duck
320–322 Creek Road
Greenwich Village
London
020 8858 1964

The Girl Can't Help It
Alfies Antique Market
13–25 Church Street
Marylebone
London
020 7724 8984

The Glamour Palace
211 Woodhouse Road
North Finchley
London
020 8368 2117

Henry & Daughter
17–18 Camden Lock Place
Camden
London
020 7284 3302

Modern Age
65 Chalk Farm Road
Camden
London
020 7482 3787

Observatory
20 Greenwich Church Street
Greenwich village
London
020 8305 1998

One Of A Kind
253/259 Portobello Road
Notting Hill
London
020 7792 5284

Oxfam Originals
26 Ganton Street
Oxford Circus
London
020 7437 7338

The Pop Boutique
6 Monmouth Street
Covent Garden
London
020 7497 5262

Radio Days
87 Lower Marsh
Waterloo
London
020 7928 0800

Rellik
8 Golbourne Road
Westbourne Park
London
020 8962 0089

Retro
30 Pembridge Road
Notting Hill
London
020 7221 2055

Steinberg & Tolkien
193 King's Road
Chelsea
London
020 7376 3660

Stitch Up
45 Parkway
Camden
London
020 7482 4404

Virginia
98 Portland Road
Notting Hill
London
020 7727 9908

What The Butler Wore
132 Lower Marsh Terrace
Waterloo
London
020 8858 2928

Yellow Submarine
38 Earlham Street
Covent Garden
London
020 7240 0908

WALES:
Hobo's
26 High Street Arcade
Cardiff
029 20341188

Hobo's
214 Oxford Street
Swansea
01792 654586

SCOTLAND:
Armstrong's
83 Grassmarket
Edinburgh
0131 2205557

Flip of Hollywood
59–61 South Bridge
Edinburgh
0131 5564966

The Rusty Zip
14 Teviot Place
Edinburgh
0131 2264634

Saratoga Trunk
93 West Regent Street
Glasgow
0141 3312707

Starry Starry Night
19–21 Downside Lane
Byres Road
Glasgow
0141 3371837

IRELAND:
Flip
4 Upper Fownes Street
Dublin
(353) 1 6714299

Jenny Vander
20 Market Arcade
South Great Georges Street
Dublin
(353) 1 6770406

A Store Is Born
34 Clarendon Street
Dublin
(353) 1 6770406

Europe Vintage Shops

BELGIUM:
Galontique
Venelle Aux Quatre
Noeuds 2
1150 Brussels
(32) 2 7701241

Idiz Bogam
76 rue Antoine Dansaert
1000 Brussels
(32) 2 5121032

Timeless
Avenue Louise 142a
B-1050 Brussels
(32) 2 6484552

DENMARK:
Kitsch Bitch
Laederstraede 30
Copenhagen
(45) 33 13 63 13

FRANCE:
Anouschka
6 avenue Coq
Paris
(33) 1 48 74 37 00

Didier Loudot
Jardins du Palais Royal
24 Galeries Montpensier
Paris
(33) 1 42 96 06 56

Killiwatch
64 rue Tiquetonne
75002 Paris
(33) 1 42 21 17 37

Ragtime
23 rue du Roule
75001 Paris
(33) 1 42 36 89 36

GERMANY:
Calypso – High Heels Forever
Neue Schonhauser Strasse 19
Mitte
Berlin
(49) 30 2816165

Dralon
Danzigerstrasse 45
Prenzlauerberg
Berlin
(49) 30 4408558

Garage
Ahornstrasse 2
Schöneberg
Berlin
(49) 30 2112760

Made In Berlin
Potsdamer Strasse 106
Tiergarten
Berlin
(49) 30 2622431

Sterling Gold
Heckmann-Höfe
Oranienburger Strass 32
Mitte
Berlin
(49) 30 28096500

Tenderloin
Alte Schönhauserstrasse 31
Mitte
Berlin
(49) 30 42015785

HOLLAND:
Lady Day
Hartenstraat 9
Amsterdam
(31) 20 623 5820

Laura Dols
Wolvenstraat 7
Amsterdam
(31) 20 624 9066

Wini
Haarlemmerstraat 29
Amsterdam
(31) 20 427 9393

Zipper
Huidenstraat 7
Amsterdam
(31) 20 623 7302

US Vintage Shops

LOS ANGELES:
Aardvark
810 Hermosa Avenue
Hermosa Beach
(1) 310 376 3688

Animal House
66 Windward Avenue
Venice
(1) 310 392 5411

Come To Mama
4019 West Sunset Boulevard
Los Angeles
(1) 323 953 1275

Decades Inc.
8214 1/2 Melrose Avenue
Los Angeles
(1) 323 655 0223

Meow Vintage
2210 East 4th Street
Long Beach
(1) 310 438 8990

NEW YORK:
Alice's Underground
481 Broadway
New York
(1) 212 431 9067

Allan & Suzi
416 Amsterdam 80th Street
New York
(1) 212 724 7445

Atomic Passion
430 East 9th Street
New York
(1) 212 533 0718

Cheapjack's
841 Broadway
New York
(1) 212 777 9564

Chelsea Girl
63 Thompson Street
New York
(1) 212 343 1658

Cherry
185 Orchard Street
New York
(1) 212 358 7131

Cobblestones
314 East 9th Street
New York
(1) 212 673 5372

Family Jewels
832 6th Avenue
New York
(1) 212 679 5023

Foley & Corinna
108 Stanton Street
New York
(1) 212 529 2338

Live Shop Die
151 Avenue A
New York
(1) 212 674 7265

Mara the Cat
406 East 9th Street
New York
(1) 212 614 0331

O Mistress Mine
143 7th Avenue South
New York
(1) 212 691 4327

Phase Vintage
29-A Avenue B
New York
(1) 212 375 8051

Resurrection
217 Mott Street
New York
(1) 212 625 1374

Screaming Mimi's
382 Lafayette Street
New York
(1) 212 677 6464

Starstruck Vintage Clothing
47 Greenwich Avenue
New York
(1) 212 691 5357

Tender Buttons
143 East 62nd Street
New York
(1) 212 758 7004

The Village Scandal
10 East 7th Street
New York
(1) 212 460 9358

What Comes Around Goes Around
351 West Broadway
New York
(1) 212 343 9303

SAN FRANCISCO:
Guys and Dolls
3789 24th Street
San Francisco
(1) 415 285 7174

Martini Mercantile
1736 Haight Street
San Francisco
(1) 415 831 1942

Speedboat
803 Pacific Avenue
Santa Cruz
(1) 831 457 9262

Ver Unica
148 Noe Street
San Francisco
(1) 415 431 0688

Volume
803 Pacific Avenue
Santa Cruz
(1) 831 457 9262

Websites

Adorable Vintage Costume Jewelry
www.adorablevintagecostumejewelry.
com
Wonderful range of costume
jewellery, from the Victorian era to
the 1960s.

Amy Pang
www.amypang.com
A stylish selection of vintage
clothing with an Asian twist, from
the 1940s to the 1980s.

Another Time Vintage Apparel
www.anothertimevintageapparel.
com
Carries a range of top quality
antique and vintage clothing and
accessories from the Victorian era
through the 1950s. Includes
children's and men's clothing.

A Vintage Wedding
www.avintagewedding.com
A good selection of bridalwear
and accessories, from the 1900s
to the 1980s.

Ballyhoo Vintage Clothing
www.ballyhoovintage.com
Excellent website, with a
comprehensive selection of
clothing and accessories from the
1930s to 1970s, including a
range of menswear.

Butterfly Vintage Clothing
www.butterflyvintage.com
Budget vintage clothing for men
and women, from the 1940s to
the 1970s.

C20 Vintage Fashion
www.c20vintagefashion.co.uk
Stylish fashion archive that sells
high quality garments from key
20th-century designers. Also has
an extensive collection of 1920s
and 1930s eveningwear.

Caroline's Closets
www.carolinesclosets.com
Young and funky website,
featuring clothing and accessories
from the 1950s to the 1980s,
arranged into themes.

Catching the Butterfly
www.catchingthebutterfly.com
Fun website offering cheap
vintage clothing from the 1940s
to the 1980s, for men and
women. Has a small section of
plus-sized vintage.

The Cat's Pajamas
www.catspajamas.com
Fabulous website, with a huge
range of vintage clothing and
accessories from the Victorian
period to the 1970s. With special
sections for menswear, childrens
wear, larger sizes and bridalwear.

Chelsea Girl
www.chelsea-girl.com
Bright and breezy website, with a
glamorous selection of vintage
clothing and accessories from the
1930s to the 1970s.

The Dress Market
www.thedressmarket.com
Small and friendly website
carrying a range of vintage
dresses, mainly from the 1950s.

eBay
www.ebay.com
A huge selection of vintage
clothing and accessories, for
men, women and children,
available to buy through auction.

Enokiworld
www.enokiworld.com
Seductively chic online boutique, featuring designer vintage clothing and accessories, from the 1930s to the 1980s. Includes a selection of vintage bridalwear.

The Fainting Couch
www.faintingcouch.com
Wonderful selection of vintage clothing and accessories from the Victorian era to the 1950s. Includes a mouth-watering range of vintage hats.

Fever Vintage
www.fevervintage.com
An excellent range of clothing and accessories for men, women and children, from the 1950s to the 1970s, but mainly the 1970s.

The Frock.com
www.thefrock.com
Elegant selection of vintage clothing and accessories, from the Victorian era to the 1960s.

Funky Closet
www.funkycloset.com
Young and fun site with clothing and accessories from the 1950s to 1980s, categorised by style.

Hemlock Vintage
www.hemlockvintage.com
Comprehensive website, carrying clothing and accessories from the Victorian era to the present, for women and men.

Hey Viv!
www.heyviv.com
Larger-sized clothing as well as accessories from the 1940s and 1950s.

K8ty Kat
www.k8tykat.com
Adorable website with a wonderful selection of clothing and accessories from the 1950s to the present.

Kakkoiimono
www.vintagecoolthings.com
Slick site, featuring clothing and accessories for men and women, from the 1950s to the 1980s.

Kitty Girl Vintage
www.kittygirlvintage.com
A simple website, offering clothing and accessories from 1910 to the 1970s.

La Pochette
www.lapochette.com
Stylish website with a wide range of vintage bags, from the 1940s to the 1970s.

Legacy-NYC
www.legacy-nyc.com
Ultra chic website, carrying clothing and accessories from the 1930s to the 1970s.

Miss Maxine's
www.missmaxine.com
This unfussy website carries a selection of vintage handbags, from the 1920s to the 1970s.

Mop Closet
www.mopcloset.com
Fun and friendly website, with a selection of budget clothing and accessories from the 1940s to the 1980s.

Neen's
www.neens.com
A comprehensive range of clothing and accessories for men and women, from the 1900s to 1980s. The site also includes a range of bridalwear.

Nelda's Vintage Clothing
www.neldasvintageclothing.com
A selection of clothing and accessories for men and women, from the 1930s to the 1970s.

Paper Bag Princess
www.thepaperbagprincess.com
Inspiring, but pricey, selection of vintage couture, from the 1940s to the present.

Party Girl Vintage
www.partygirlvintage.com
Specialising in evening and party wear from the 1940s to 1970s categorised by event.

Plush Vintage
www.plushvintage.com
Good selection of clothing and accessories for men and women, from the 1920s to the 1980s.

Polyesters
www.polyesters.net
An extensive selection of men and women's clothing and accessories, from the 1920s to the 1970s.

POSH Vintage
www.poshvintage.com
Superb collection of top range vintage clothing and accessories, from the 1950s to the 1980s, with special sections for menswear and recycled designer clothing.

Retrodress
www.retrodress.com
Clothing and accessories from the 1950s to the present, including some men's items.

Rusty Zipper
www.rustyzipper.com
A huge range of budget clothing and accessories, from the 1920s to the 1980s, for men and women.

Sassypants Vintage
www.sassypantsvintage.com
A small range of men's and women's clothing and accessories from the 1950s and 1960s.

Tangerine Boutique
www.tangerineboutique.com
A good range of clothing and accessories from the 1930s to the 1970s, with special sections for menswear and larger sizes.

Then Plus Now 2
www.thenplusnow2.com
Specialises in vintage handbags, from the 1920s to the 1970s.

The Way We Were
www.the-way-we-were.com
Tantalising selection of vintage and antique jewellery, for men and women.

Those Fabulous Forties
www.fabulous-forties.com
An exceptional collection of 1940s clothing and accessories, as well as pieces from the 1930s, 1950s and 1960s.

Trashtique
www.trashtique.com
Cool range of clothing and accessories, organised by type or by theme, including runway-inspired items. Carries items from the 1950s to 1980s.

Vintage Blues
www.vintageblues.com
Wide selection of clothing and accessories for men and women, from the 1940s to the 1970s. Has a lovely range of bags made from recycled vintage clothing.

Vintage Cachet
www.vintagecachet.com
Charming website with a good range of clothing and accessories from the 1950s to the 1980s.

Vintage Glad Rags
www.vintagegladrags.com
A beautifully designed site, with clothing from the Victorian period to the 1950s. Carries some men's clothing.

Vintage Instyle
www.vintage-instyle.com
Offers a lovely range of vintage handbags, from the 1930s to the 1970s.

Vintageous
www.vintageous.com
A range of clothing and accessories from the 1930s to the 1960s, specialising in items from the 1950s.

Vintage Vixen
www.vintagevixen.com
An extensive range of clothing and accessories, from the 1930s to the 1980s. Includes a selection of children's clothes and menswear.

Vintage Wedding
www.vintagewedding.com
An inspiring range of wedding gowns and accessories, as well as groom's clothing, from the Victorian era to the present.

Viva la Frock
www.vivalafrock.co.uk
Superb selection of clothing from the 1920s to the 1980s. Specialising in glamorous evening gowns, and also has an extensive selection of wedding dresses.

Viva la Vintage
www.vivalavintage.com
User-friendly website carrying clothing and accessories for men and women from the 1940s to the 1980s. Includes a section for larger-sized vintage.

key clothing terms

ACETATE: a synthetic fabric made from wood or sometimes cotton fibres, with a soft, crisp feel and the appearance of silk.

ACRYLIC: a synthetic fabric made from coal, water, petroleum and limestone; it is durable and has a soft, woolly feel.

A-LINE: a style of dress or skirt that resembles the outline of the letter "A", flaring out straight from the shoulders or waist.

APPLIQUÉ: a method of decorating a garment by stitching a shaped piece of fabric on to it.

ASYMMETRIC: designed so that one side looks different from the other, often applied to tops or dresses with only one strap or sleeve.

BABY DOLL: a short A-line dress or nightgown.

BAKER BOY CAP: a floppy, round cap, a little like a beret but with a larger and fuller crown.

BALLERINA-LENGTH: a hem length that falls a little above the ankle, often used to describe full-skirted dresses.

BANDEAU TOP: a strapless top that forms a band around the breasts, usually made of stretchy material.

BASQUE WAIST: a waistline that starts at or below the natural waist and dips to a V shape at the front.

BATWING SLEEVE: a wide sleeve, which is attached down the side seams of a garment and sometimes tapers at the wrists.

BELL SLEEVE: a full sleeve, which flares at the wrist in the shape of a bell.

BIAS CUT: cut diagonally across the weave of the fabric, enabling the fabric to drape the body.

BLOUSON: an effect of fullness that's gathered and falls over a seam or waistline, similar to when a blouse is tucked into a skirt or trousers.

BOAT NECK: a high, straight neckline, which falls just below the collarbone.

BODICE: the part of a garment above the waist.

BODYSUIT: a close-fitting top, which fastens under the crotch and is usually made out of stretchy material.

BOLERO: a fitted jacket, cropped so that it ends above the waist.

BOUCLÉ: a curled or looped yarn that gives the fabric a thick, knobbly effect.

BRACELET-LENGTH SLEEVE: a type of sleeve that ends at around the mid-forearm.

BROCADE: a rich, heavy design on which a motif, such as flowers or scrolls, stands out against a satin weave background; sometimes made with coloured or metallic thread.

BULLET BRA: a steel-boned bra modelled on the "up-and-out" bra designed for Jane Russell in the film *The Outlaw*, which was banned at the time partly because of her bulging cleavage.

CAP SLEEVE: a short sleeve, which covers the outside of the upper arm and tapers to nothing under the arm.

CAPRI PANTS: tight-fitting, three-quarter-length trousers, named after the Italian island on which they first became popular.

CASHMERE: a type of wool, which originally came from goats living in the mountainous region of Kashmir in India.

CHANTILLY LACE: named after the French city where it originated, this delicate lace is often decorated with a subtle floral or swirl design.

CHEESECLOTH: a thin, very loosely woven cotton originally used as a wrapping for cheese.

CHEMISE: an unwaisted top or dress, loose-fitting and hanging from the shoulders.

CHEONGSAM: a Chinese-style dress, with a high neck, buttons at the side and slits at the legs.

CHIFFON: a fine, transparent or semi-transparent fabric, made from silk, nylon or other fibres; often used in evening wear because of its "floaty" quality.

CHINOISERIE: a style of decoration, which uses Chinese motifs and designs.

CLOCHE: a closely fitted, bell-shaped hat.

CONCERTINA PLEATS: small pleats that stand up rather than lying flat against the garment.

COOLIE HAT: a brimless, cone-shaped hat.